S0-ASN-777

With the Whales

PHOTOGRAPHY BY FLIP NICKLIN

INTRODUCTION BY DR. KENNETH NORRIS

TEXT BY DR. JAMES DARLING

With the Whales

PUBLIC LIBRARY
DEC 20 1990
SOUTH BEND, INDIANA

599.5 N536w RBF
Nicklin, Flip
With the whales

In memory of Charles Richard Nicklin Sr., who loved the wild.

Contents

Preface

BY DR. KENNETH NORRIS

Whales are almost creatures of another planet. No barrier on earth is more complete than the sea surface that lies between us. On the land where we spend our days are arrayed our teeming cities and valleys squared with farms. Rivers are channeled and bridged. Even the mountains and the frozen poles hold few places where man has not penetrated.

But board a boat and cruise from any harbor and your keel will race over terrain almost entirely unseen since the earth began. The numbers we print on charts to show the depths fool us. They were obtained from a boat cruising at the surface, generated by a machine that pinged little sounds out into the blackness below. They are measures of the thickness of the unknown and no more.

In the depths it is a world of whales. *With the Whales* takes you as far into that other sphere of life as anyone has gone on his own. Your escorts are two intrepid explorers of that blue domain. One is Flip Nicklin, a photographer unmatched anywhere, who has somehow found ways to insinuate himself into that world and to bring back priceless images for us to study and dream over. He has even played with these foreign creatures in a kind of underwater tag, where he was the "little one from land," swimming among the behemoths, each regarding the other with the most surprising gentility.

The other, Dr. James Darling, is a rare scientist whose vistas of understanding also spring from hundreds of forays beneath the sea. Jim takes you with him as he looks, measures, discards, and then constructs what it is like to be a whale. He has reached out with his mind and all the dispassion of his scientific training to thread his way through myth and imagining to tell you his stories.

These two have wandered throughout world's oceans in building this book. They have found places where the paths of the truly remote creatures of the open sea circle around sea pinnacles and where the authors, dropping into the clear oceanic water, could meet and reach out to them.

It is remarkable to me how many times they have achieved this touching across worlds and how accepting the whales have been. That, in fact, is the mystery of mysteries, because in their own world the whales are not too different from land mammals. As scientist Darling has shown, humpback whales engage every year in titanic struggles for the right to mate, and even the largest among the whales may fall prey to packs of predatory cousins that may tear them to bits. Yet photographer Nicklin ventures fearlessly into their midst and is accepted with grace. The whales flirt their giant flukes inches over his head as he swims down alongside their truly vast bulks where a single rush or a crashing blow from twelve-foot flukes could reduce him instantly to a senseless and sinking shape. It is that discrimination that continues to amaze me after my own thirty five years spent studying them. The whales, apparently throughout the oceans, seem clearly to recognize that we are of another world and essentially helpless in theirs, and then, not infrequently, take the wholly exceptional next step of all but ignoring our approach into their midst. To put this set of events into proportion, imagine what would ensue if you tried such an approach to a wild lion pride or a group of dangerous African buffalo. No matter how hard we try to rationalize it, there is something striking going on here.

As you look at Nicklin's images of the truly vast span of a right whale's flukes, transport yourself for a moment to his situation. There he is, camera in hand, stroking his way toward them; they ignore him as he moves closer. Then he is among their mountainous bodies and still they barely acknowledge him.

There is much daring of the unknown in this book. It is, in fact, a long and wonderful saga of humans testing the whale's boundaries and each time finding that the fear was theirs alone.

Above all this is a true book about whales. You learn what we really know about whales. And then you see it, up close, and you too may feel the swish of the giant animal's flukes and wonder at that unknown that still surrounds us just beyond the land's edge.

EYE TO EYE

We spotted this large pilot whale doing a series of spy-hops near our boat. I quickly dove and within seconds was eye to eye with this curious whale. As I drew closer, I could see the results of an encounter with a cookie-cutter shark. Fortunately for this pilot whale the shark did not complete its bites.

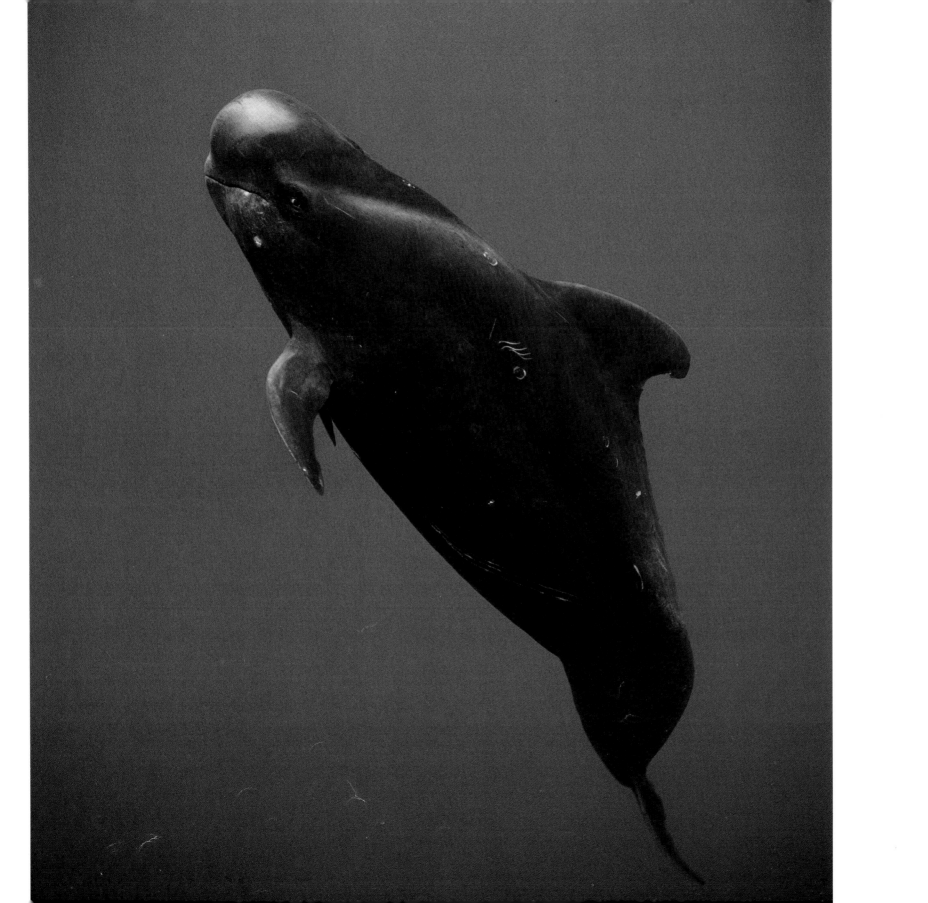

Portfolio

"There Leviathan,
Largest of living creatures, in the deep
Stretched like a promontory sleeps or swims,
And seems a moving land; and at his gills
Draws in, and at his breath spouts out a sea."

MILTON, PARADISE LOST

FRIENDLY HUMPBACK

Some whales are friendlier than others. This young humpback stayed with us for half an hour, just checking us out, watching what we were doing. Researchers and photographers truly enjoy these extended, amicable times. The "friendlies" are fun, for they let us observe them from various points of view and get close enough to take photographs. There are days when some whales will spend hours in areas where there are boats and swimmers. The humpback's long, white fins typically are one-third the length of its body. This humpback was one of three that came around us frequently while we were doing research off Hawaii's Kona Coast. After a while, we wondered who was studying whom.

NARWHALS IN CRACK

Narwhals (overleaf) make strategic retreats to avoid predators like killer whales or native hunters. This large group swam into a narrow lead in the spring ice, lying still, close to the surface, huddling together. We had been moving to safer ground as the ice was breaking up all around us. We found this quiet gathering as we hurried toward land.

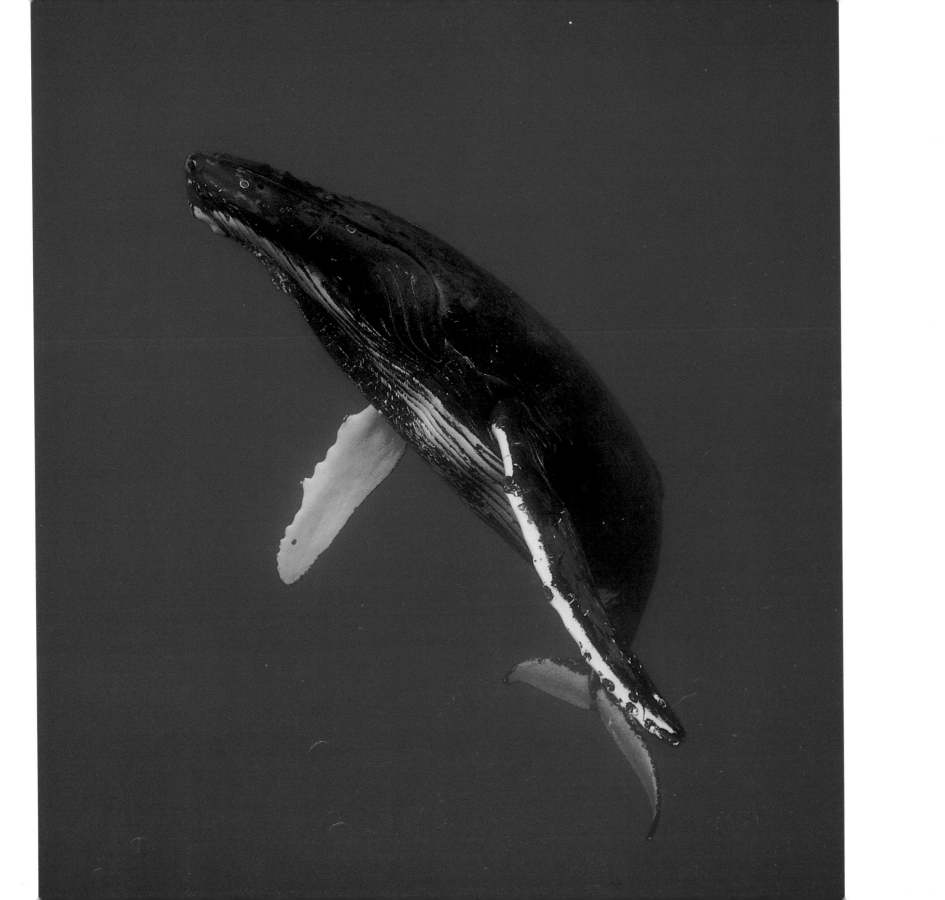

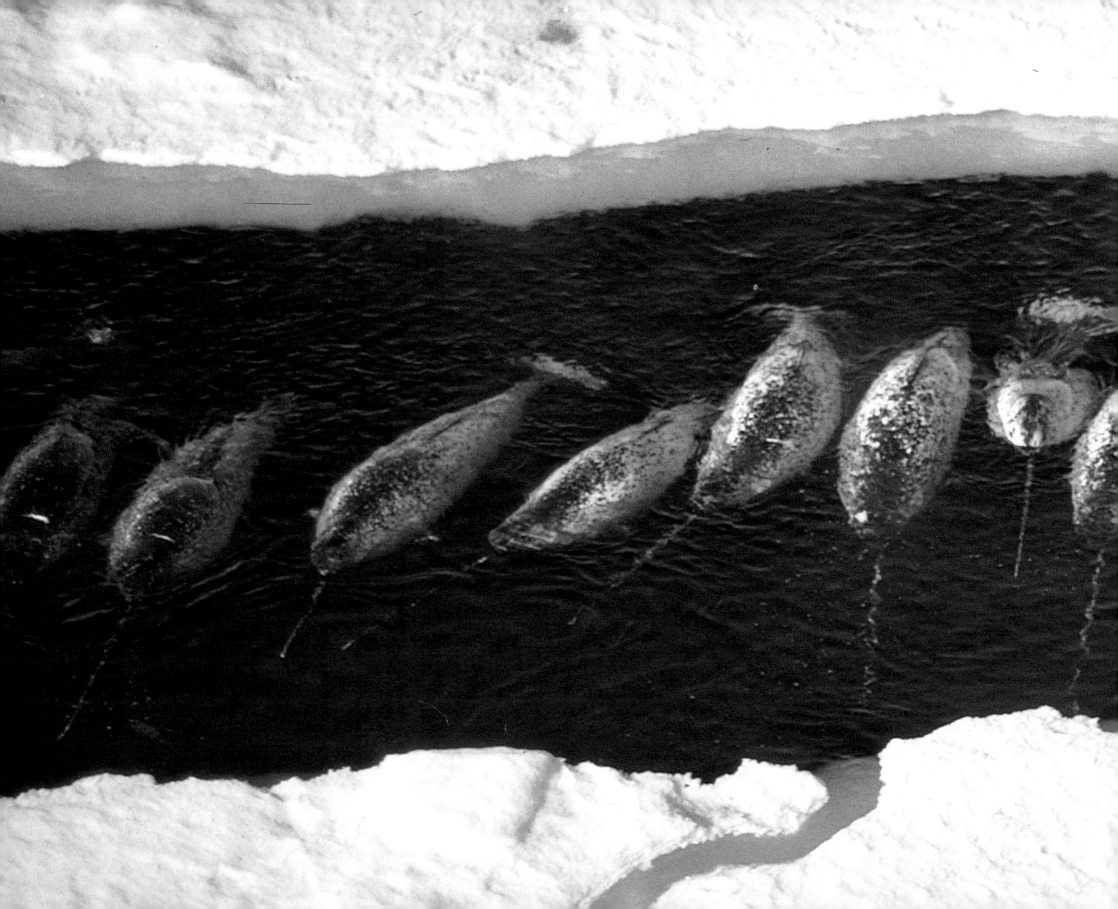

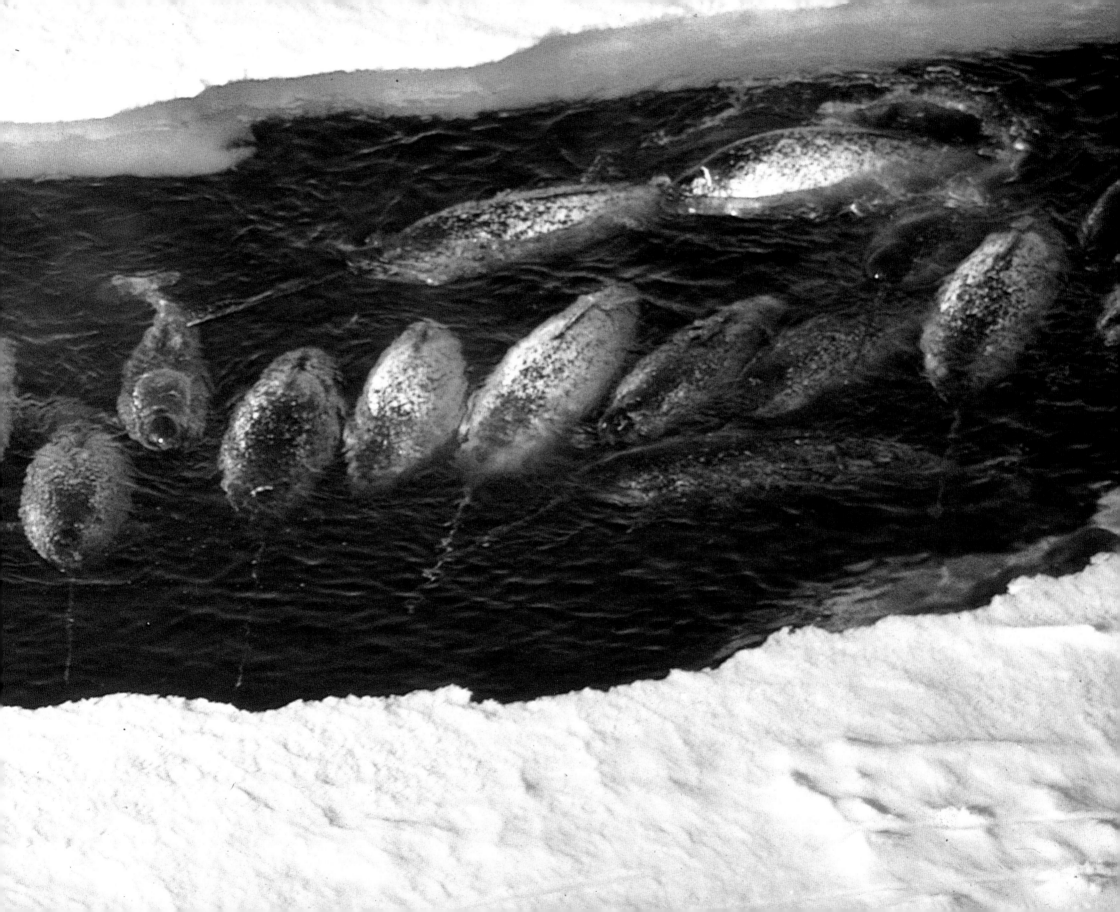

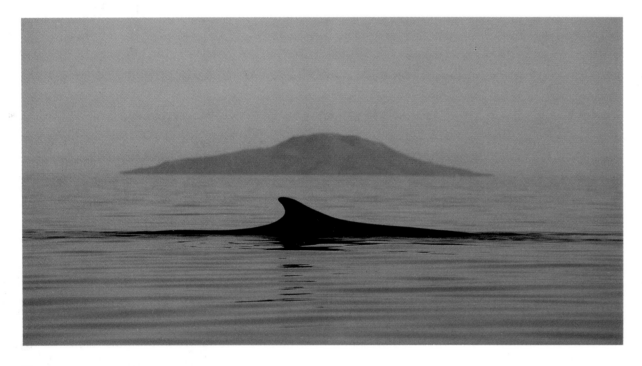

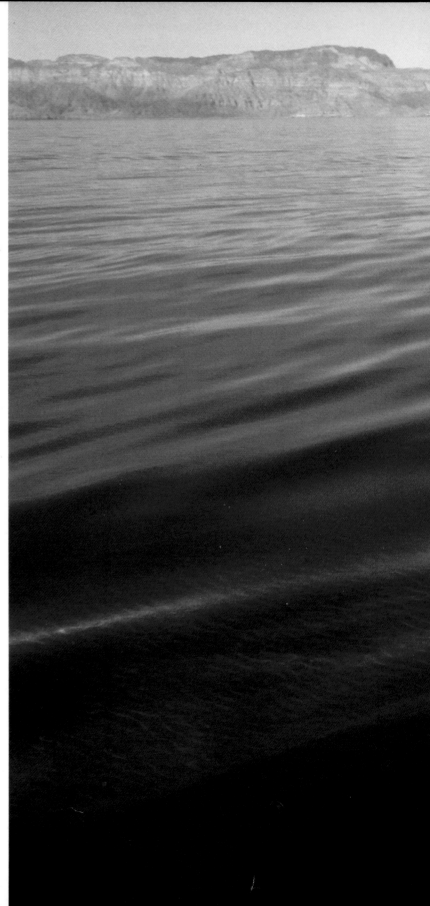

THE ISLAND WHALE

I *caught this striking silhouette (above) of a fin whale near an island in the Sea of Cortez. Although we were looking for blue whales among the islands of Loreto, we were delighted to find the curious and beautiful fin whales.*

SURFACING FIN WHALE

I*n the glassy calm (right) of the Sea of Cortez, the fin whales are sleek, graceful and unquestionably beautiful. Nicknamed "The Greyhound of the Seas," they can race across the surface at speeds exceeding ten knots.*

BIG BAJA BLUE

T*he blue whale (overleaf) is the largest creature on earth, yet it is difficult to find one. We searched for six weeks off the coasts of Panama, Costa Rica, and Newfoundland. Finally, we traveled to Baja California and the Sea of Cortez. There, on the first day, aloft in a small plane, we spotted this magnificent eighty-foot blue whale. They have a regal grace as they surface and dive. Blues also tend to glow as they come to the surface. Their mottled blue-gray pigmentation has a special brilliance about it. We spent ten days with the whales. Then suddenly and inexplicably they were gone.*

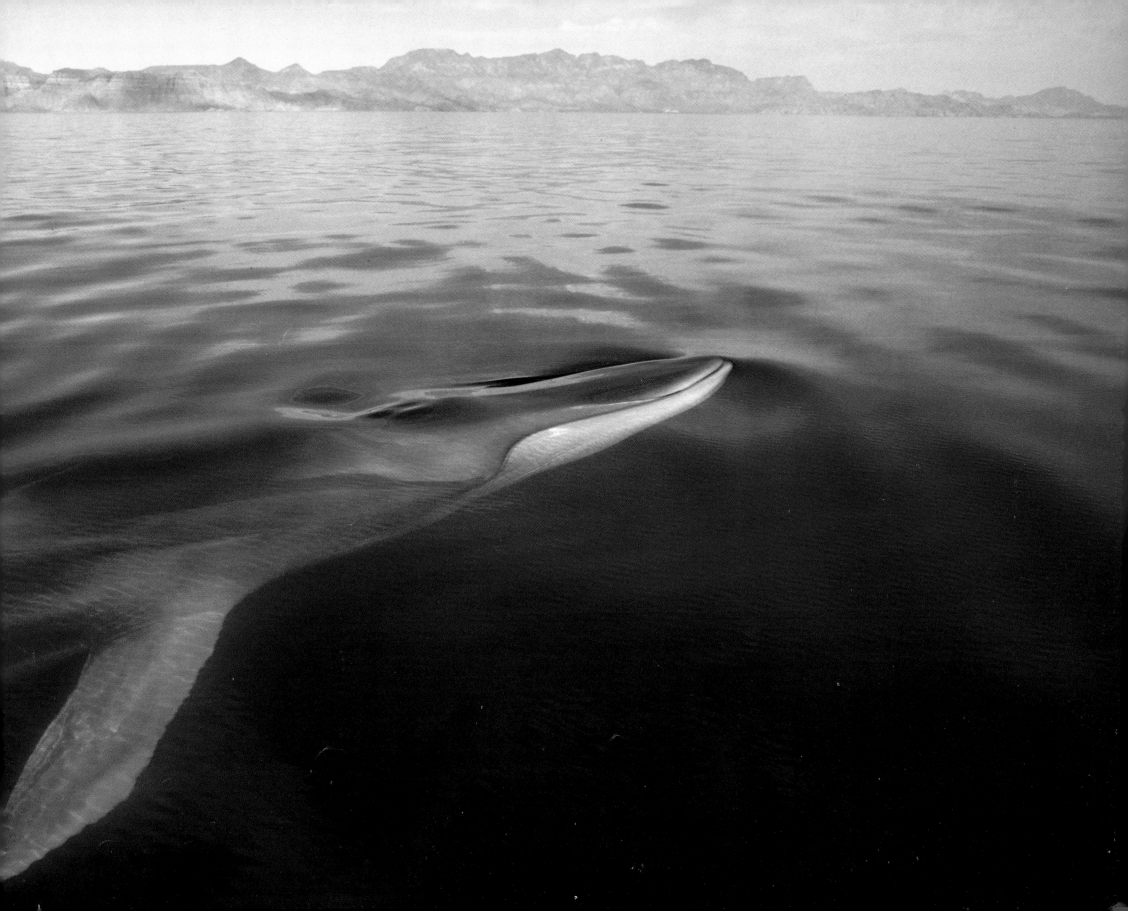

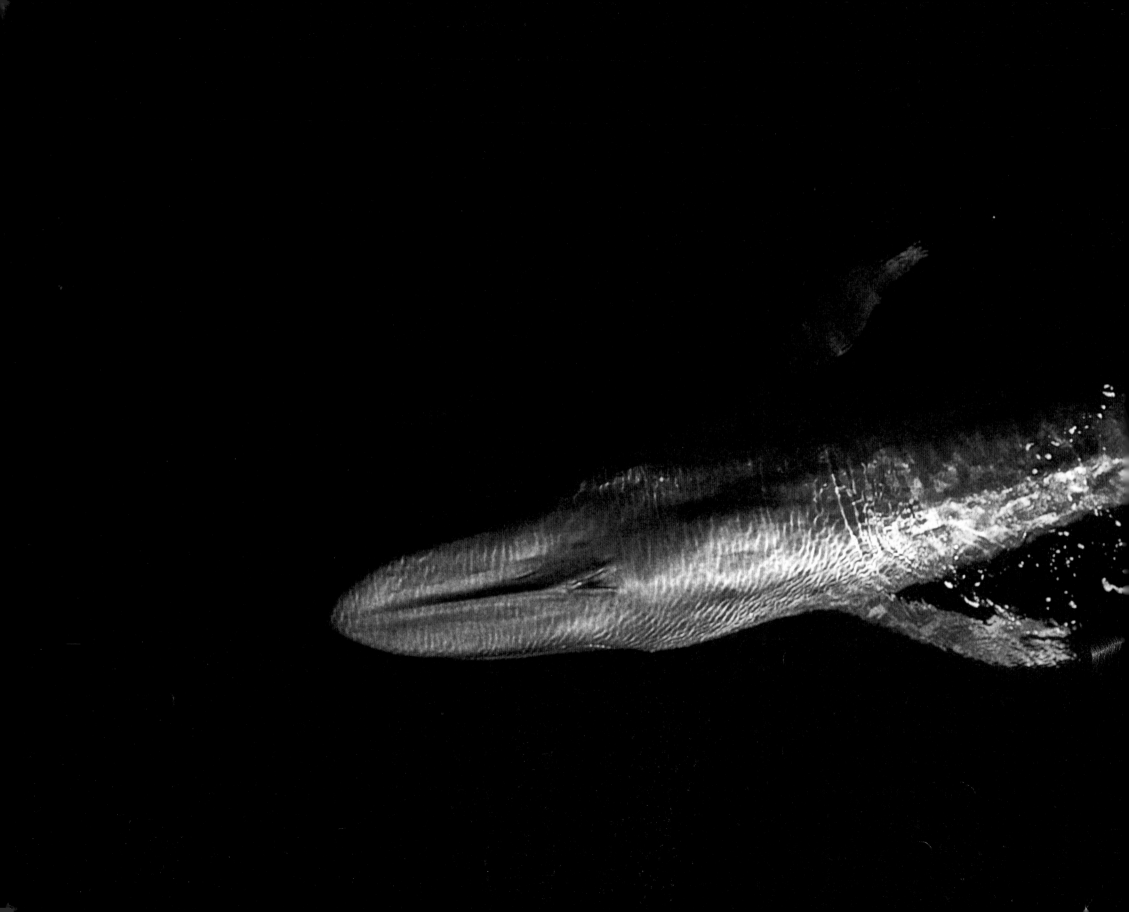

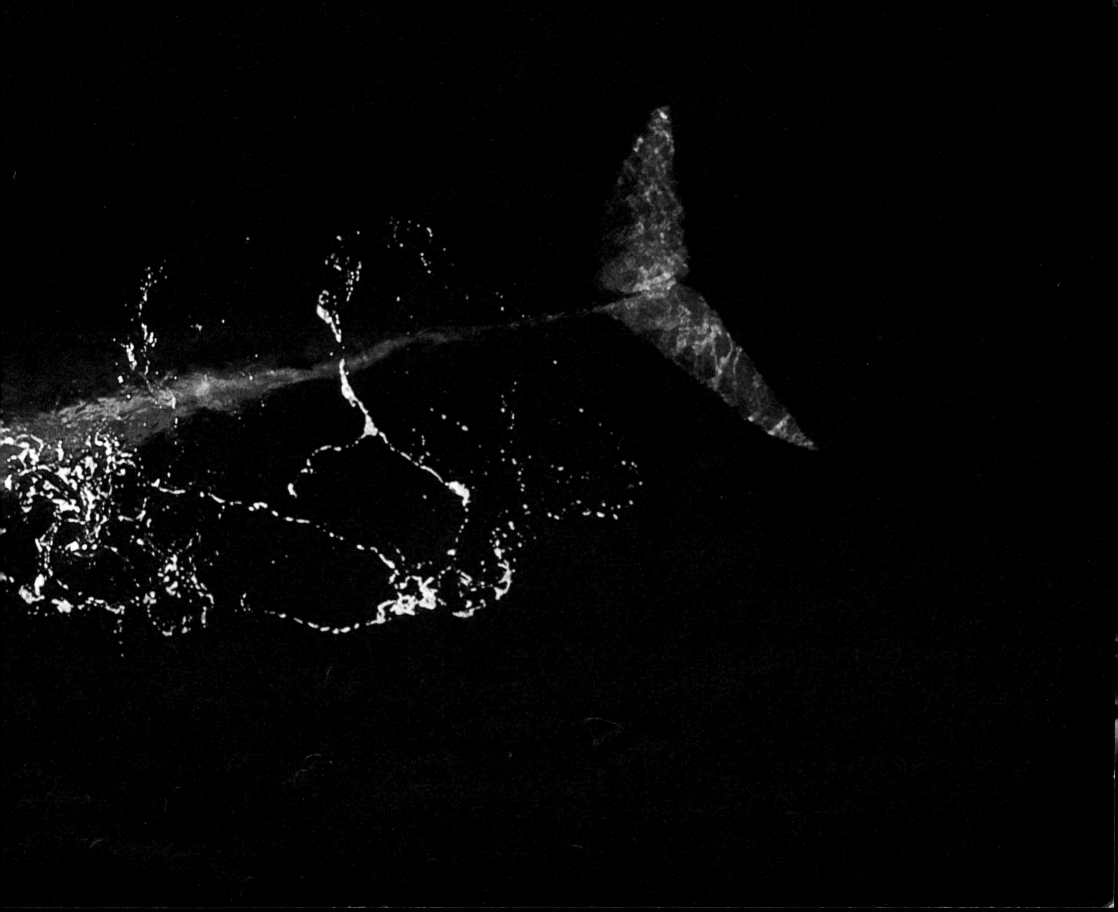

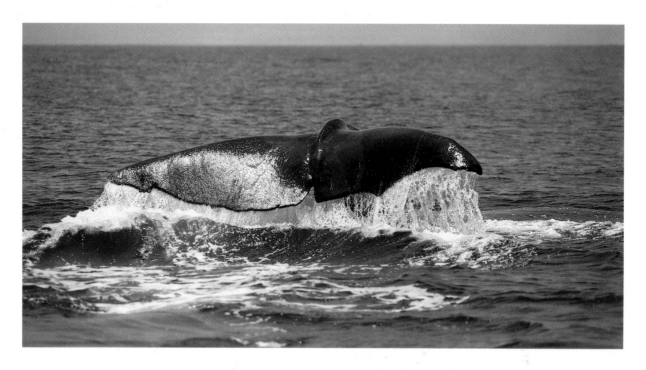

SPERM WHALE TAIL

We followed a sixty-foot square-headed sperm whale (above) as it swam and dove fifteen miles off Hawaii's Kona Coast. Neither friendly nor hostile, it showed us little more than its flukes.

SPERM WHALE PORTRAIT

After months of trying to find a sperm whale (right) in clear water, we watched in awe as this one swam by us three times before it lost interest and swam off. This is the animal that inspired Melville to write "Moby Dick".

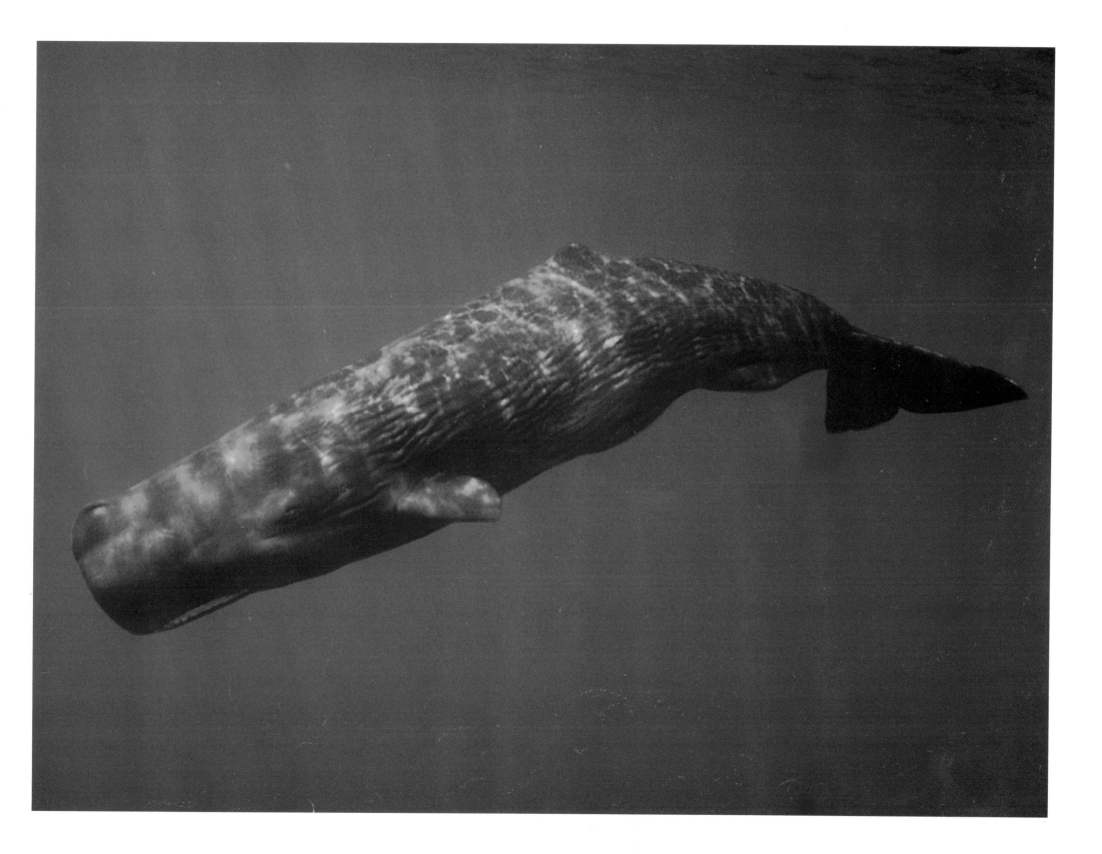

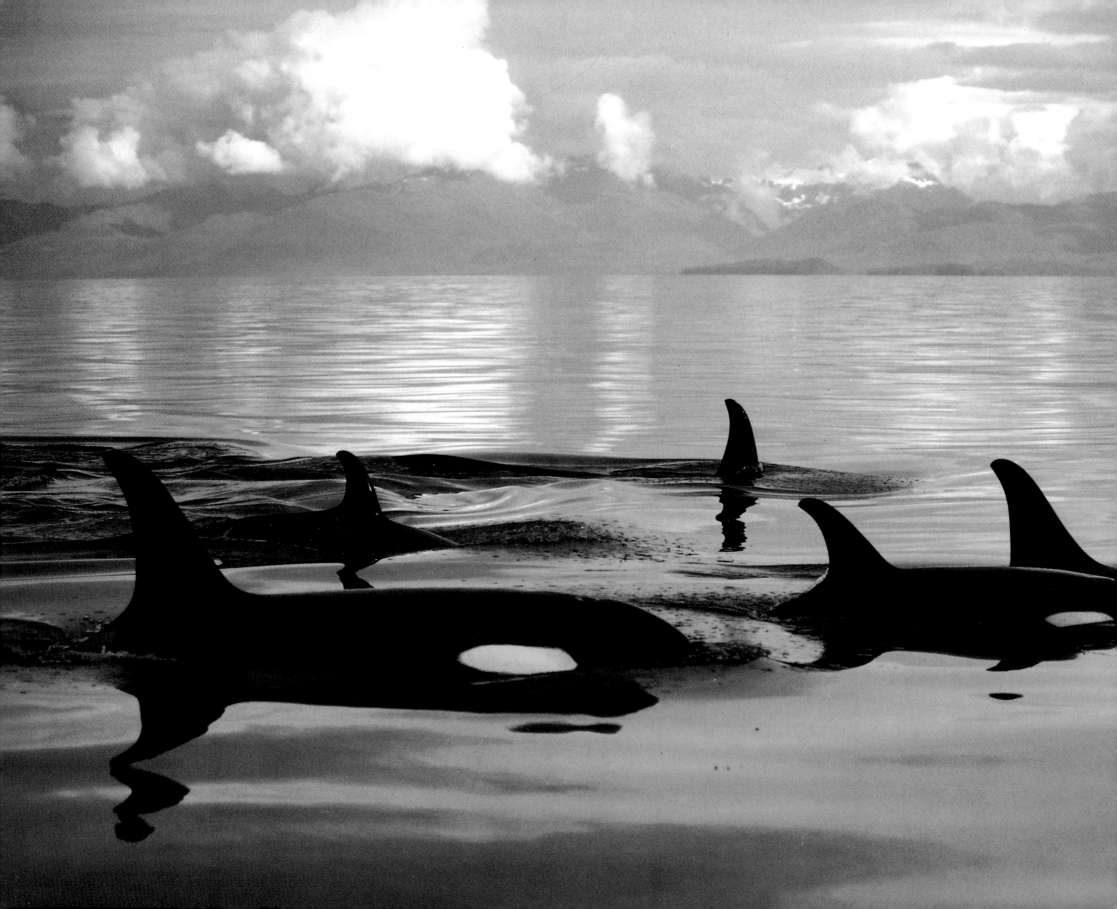

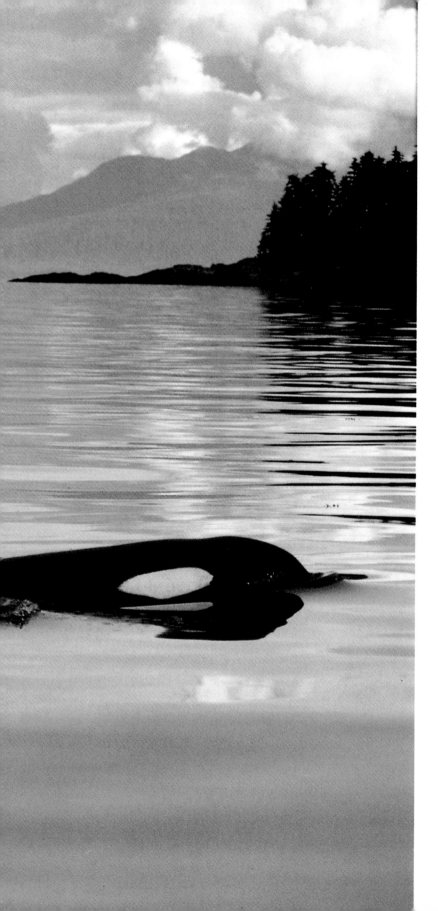

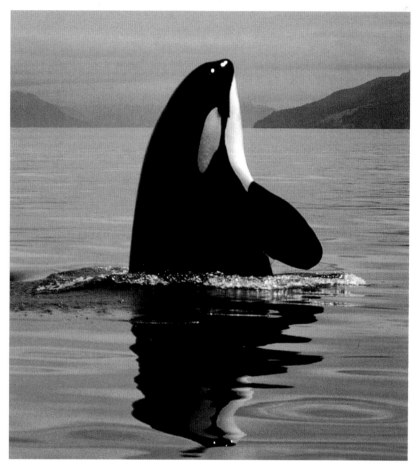

ALASKAN RESIDENTS

There are two distinct killer whale groups, residents and transients. Transients attack and kill other mammals — seals, sea lions, whales — while resident killer whales eat fish.

These whales (left) live in Southeast Alaska where the waters are bustling with many different species of whales in the summer feeding season. This is a major reason to protect this delicate habitat.

B-3

This killer whale (above), named B-3, has been observed in British Columbia's Johnstone Strait for nearly twenty years. B-3 had a distinctive black dot on his chin that distinguished him from his relatives in the resident B Pod.

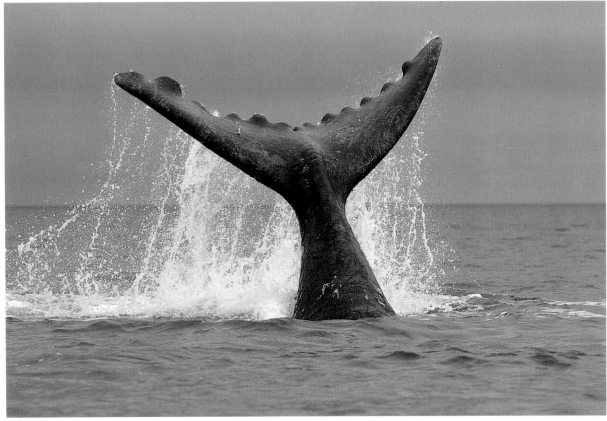

LASAGNE TAIL

Sometimes whales are easy to name. Lasagne Tail (above) is one. This frisky and friendly right whale calf was always in the middle of the action off the coast of South America. The Peninsula Valdes area is a wildlife sanctuary, offering researchers and photographers one of the finest areas in the world to study southern right whales.

TOO FRIENDLY WHALE

Friendly whales don't know how big they are, or how small humans are. Usually, it is very difficult to get directly in front of one, but this precocious right whale (right) was very obliging. With a sweep of its tail the whale playfully ran me down.

PERFECT SWIMMERS

Two killer whales (overleaf) at the surface. The hydrodynamics of killer whales are envied by all who travel on or under the sea. This is one of my favorite whale photographs.

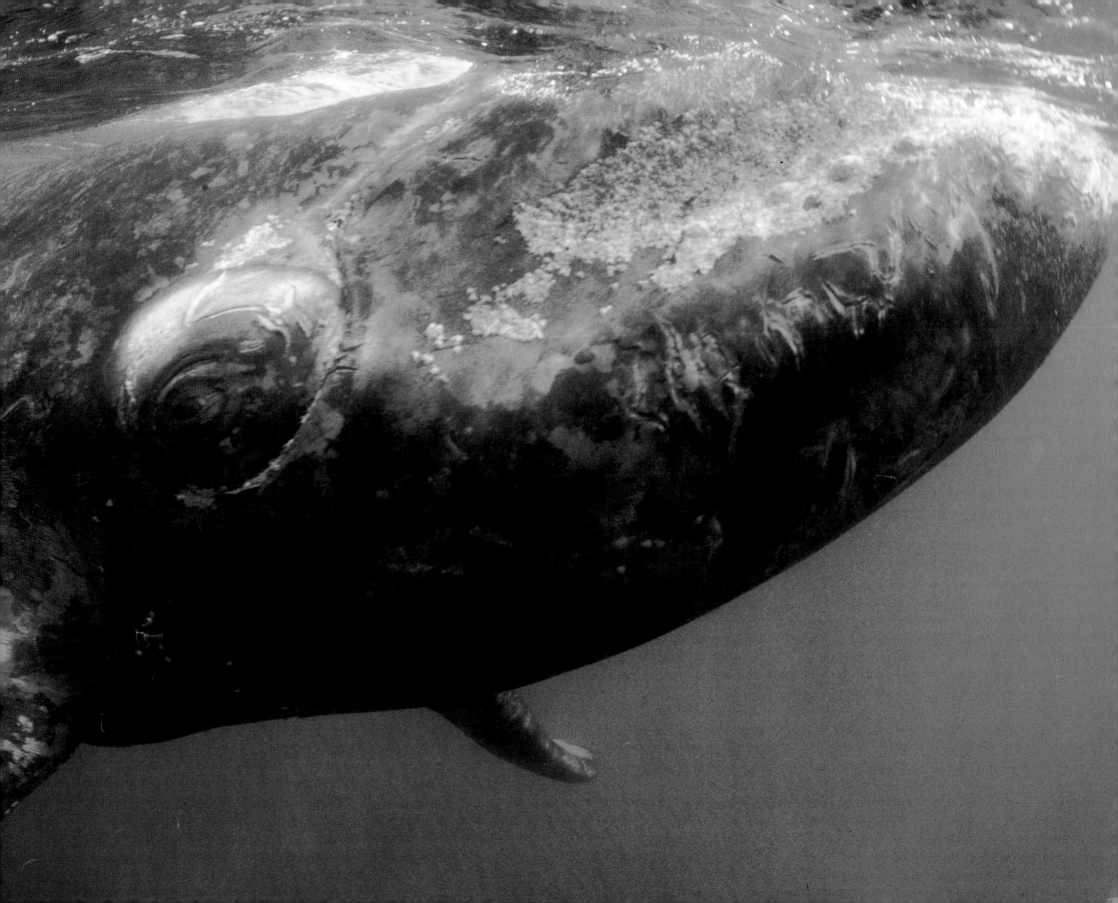

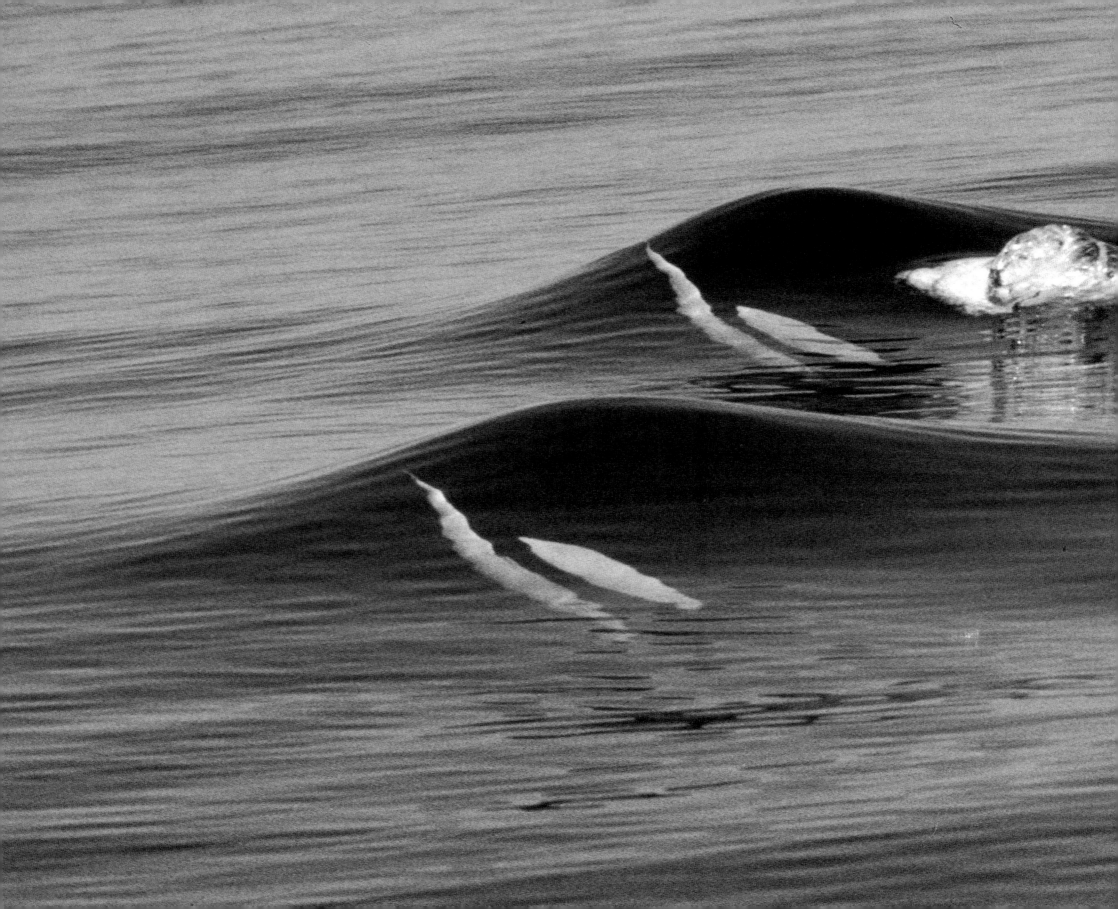

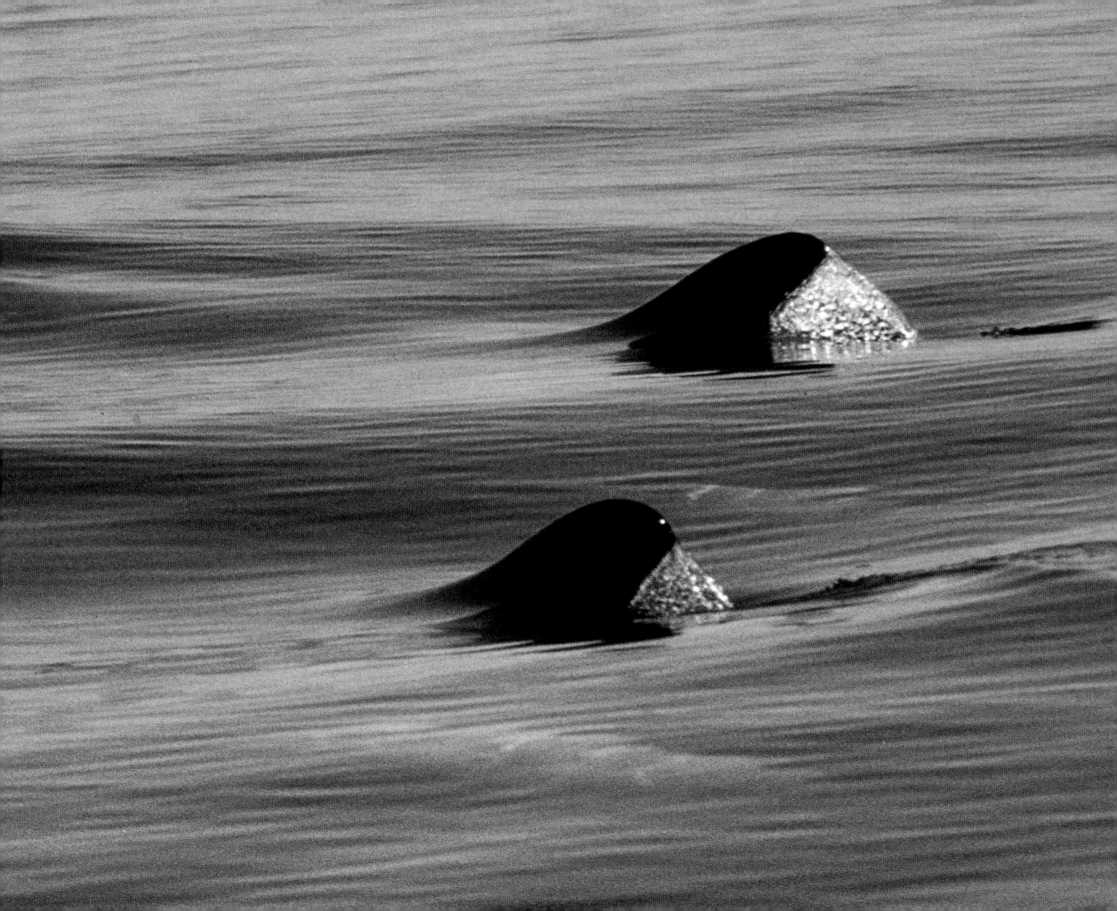

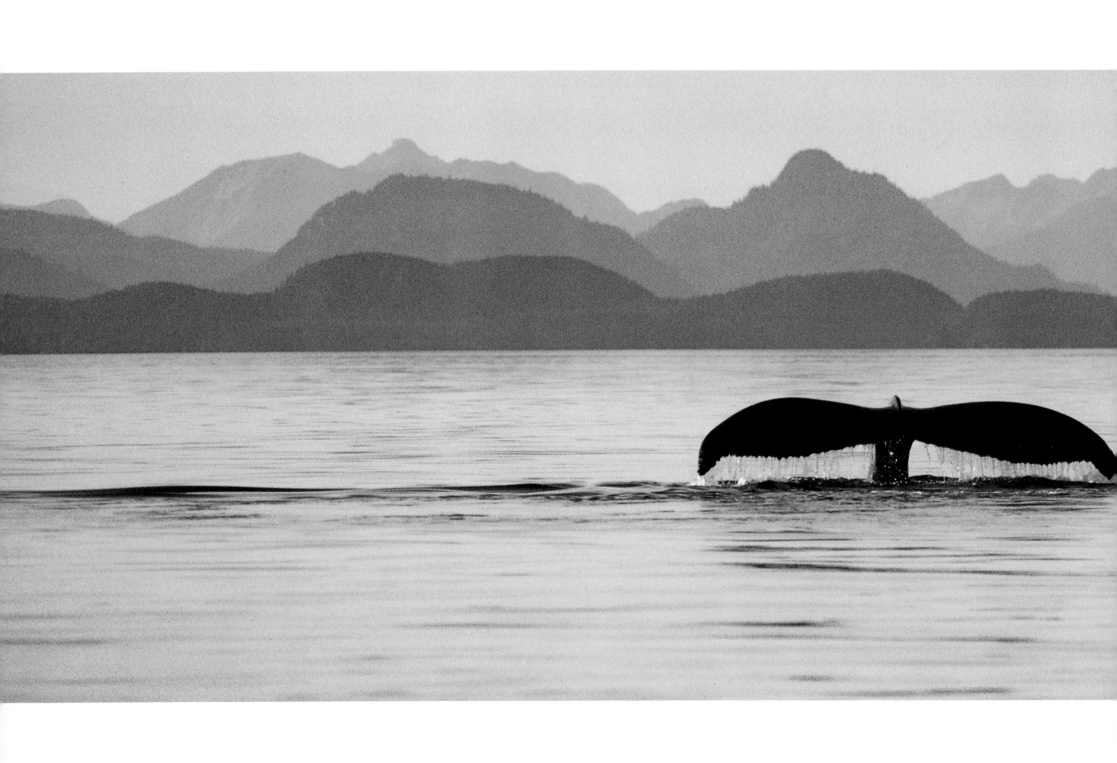

SMALL TAIL

A *solitary humpback (left) dives in its summer feeding grounds at Frederick Sound within the Alexander Archipelago of Southeast Alaska. We found humpbacks, killer whales, and minke whales in the same area.*

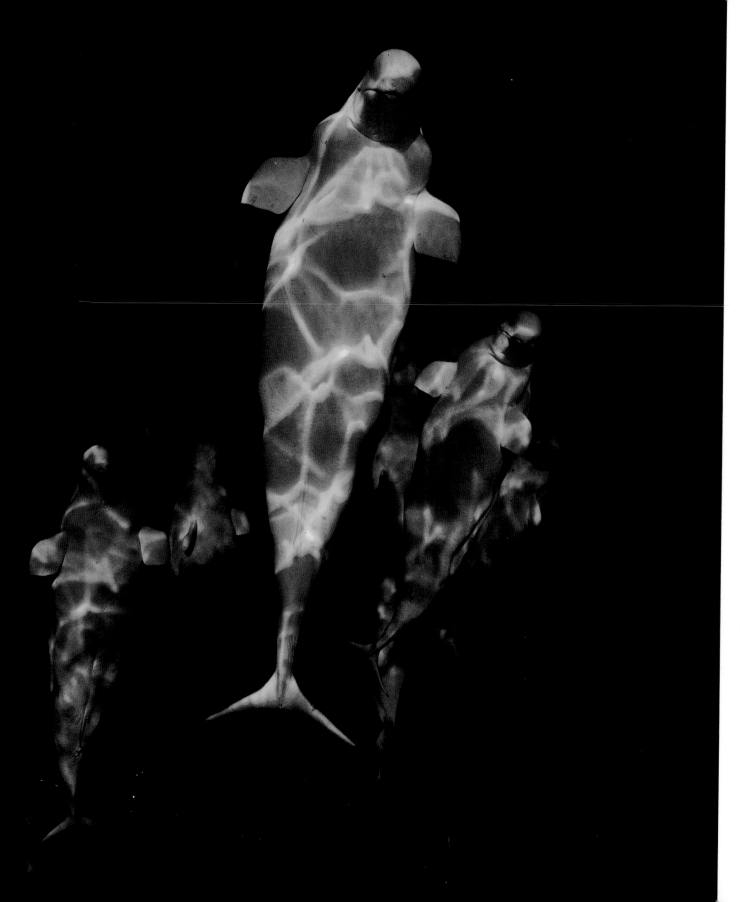

CURIOUS WHITE WHALES

Beluga whales (left) seem to play games, especially hide-and-seek along the edges of the floes. We could look down from the ice and see a dozen white faces of the belugas looking up at us. While diving with them in the waters of Lancaster Sound in the Canadian Arctic, I would frequently watch one beluga come up to check me out. Then the whale would go away, but it would come back in a few minutes with three or four dozen belugas.

BELUGAS AT BREAKUP

Belugas (right) seem to be right at home in the arctic ice. In eastern Lancaster Sound alone there is an estimated population of 10,000 beluga whales. They work their way through the maze of ice floes, with the ice cover determining their movements.

With the Whales

No living animals have captured our imaginations as have the great whales. Subjects of myths, legends, fables, tales and film stories, whales have fascinated us no less than dragons, sea monsters, Greek gods and aliens from other worlds. Until recently, they have been about as accessible.

For centuries whales have existed, for most of us, only in our imaginations, as sketches or paintings we've seen in books, or as rumors of giant corpses washed up on a remote beach. These observations have only intensified the whale mystique. The mystery, however, has started to fade as it is being replaced with knowledge. From the patient, careful studies of a handful of researchers, a far more worldly picture of whales is developing.

We are beginning to see two very different pictures of whales. One is of vast herds of these huge animals grazing fertile oceanic plains, not unlike the bison of the North American prairie or the caribou of the tundra. The other picture is that of certain whales belonging to tightly knit cooperative hunting societies best compared to groups of lions or wolves. In fact, although whales' bodies are obviously adapted to an oceanic existence, their life patterns are strikingly comparable to those of their better known relatives, land mammals.

Still, they fire our imaginations and stab at our emotions. They do inspire our art, literature and music. And so they should. The indescribable blend of grace, power and beauty of a whale as it glides underwater, leaps toward the sky, or simply lifts its flukes and slides into the sea symbolizes a vanishing poetry of the wild.

To learn more about whales and the fascination we humans have for them, Flip Nicklin and I, as part of a National Geographic Society project, spent two years studying the giant mammals and discovering the limits of human knowledge about them. We went in search of whales and the people who know them best. We found both.

We found whales in vast evergreen archipelagoes surrounded by snow-capped mountains, in oceans bordering cold pastel deserts, on the edge of a soft white wilderness of sea ice, near the shores of steaming volcanos, in estuaries of great rivers, and in quiet kelp-filled coves.

We found the researchers in beat-up cars, in rain-soaked tents, in coffee plantation shacks in the tropics, in plywood shacks in the Arctic, and in broken boats sitting in parking lots. In total we found fifteen scientists to help us in our quest, and my only regret is that I couldn't get to another fifty who would have contributed as much.

Whale researchers are an interesting lot.

"We'd go up there every single damn day and wait. We were going out of our minds, wondering what on earth we were doing," reminisces Peter Thomas over his studies of the right whale calving season in Patagonia.

"I spent four months going out every day in the boat, looking. . . looking. . . looking, and never finding pilot whales except for one day," notes Susan Shane on her discovery of the effect of *El Nino* on pilot whale distribution.

Dan McSweeney recalls his memories of studying humpback whales in southeastern Alaska: "We sat in gales and storms for fifteen straight days and it never let up. This was summer! In the middle of August we had almost ninety inches of rain."

The romance of whale research dies hard but fast. One's motive has to be strong and clear when sitting on a hard rock cliff in the Patagonia desert with a near-freezing wind driving sand through your clothes — for eight or more hours a day, every day, for two months. Or spending a day in a small open boat, the pounding waves slowly driving your spinal column into your brain; or camping on arctic ice in wind so strong the only reason the tent stays in place is because you are lying in it — while polar bears lurk around on the surrounding ice pack; or finding yourself sick in equatorial heat, or out at sea in a tiny boat crammed with gear.

To do all this one has to be dedicated.

Whale researcher John Ford tested his devotion during a trip to the Arctic: "All around camp the ice was creaking. I mean, you could stand and actually watch the camp go up and down. Suddenly a pressure

KILLER WHALE FIN

A *large male killer whale (right) surfaces near Brothers Island in Southeast Alaska, a very important summer feeding ground for a number of whale species.*

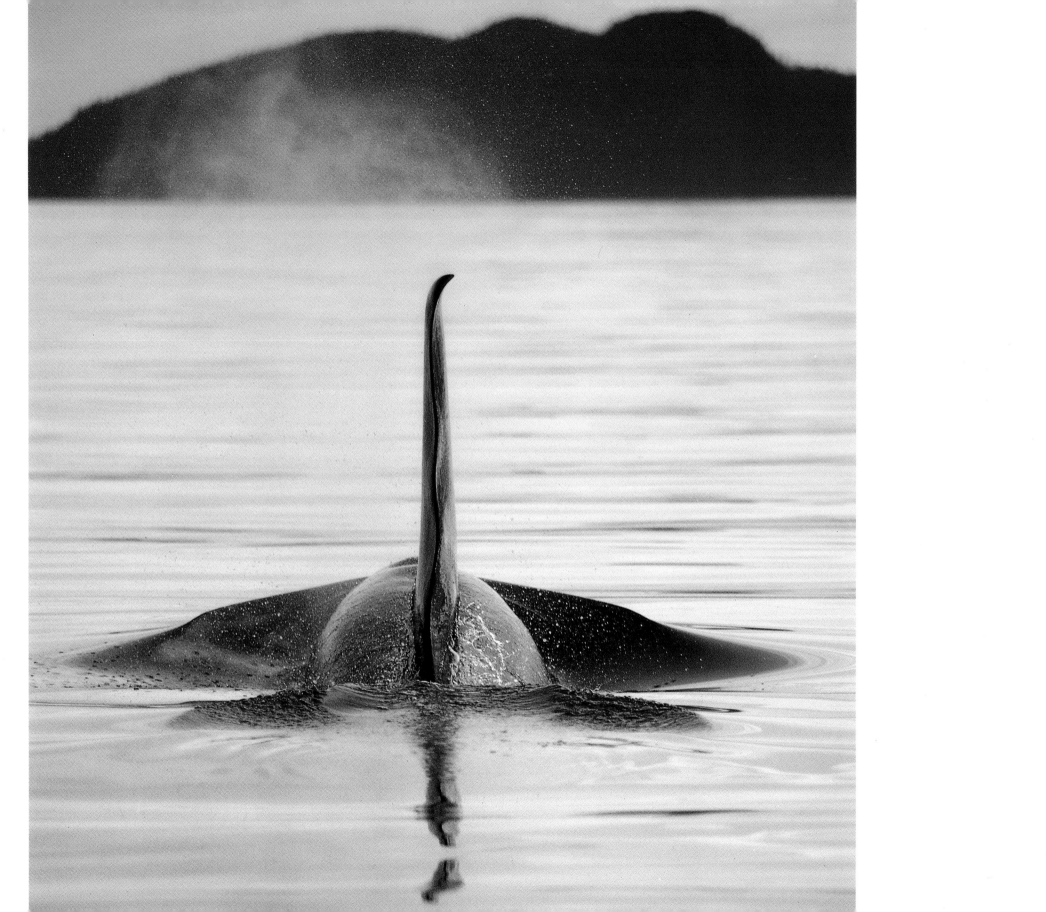

ridge broke through. It was frantic. Everything was disintegrating. By the time we got our gear back a ways, what had been our camp was little ice chunks about ten feet square, all moving." Then, he said, he knew why the Inuit hunters with him hadn't gone to sleep that night.

As a group, field researchers are determined, capable, inventive, patient, passionate and often frustrated people. They love their work but are usually constrained by tight research budgets. But they never quit. Their love for these magnificent animals and the ocean and their joy of discovery is a powerful antidote for rain, cold and chronic shortages of research funds. Considering the resources available, the progress being made is extraordinary, an eloquent testament to the dedication of the people involved.

The study of living whales was launched by people who didn't know it was impossible. Through the 1960s the study of whales was mostly confined to sorting out data generated by the whaling industry. It was simply not considered possible to study wild whales at length in the vast expanses of the world's oceans. But times and techniques have changed, and we have learned more about living whales in their natural environment in the last two decades than in generations of previous research efforts.

This renaissance in whale research, as Steve Katona describes it, began in the late 1960s with people discovering they could recognize individual whales by a variety of natural markings: individual differences in dorsal fins, skin pigmentation patterns, or, in the case of right whales, differences in the callosities or horny growths on the whales' heads. Photographs of these markings and repeated sightings of individual whales have become the basis for studies of abundance, distribution, behavior and social organization of the various cetaceans.

Many researchers have large catalogs of individuals ("their" whales) they have sighted and photo-identified and dossiers on each including sex, movements, and behavior. Today we know humpbacks named Spot and Sarge; gray whales Two Dot Star and Stella; right whales Troff and Troll; blue whales Laser and Backbar, and a beluga named Walter the Waiter. These whales have become part of the lives of the research community. We know these animals as individuals and have, with every sighting, an extended relationship with them, an impossible thought just a few years ago. Now we talk of them as old friends as we learn about their migrations, calving intervals, ages of maturity and social behavior. Such information is reflected in the notes of whale researchers.

"First we saw Spike with her calf and Singer, and then two days later females Flat Scratch and False Division went by together. All are from southeast Alaska," recalls Dan McSweeney, noting the affiliations of whales that were identified in Alaska before they migrated to the Kona coast of Hawaii six months later.

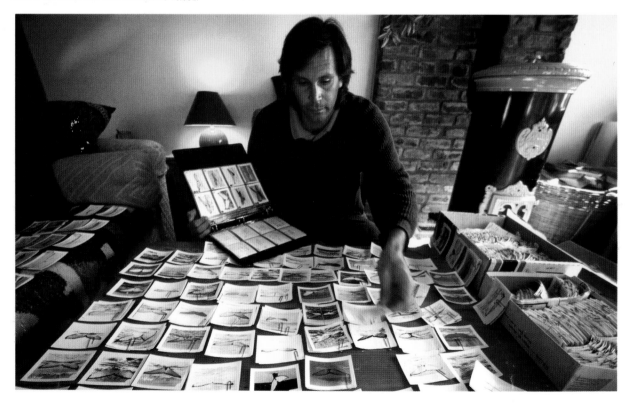

*Author Jim Darling sorts through
photographs of whales to establish
travel patterns, life expectancies and
other vital research information.*

Debbie Glockner-Ferrari keeps close tabs on Daisy, a female humpback: "Daisy is the only humpback I know that has had a calf four years in a row. She had a calf each winter from 1979 to 1982. I didn't see her in 1983, but she had a calf in 1984. I didn't see her in 1985 and she had a calf in 1986."

Carol Carlson speaks fondly of Silver, a well-known North Atlantic humpback with only half a fluke. "Silver had her first calf in 1980," Carlson remembers, "and that was a female we named Beltain who returned every year and brought back a calf in 1985. That was the first third generation record we have. Now we have five in the third generation. Beltain was one of those that died that fall when we lost all those whales to red tide poisoning. She was seven years old and had a belly full of mackerel. She got pregnant at age four and had her first calf at five."

Scott Kraus and Maureen Brown have a twenty-year history of a North Atlantic right whale: "Stripe is our longest match. . .we have a photograph of her from 1967. She had babies in 1978, 1981, 1984, and 1987. We know of four babies she's had. She appears to be on a three-year cycle. Her 1982 calf gave birth in 1986."

Richard Sears reflects on the nature of blue whale associations in the Gulf of St. Lawrence: "Laser and Spindle were together a lot. In 1983 they were together for three weeks to a month. The following year we just saw Laser, not Spindle. The next year, Laser showed up in mid-August and stayed around a whole month, and Spindle appeared in the beginning of September and within a day they were paired up again."

Understanding the lives of individual whales is a long process, and there are no shortcuts. It takes ten and twenty-year studies to confirm suppositions. Progress is often frustratingly elusive; instead of coming by giant leaps or major discoveries, it usually results from the collection and sifting of endless quantities of small bits of information.

The Whales and Their World

CHARACTERISTICS

STATUS

Blue Whale —
Balaenoptera musculus
(Baleen Whale)

Big isn't a big enough word to describe the blue whale, the largest animal ever to inhabit the planet. Not even the largest prehistoric dinosaurs matched the blue whale in size. Weighing up to 200 tons with a length of 100 feet, a blue whale can consume four to eight tons of krill (two inch shrimp-like animals) per day. To capture that much of its favorite food, the blue whale takes giant mouthfuls of water which expands its throat and chest. It then closes its mouth and forces the water through its baleen plates, trapping the krill. The newborn blue whale calf will weigh seven tons and will gain over eight pounds of weight per hour during the six-month nursing period. Blue whales summer at the edge of the ice pack and winter in temperature subequatorial waters.

Blue whales still range temperate and cold waters worldwide but in small numbers. The blue whale is highly endangered. Its pre-whaling population of perhaps 200,000 has been reduced to a meager 5,000 - 10,000 animals. There are six distinct blue whale stocks.

Bowhead Whale — Balaena mysticetus
(Baleen Whale)

The bowhead whale is one of the rarest of the great whales, living only around Greenland and Alaska. It has a rather odd shape. The head comprises forty percent of the whale's total length. These are oil-rich whales that were ruthlessly hunted by Yankee and European whalers. The bowhead averages fifty feet in length and fifty tons in weight. Because of its remote range and small population, relatively little is known of the bowhead behavior except the fact that it rarely strays from drifting ice.

Like most of the large whales, the bowhead is endangered. Its present population is estimated to be around 8,000, a number considerably larger than estimates of ten or fifteen years ago when the bowhead was feared to be at the very edge of extinction. Its pre-exploitation population has been estimated at 65,000 animals. Bowheads are found primarily in four locations: the arctic waters off northwestern Canada, off the coast of Japan, in northeast Canadian waters and off eastern Greenland.

Southern Right Whale —
Eubalaena australis
(Baleen Whale)

Early whalers provided the name for this passive whale. They considered it the "right" whale to kill because it moved slowly, floated after it died and offered large amounts of oil and baleen. Right whales average about fifty feet in length and fifty-five tons in weight. Exceptionally large right whales might weigh 100 tons. They feed primarily on plankton.

Although protected since 1935, the right whale is among the most endangered of the great whales. It lives today singly or in small pods. A population of 50,000 roamed the world's oceans prior to the whaling era, but now, by best estimates, about 3,000 right whales inhabit the world's oceans with the dominant population in the southern oceans. The right whale has not shown signs of recovery.

Humpback Whale —
Megaptera novaeangliae
(Baleen Whale)

The humpback whale does not have a "hump." Its name derives from its diving technique. When it dives the humpback arches its back sharply and displays the prominent dorsal fin. It is a rather playful and acrobatic whale. It is the favorite of whale watchers in the Hawaiian Islands in winter and in Alaskan waters in summer. The humpback is known for its haunting, ethereal "songs," some lasting twenty minutes. Its diet includes plankton and fish.

The humpback's habit of clustering around islands and following shorelines made it one of the easiest whales for whalers to exploit. This slow moving whale endured heavy losses in the early 20th century, especially from the Antarctic whaling fleets and shore stations in the Southern Hemisphere. Protected worldwide in 1966, the humpback today has a worldwide population of roughly ten percent of the pre-whaling era population estimate of 125,000.

Gray Whale — Eschrichtius robustus
(Baleen Whale)

The gray whale is the traveler. Each year they swim from Alaska, where they feed in the summer months, to Baja California, where they calve during the winter. This 8,000 mile trip is the longest migration of any mammal. During this migration, they often swim close to shore, sometimes just beyond the surfline. Gray whales can lose up to six tons of their weight enroute. Nicknamed "devilfish" by early whalers, the gray can be quite aggressive when threatened. Grays are actually a dark gray or even black but are usually so covered with scars and barnacles that they appear mottled.

There are few success stories in the world of whales but the gray whale's story has a happy ending. Severely depleted at the turn of the century, the grays of the Eastern Pacific have managed a remarkable comeback. Protected since 1937, the coast-dwelling gray's population has returned to about 20,000 animals, close to its pre-exploitation population. Unfortunately the Atlantic population disappeared in the 18th century. Another group of grays living off the coasts of Korea and Japan were virtually exterminated by whaling activity early in the 20th century.

Sperm Whale - Physeter catodon
(Toothed Whale)

Killer Whale — Orcinus orca
(Toothed Whale)

Pilot Whale — Globicephala melaena
(Toothed Whale)

Narwhal Whale — Monodon monoceros
(Toothed Whale)

Beluga Whale — Delphinapterus leucas
(Toothed Whale)

CHARACTERISTICS

This is the submarine of whales. Sperm whales can stay submerged for over an hour and can dive to extreme depths, presumably looking for giant squid. One sperm whale off South America became entangled in a submarine cable at a depth of 3,700 feet. Scientists believe sperm whales can dive to twice that depth. Inside the gigantic head (twenty feet of a male sperm whale's sixty foot length) rests the largest brain on the planet. The sperm whale roams all ice-free ocean expanses. With its battering ram styled head, the sperm whale figured prominently in whaling adventure stories, most notably *Moby Dick*. Albino sperm whales actually have been sighted.

Killer whales, also known as orcas, roam the sea in close family groups. While they feed mainly on fish, they also capture seals, sea lions, dolphins and small whales. Occasionally they attack even the great whales. Captive killer whales have become star performers in marine mammal parks. They are easily trained and have gained a reputation for being the smartest cetacea. Their distinctive dorsal fin makes identification quick and easy. In the wild, orcas engage in sophisticated cooperative hunting.

The pilot whale at eighteen feet in length is slightly larger than the narwhal or beluga. It is well known not for its size but its predisposition to beach itself is a phenomenon scientists are unable to explain. Some believe the behavior is simple disorientation or a dysfunctioning of the whale's echolocating system. Others suggest it's a deliberate action. Many attempts to rescue groups of pilot whales have failed when the whales kept returning to the beach after being pushed back out to sea. The pilot whale has been utilized in military research. One famous pilot whale was trained by the U.S. Navy to dive as deep as 1,600 feet to retrieve "lost" torpedoes. The favored prey for pilot whales is squid.

The narwhal whale is one of the strangest creatures of the sea. Its tusk is really a tooth found only in the males. Many believe the narwhal was the inspiration for the unicorn myth. The tusks have been prized possessions of kings and princes. Magical properties were often attributed to the outlandish tooth which spirals right to left. The whale is modest in size, around fourteen feet with a weight of around 3,000 pounds. The most northerly of all cetaceans, the narwhal has four inches of blubber which can be a third of its total weight. Like the belugas with whom they often share feeding grounds, the narwhals are extremely gregarious. They generally travel in small groups of ten to twenty animals but aggregations of up to 2,000 have been observed. They feed on fish, squid and crustaceans.

The snow white beluga looks very much at home in the far northern ice floes. Known by early whalers as the sea canary, the beluga creates a wide range of sounds, variously described as squeaks, squeals, barks, chirps, whistles or moans. It is a small whale with a maximum length of eighteen feet and weight of 3,500 pounds. It features cold water adaptations of very thick skin and heavy blubber. For centuries the beluga has been important to native Eskimos for its meat, oil, skin and bone. Belugas have a diet of primarily fish, preferring flounder and cod. Belugas are extremely gregarious. Groups of up to a thousand have been sighted.

STATUS

This is the most numerous of the great whales. Despite heavy hunting during the whaling era, about one million remain, roughly half of pre-whaling population estimates. It is not an endangered species and is found worldwide. There is a concern, however, that the population may be comprised of many subgroups which are at populations below the sustainable level.

The killer whale is fairly common in northern Pacific waters but no population estimates are available.

The pilot whale does not enjoy any special status. It is presently not endangered, but no population estimates are available.

The narwhal was for generations the mystery of the Arctic. Very little hard data exists on its pre-whaling population. Today's population is estimated to be 30,000, living mainly in northwestern Greenland and the eastern Canadian Arctic. More research is needed to establish any population trends.

The curious beluga has been an easy mark for whalers. The population today is roughly half of the estimated 100,000 pre-exploitaton population level. The beluga's present range is circumpolar in the Arctic, found primarily in Hudson Bay and off Bafflin Island. A famous but endangered small group is present in the St. Lawrence.

Origins

The origins of whales date back about sixty million years to members of a family of early mammals known as mesonychids. These animals were some of nature's early designs for mammalian life on land. They had four legs and a tail, were furry, carried their fetuses until birth and nursed their young. Some lived along the shores of swamps or estuaries. They must have walked along the beaches when foraging for food.

Then, perhaps, some began wading in the water and, holding their breath to duck their heads under the surface to catch something edible. As they waded deeper, they found more food. Some began swimming and diving in the shallows, returning to land between feeding bouts. The longer they stayed at sea the better off they were. A land base became progressively unnecessary, and finally, over an unimaginable time span, some broke the connection: land mammals had gone to sea.

Once at sea, they gradually took on the general shape of a fish. Phenomenal diving and underwater navigational abilities developed. Adapting to take advantage of every food source, their acoustic sense developed, allowing them to listen to their environment and to develop underwater communication systems. Similarly, inherent mammalian behavior patterns — notably mating, birthing, social organization — were altered to function in the very different world of water.

Today's whales are so well adapted to life underwater, it's easy to forget they are the product of both the land and the sea. Not all of the mesonychids went to sea. This is one of the most useful bits of evolutionary information for whale researchers. Some mesonychids survived well with the food available on land. This branch of the family became as successful on land as whales became at sea. They became the modern artiodactyls, the familiar hoofed animals we know as the antelope, buffalo, caribou, hippopotamus, cows, pigs, moose and the musk ox. Modern whales share a common ancestral family with the modern artiodactyls — actually the closest living relatives of the whales.

Evolutionary relationships are studied by examining fossils. More recently a powerful new technique known as molecular phylogenetics is used; it is a technique which compares the molecular structure of animals to determine their relationships. The results of the molecular research give us invaluable insights about whales. Molecular exploration into the ancestral relationships of living animals is done by comparisons of the structure of particular proteins of the animals being compared. We are provided protein blueprints to compare.

Molecular evidence collected by researchers Vince Sarich and Jerry Lowenstein suggests that the hippopotamus is actually the closest living relative of whales. The pig, camel and cow are not too distant. It appears that the whales and artiodactyls are more closely related than the artiodactyls and any other land mammal. The analysis shows that the hippopotamus and the whale share 90% of their molecular sequences, whereas a hippopotamus and a horse, the next closest relative in the mammalian family to the hippopotamus, share no more than 80% of their sequences. The implication is that, in molecular terms, comparing a whale to a deer is as appropriate as comparing a horse to a deer. Not surprisingly, most people looking at a whale and a deer will have trouble immediately seeing a similarity. Although well hidden by the anatomy, science has shown us that that similarity is most definitely there.

The early whales of primal swamps or estuaries branched into the approximately seventy-seven known species alive today. They have successfully spread into virtually every niche in the world's oceans. The first whales had the teeth of their land ancestors. They probably moved into the ocean to take advantage of fish, an abundant food source. Over time some of these animals specialized to take advantage of another source of food in the ocean — swarms of tiny planktonic animals. This group lost their teeth and developed a baleen filtering system.

Scientists use the toothed and baleen distinction to classify whales. The toothed whales — *odontocetes* — include all the dolphins, killer whales, and the sperm whale, the largest of the toothed whales. The baleen whales — *mysticetes* — include the largest whales such as the

THREE GENERATIONS OF WHALE RESEARCH

Three generations of whale researchers watch the flukes of a right whale in Argentina's shallow coastal waters. Roger Payne (right) was key to the renaissance in whale research. He was followed by Jim Darling (left) and now by young researchers like Gustavo Alvarez Columbo (center). My photographic pursuit of the world's whales is dependent upon the work of people such as this trio.

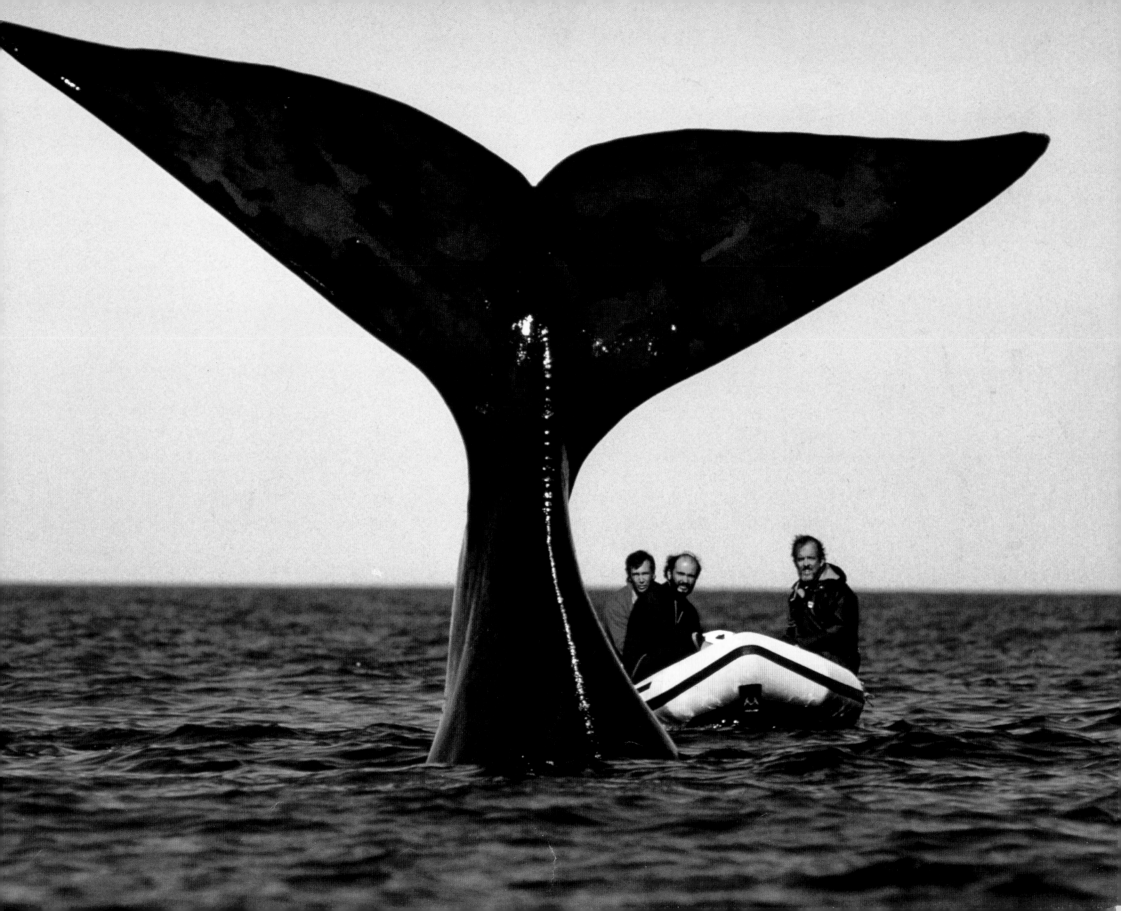

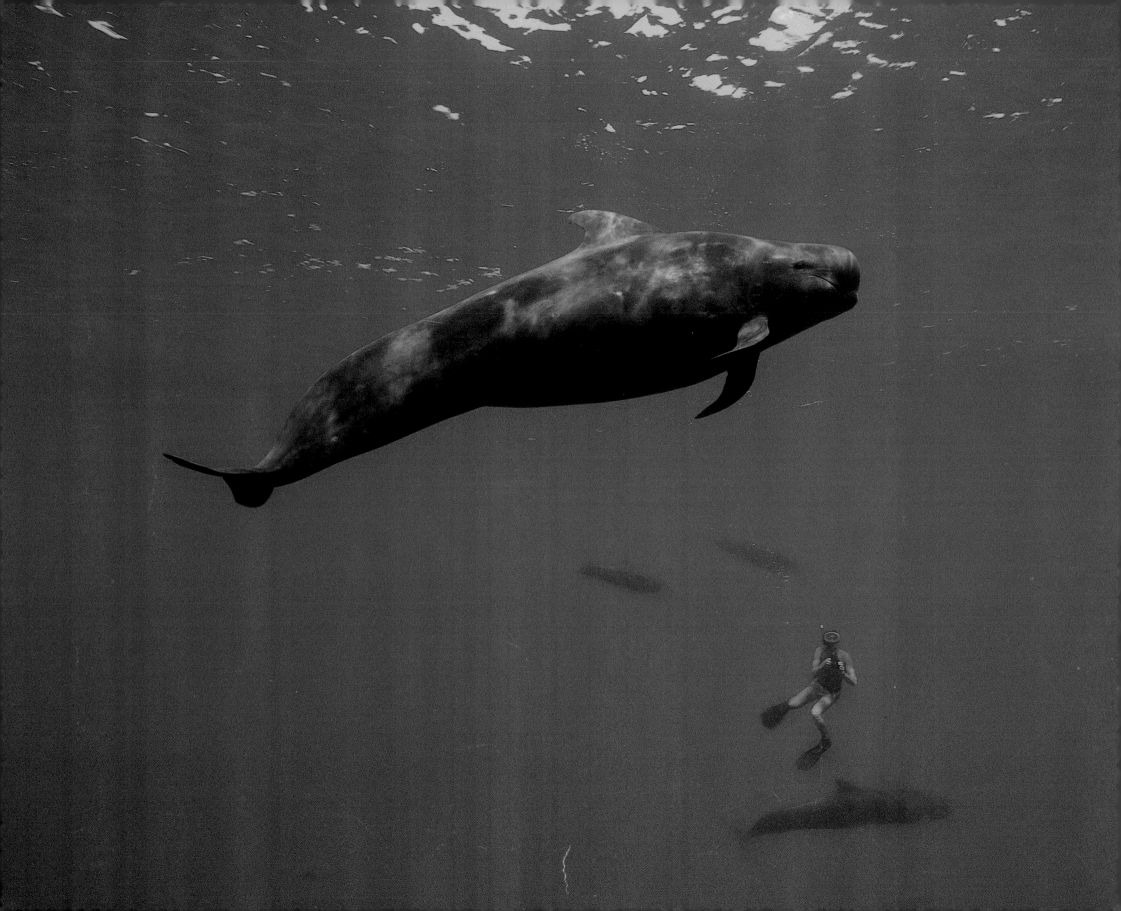

DAN AND PILOT WHALE

Photography, both on the surface and underwater, is a major tool for many researchers. Here Dan McSweeney takes pictures of pilot whales off Hawaii's Kona Coast. Only in the past few years have scientists taken the leap beneath the waves to study the whales' deeper environments. Dan works primarily on gathering information about humpbacks off Alaska and Hawaii. However, he often encounters pilot, sperm, beaked, killer and other whales during his humpback research.

blues, fins, humpbacks, rights, grays, and bowheads. Today there are approximately sixty-six different types of toothed whales and eleven types of baleen whales. The toothed whales eat a variety of larger fish, squid and marine mammals; the baleen whales eat smaller fish, plankton and bottom-living crustaceans. Each species has specialized to some extent with teeth or modified baleen best suited to its particular feeding style. While some species are generalists, feeding on a wide variety of foods, others are devout specialists feeding only on very select food items.

The variety of different types of whales demonstrates that there are a variety of distinct ecological homes in the ocean.

Think of the ocean in relation to a watershed in the North American mountains. Many different types of hoofed animals live there: the moose live in the wetlands below; deer in the forests; mountain sheep live in the high meadows, and mountain goats on steep mountainsides. Even though they are all in the same family, these ungulates look considerably different; they eat different things; they behave differently and have different social organizations. Within that watershed, they all live in slightly different habitats or ecological niches.

Although we have yet to definitely describe or to understand the ecological niches in the ocean equivalent to the wetlands, forests, meadows and mountain cliffs on land, the great variety seen in whales tells us they exist. We see similar differences in anatomy, diet, behavior patterns, and social organization of whales, just as in the occupants of the mountain watershed. Whales mirror the variety and complexity of mammals on land.

My origins in whale research involved spending a lot of time on a beach. I first saw whales from a surfboard along the west coast of Vancouver Island. Sitting just outside the breaking waves, I would be getting ready for a ride when gray whales, searching for food in shallow water, would blow a few feet away. It always came close to stopping my heart.

The urge to spend time along the outer coast of the island led to a summer job running a tourist boat. We took people out to see sea lions, and often we would encounter gray whales during the trip. Having just completed a university biology degree, I went dutifully in search of information about gray whales. I found nothing about the gray whales of Vancouver Island but did find several papers stating that *all* gray whales spent their summers feeding in the Bering and Chukchi Seas, several thousand miles to the north. Yet, I had been watching gray whales feeding off Vancouver Island all summer. This was my first experience with the inconsistency between what is written about whales and what actually occurs with whales. It wouldn't be my last.

Two things happened over the next couple of years that set the course that made whales part of my life forever. First, I was contracted by a new national park in the Vancouver area to do a literature review on gray whales, to see what we really did know about "our" whales. I collected and read everything that had been written about these animals, from the first report dating back to 1725. I quickly realized how very little we actually knew. Second, another biologist in the area and I discovered that we had both seen and photographed the same whale (though photographed in different years). It could be clearly identified by a large scar on its side. Gray whales were not only present in the summer when they were supposed to be "up north," but the same whales, it seemed, were returning each summer. The research implications of those "photographic IDs" were obvious.

The discovery prompted me to look for other "marked" animals. Eventually I found that all gray whales could be identified by photographs of their different skin pigmentation patterns. This simple technique became the basis for all of my research. Later I learned that researchers in other parts of the world were developing, at about the same time, the same technique for other species of whales.

In the space of just a few years in the mid-1970s, I had accidentally become involved with a population of whales, developed many

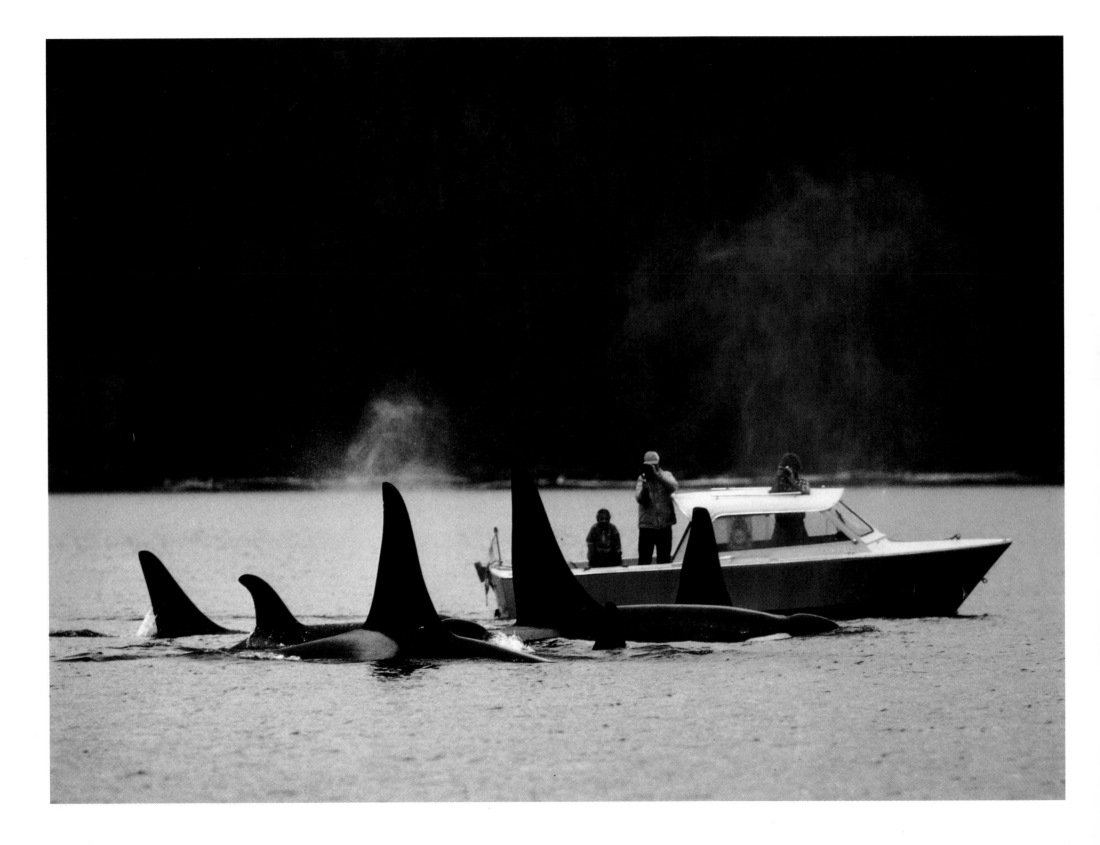

THE A-5 POD

The research of Mike Bigg and Graeme Ellis on killer whales has produced information about the fascinating social and communication systems within the resident families and kinship pods off the coast of British Columbia. Here (left) they are taking pictures of the A-5 Pod of Vancouver Island. The identifying nicks and scars of the dorsal fins and the saddle patches show up easily in photographs, enabling them to catalog and trace the movements and behavior of individual members of the killer whale clans they have observed for years.

A-5

Here A-5 carries a streamer of kelp from his large dorsal fin as he swims the Johnstone Straits. These I.D. photographs have been an important tool in whale research.

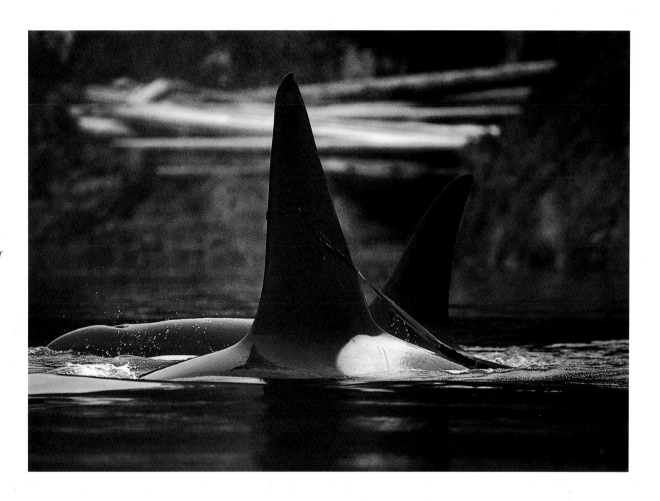

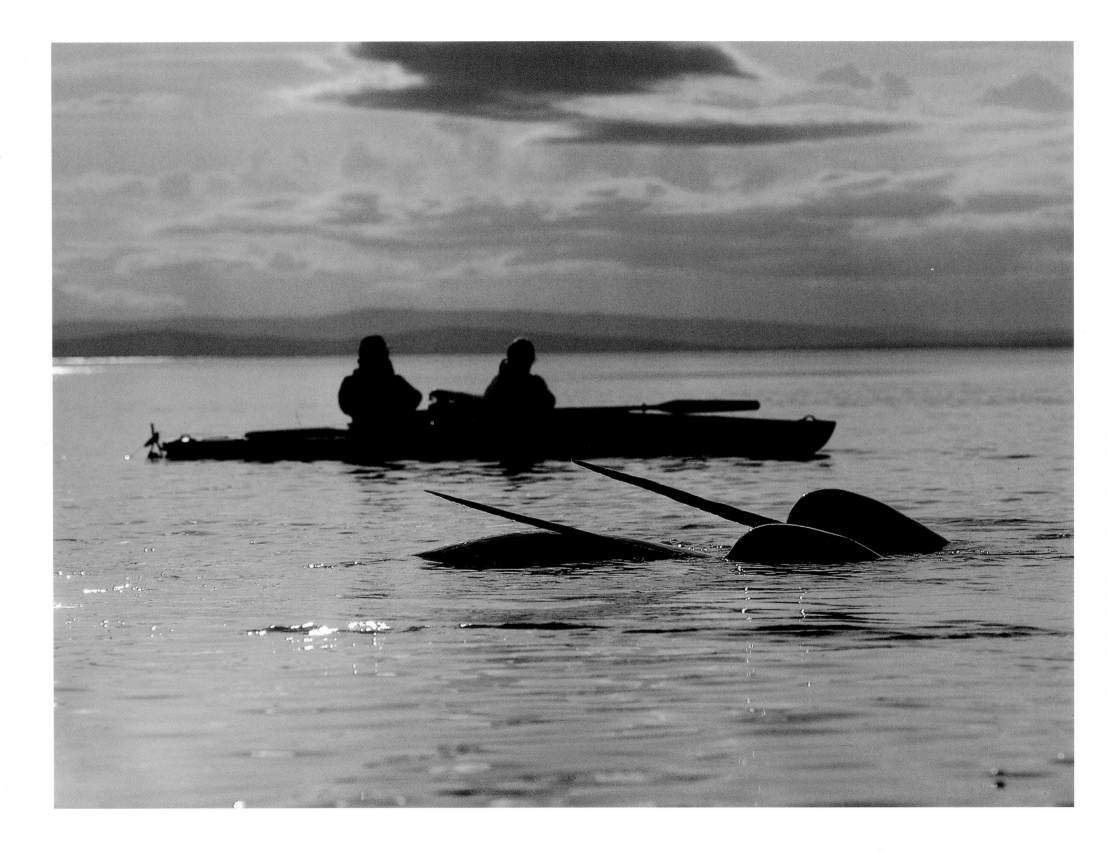

Researchers John Ford and Debbie Cavanagh used the kayak, a craft of ancient Inuit design, to stay close to the whales they were observing.

questions about them, and then stumbled across a technique which could answer them. By photographically identifying the whales and making repeat sightings, I was beginning to understand why we were seeing gray whales off the beaches of Vancouver Island. My interest in whales led to a Masters degree program on aspects of the behavior and ecology of Vancouver Island gray whales, a study which raised as many questions as answers.

At a 1975 conference on whales, I heard Roger Payne discuss the incredible things he was learning about right whales in Argentina. He had based his study entirely on the photographic identification of individual animals. It was very close to what I had been doing in British Columbia. I had no idea until then how powerful the technique could be. Later, Roger Payne became an advisor for my Masters degree research.

In addition to their right whale studies, Roger and Katherine Payne had been studying humpback whale songs since the early 1970s, primarily from song recordings made in Bermuda. In 1976, they decided to begin a more detailed study of humpback songs in Hawaii. In one of my meetings with Roger, he happened to mention they were looking for someone to record songs for them in Hawaii. I thought about it for at least five seconds. That opportunity led me further into the world of whales.

That early work in Hawaii in 1977 and 1978 did concentrate on recording singing whales, but we also wanted to locate the singers and identify them with photographs of their flukes. I spent hours in the water with the whales, getting to know whales in a way that can only come with direct contact. Yet I had not yet been able to actually see a singer underwater. Singers spend only seconds on the surface, taking a few breaths, then disappearing for about fifteen minutes. After spending hundreds of hours listening to them at the surface, we wanted to know exactly what they were doing down below.

In 1979 I met Flip Nicklin. He had come to Maui with a film crew to do an underwater film on whales. Flip was the still photographer on the film, a job that allowed him to combine his remarkable diving and photographic abilities. By that time, I had become fascinated by the interaction of singers with other whales. However, little was known about the actual function of the song. Since cows and calves are the easiest to approach, most underwater whale filming is done with them. Over the weeks with the film crew, we began discussing the possibility of actually locating and filming the singers.

March 10, 1979, was a dead calm day in Auau Channel of West Maui. The film crew was in a large boat out of sight but in radio contact. We were listening to a singer and I was taking photographs of its tail flukes. I remember cutting the engine and gliding over the spot where we had seen it dive last. With our outboard motor off, we could actually hear singing coming through the hull of our boat. Looking over the side we noticed a turquoise gleam deep below us, and first thought it was a school of fish. It turned out to be the singer's white flipper. The singer had dove and stopped just fifty feet below us. The water was so clear and calm that by simply putting our heads over the side we could easily see the whale. His head was pointing down, his body slanting towards the surface. At the time, we did not know that this was the classic singing posture of a humpback. The whale was motionless in this position.

I radioed the film crew and suggested they try filming a singer in action. They came quickly. The crew eased over the sides of their boat with the huge IMAX camera. Over a period of hours, they managed to photograph the whale underwater. We stayed with that whale all day, even after he was joined by two other whales and stopped singing. This was a special day: we had recorded a song, located the singer, identified it by photograph, filmed its behavior underwater, photographed its underside to determine its sex, and we followed its interactions with other whales. We had named the whale Frank.

Flip and I had dinner just before he and the crew returned to the mainland. He asked if I was coming back to Hawaii the next year. Since

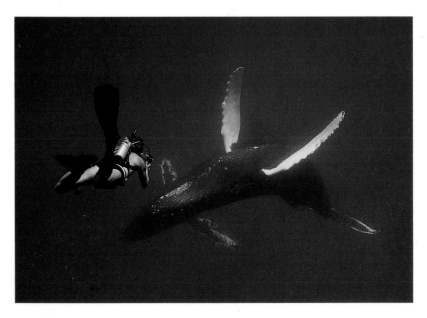

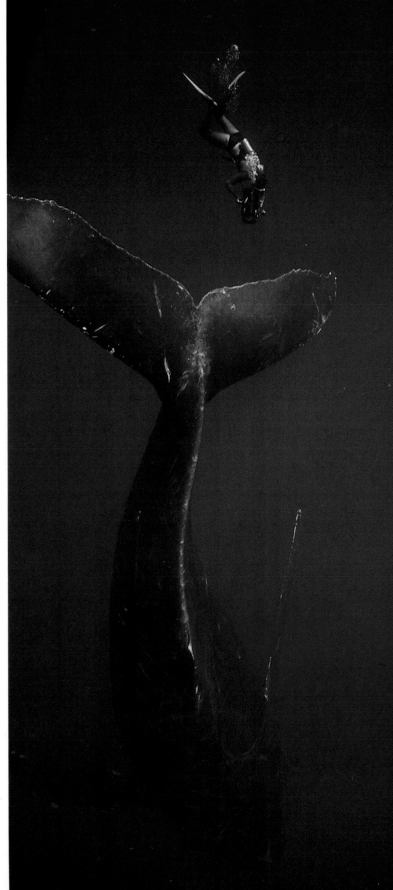

CHUCK & FRIENDLY HUMPBACK

My father, Chuck Nicklin, was filming whales off Hawaii long before I began taking still photographs. He introduced me to my first humpback in 1979 when he was making a film in Maui. I still remember being amazed at my first sight of a forty-foot whale (far left) that came close to us and then stayed for an hour.

CHUCK FILMS A SINGER

Chuck Nicklin was filming "Nomads of the Deep" when we got a call from Jim Darling who was very excited after locating a "singer" just under his boat. He thought we could use the footage, and he was very interested in sexing the singer. My father filmed the singing whale (left), and I took still pictures. For the first time, singing humpbacks were positively identified as being males, and we were also able to capture the previously unkown head-down position taken by the singers.

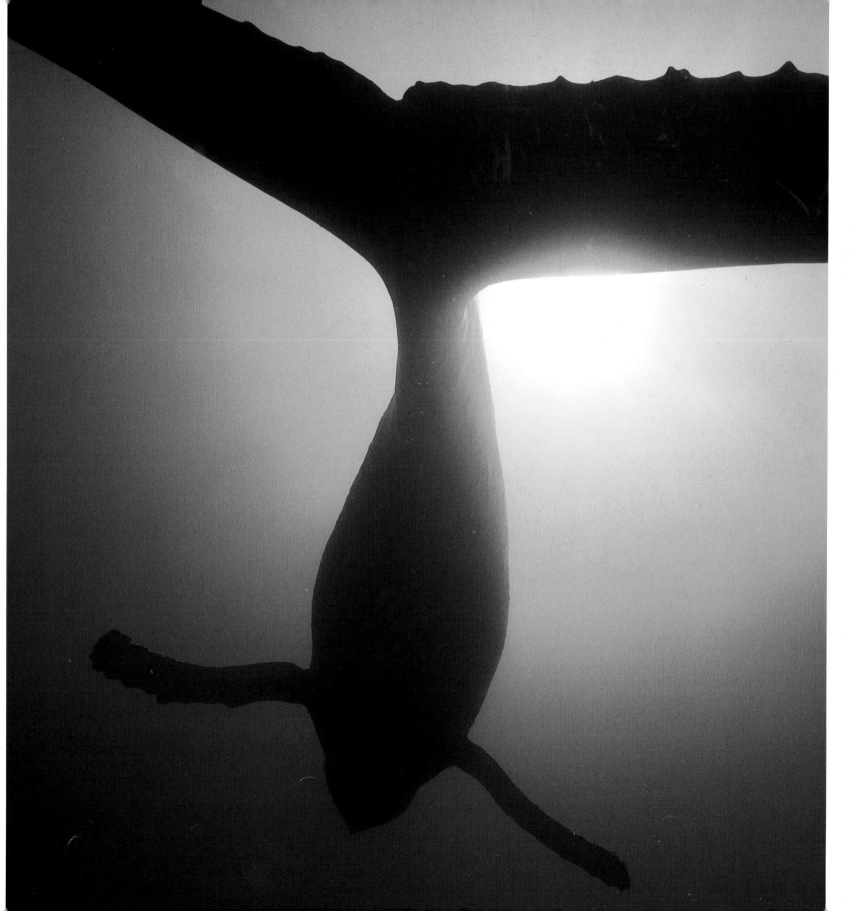

SINGER SILHOUETTE

*J*im *Darling asked us to swim under this singing humpback (right) thirty feet beneath his boat. It had never been done before. We had no idea of what to expect. We certainly did not expect to be shaken by the songs — our bodies actually vibrated to the tune. It was an amazing experience and helped us to understand the raw, acoustical power of the songs of the humpback.*

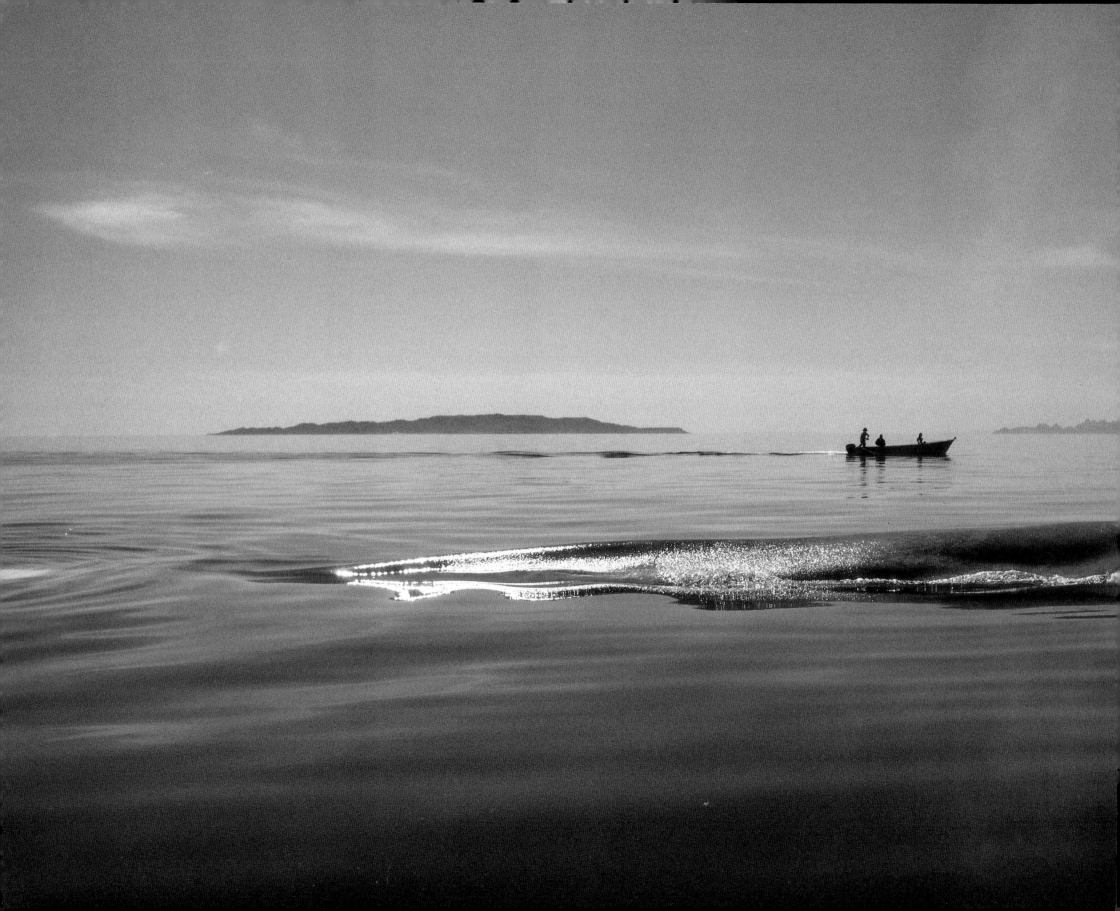

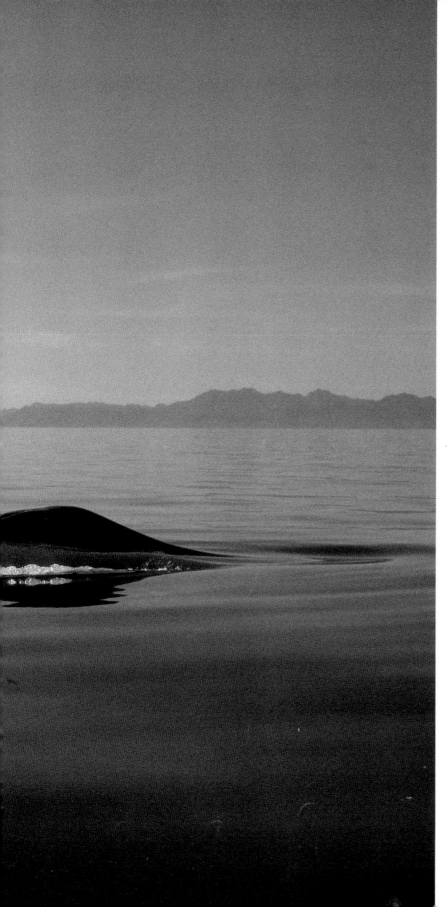

SMALL BOAT/LARGE WHALE

*M*ost whale research is done from small boats near shore. One's relative importance is driven home when eighty feet of whale surfaces next to twenty feet of boat.

BLUE RAIN

*T*he flukes of a blue whale (overleaf) can reach twenty feet in width. Blues can be one hundred feet long. Being with blue whales is unlike any other underwater experience. Not long ago, it was thought that these giants were doomed to extinction, but the killing has ceased and we are now beginning to understand their habitats and behavior. Researchers are cautiously optimistic about the future of the blue whale.

I was making arrangements with Ken Norris to do my Ph.D. on gray whales in Mexico, I didn't really know.

Flip pressed his point: "If you can put me on to more singers like that one (the March 10th whale), I think I could dive underneath them and get good enough photographs to sex them for you." At that time, the absolute key question to understanding the function of the humpback song was determining the sex of the singers, and learning that was almost impossible without photographs of the genital area. We knew now that it was possible to take such pictures. It was an opportunity I had to take.

Fortunately, Ken Norris, my Ph.D. advisor, understood the potential of continuing the work in Hawaii and allowed me to switch my topic to humpback whales. Flip and I then spent two incredible years in Hawaii, studying the behavior of humpback whales.

Since Hawaii, Flip and I have traveled extensively, spending a lot of time in small boats or on sea ice, watching whales. It has been a great time to be involved in the study of whales.

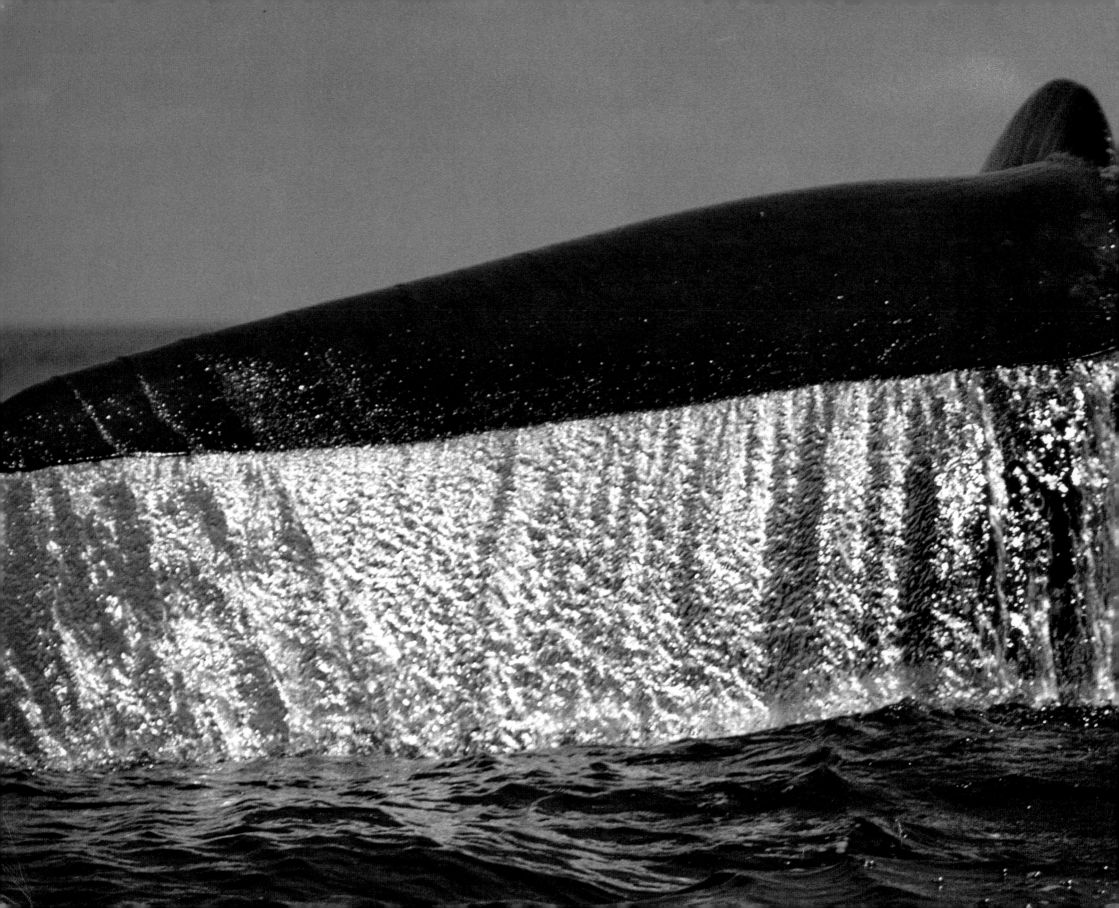

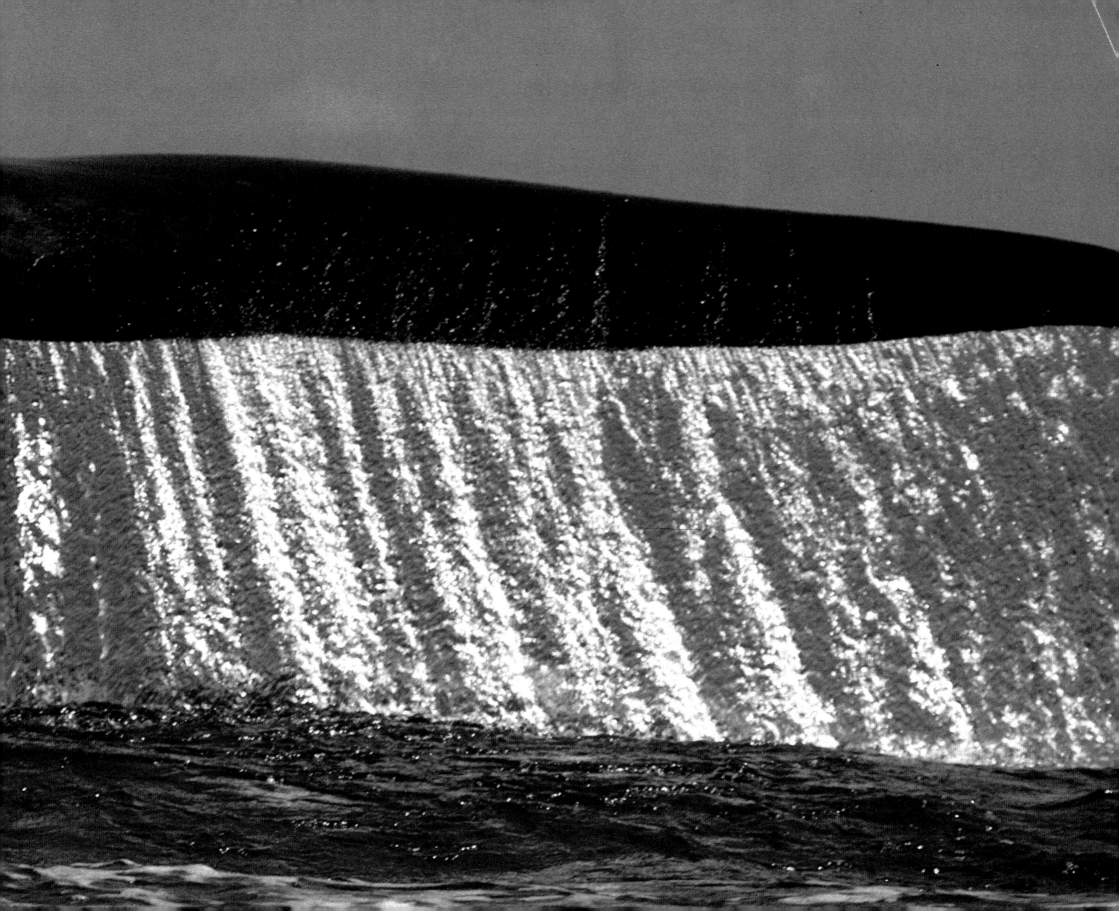

BLUE GEYSER I AND II

When a blue whale surfaces (right), there is a moment when it looks like a small, aqua-blue reef in the middle of an empty ocean. Then suddenly, a gigantic geyser of water explodes, arching as high as thirty feet. These two photos were taken one second apart. Before us was an eighty-foot blue whale blowing through its double blowholes. The pictures also demonstrate the distinct, U-shaped rostrum of the blue whale.

RICHARD SEARS AND BLUE WHALE

Researcher Richard Sears (far right) gets up-close with a blue whale. Richard works both coasts of North America, spending time in the Gulf of St. Lawrence and the Sea of Cortez, gathering research data on fin and blue whales. As might be expected, cameras tend to suffer from salt spray when the assignment is taking whale photographs.

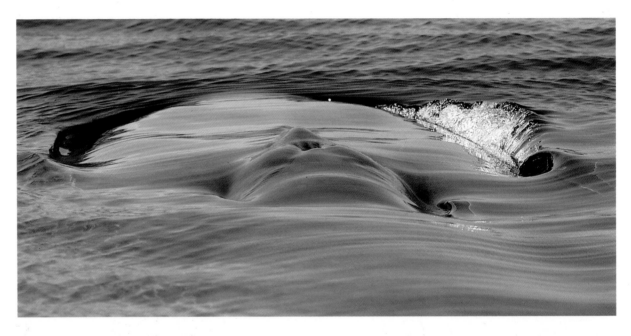

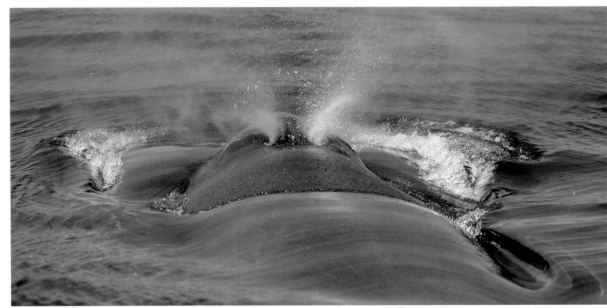

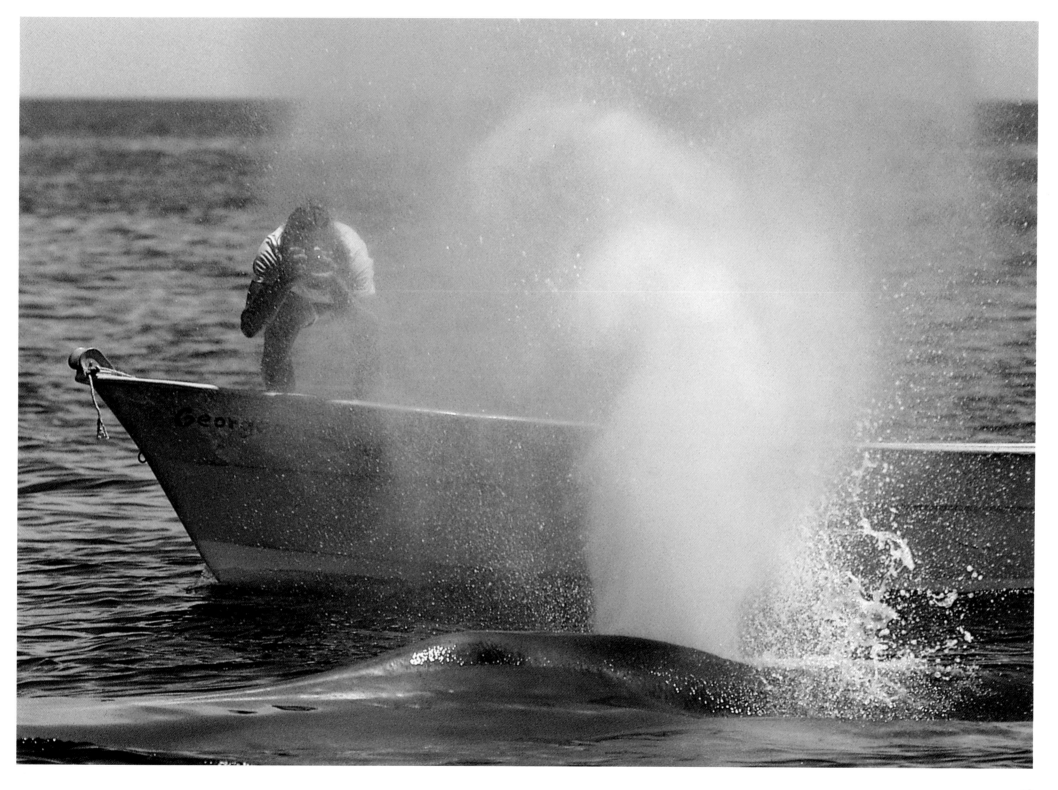

Swimming With The Rights

J im Darling, Carlos Garcia and I were in an inflatable motorboat, floating on Argentina's Gulfo Nuevo. We had found the adolescent right whales were as equally curious about what we were doing as we were about their activities. These 35-foot youngsters would hang in a water column and stare at us. We could get close enough to stroke their sparse, bristly chin hairs. When a photographer gets this near the subject, film is used rather quickly and, of course, the really exciting stuff then happens when the camera is unloaded.

The wind was coming up, so I had little chance to change film in the wet boat. I stayed with the whale I had been taking pictures of, giving him a pat. I put my hand, slowly, on the fold of skin just below his eye. It didn't startle him. He seemed to enjoy the contact and began to lean in toward my hand. I could see the skin start to ripple just before it came into contact with me.

Before I knew it, he was moving me toward his tail. My fascination began to wane as I started to try to figure out how I was going to get away. This wasn't fun anymore. After he raked his tail over me, I was a mess and out of breath. I looked around, and he was back for more. The whale wasn't being aggressive or mean, but his gentle movements were pounding me around.

Finally, Jim and Carlos pulled me out, with no real harm done.

Flip Nicklin

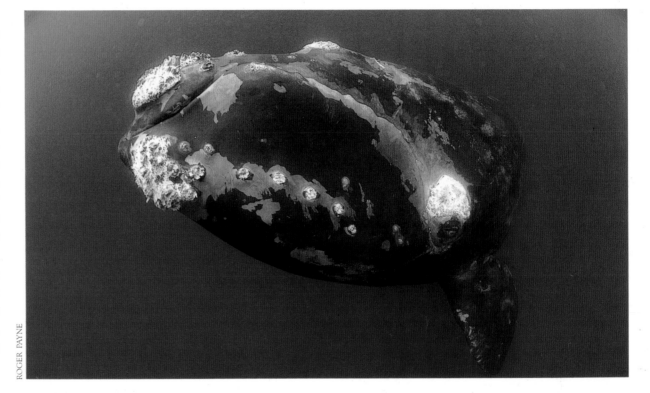

ROGER PAYNE

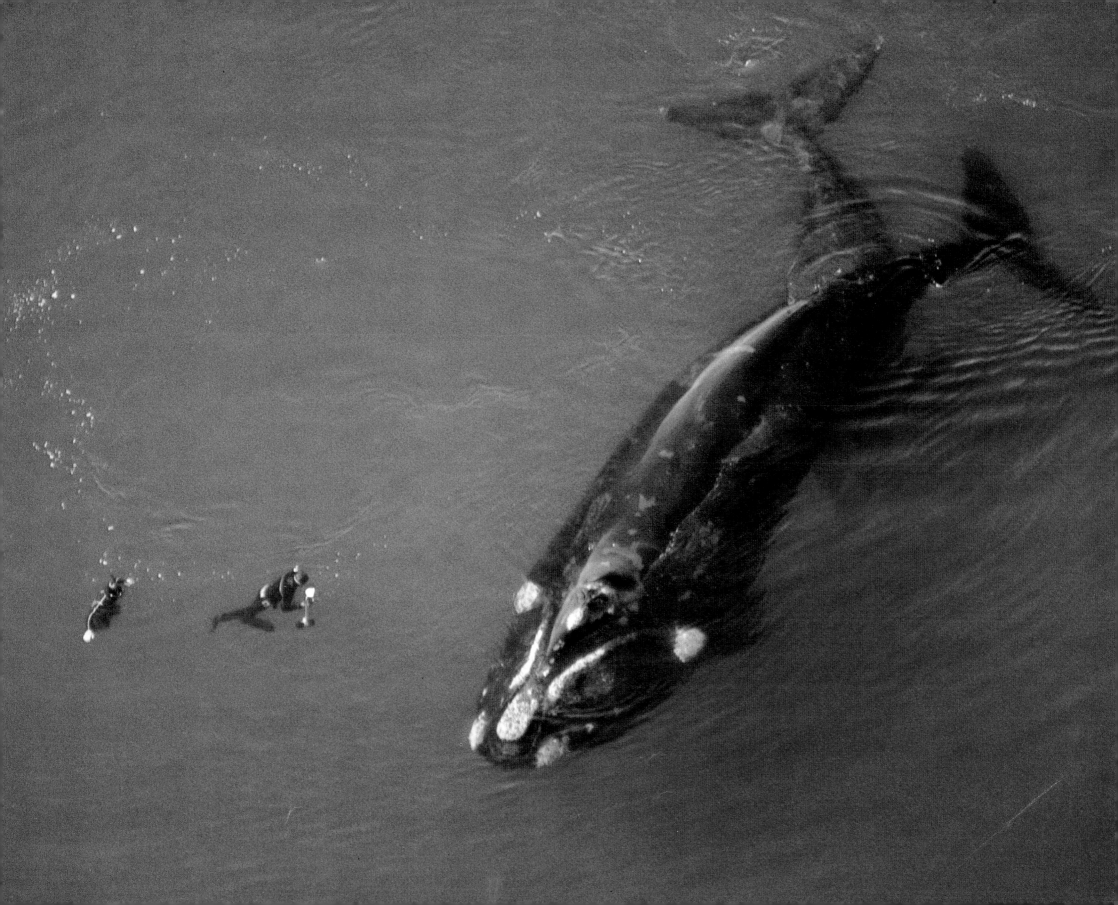

Cetacean Society

After fifteen years of identifying individual gray whales off the west coast of Vancouver Island, I became used to seeing certain whales together: if Saddle is here, Whitepatch must be nearby. Vancouver Island is the summer home range for a specific group of gray whales, and each summer for the past fifteen years Saddle and Whitepatch have joined other grays in these fertile waters. They are usually, but not always, together. Even though they both have other close associates within the home range group, these two have some extra attachment; they seem to know each other well. They could be siblings. Their relationship also could be a hint at a level of social organization in gray whales below the overall herd structure.

Whale societies, the organization of the groups in which whales live, are determined ultimately by the animals' ecological niches. With whales there is a distinct relationship between feeding strategy, body size, group size, antipredator behavior and mating behavior. These relationships produce the kind of society or social organization in which whales live. As whales evolved, they filled different ecological niches of the ocean and developed a variety of different societies: some whales live alone or in small, sexually segregated groups; some in extended family groups; some in complex schools numbering in the hundreds; and others in huge herds of thousands of animals.

Whale antipredator behavior is one factor determining the structure of a particular whale society. Quite simply, antipredator behavior is the series of actions a whale takes when attacked by a predator. For example, in some species of whales the only way to defend against predators is to live in groups and fight; in other species, living alone and unnoticed is the best defense. Killer whales, the major natural predator of other whales, are often the focus of defense behavior in whales.

There have been reports of killer whale attacks on grays, humpbacks, blues, rights, Bryde's, minkes, sperms and a variety of dolphins and porpoises. It is not clear how often killer whales successfully attack the larger whales, but many identified whales of each species have killer whale teeth marks and scars. The smaller cousins of killer whales, the false killer whale and the pygmy killer whale, may also attack other whales. There is one observation of a group of false killer whales apparently rushing a humpback mother and calf in Hawaii. A lot of blood was seen in the water and the calf disappeared.

While conducting aerial surveys of southerly migrating gray whales off the Channel Islands in southern California, Steve Swartz and Mary Lou Jones witnessed a dramatic killer whale attack on a gray whale. "Mary Lou saw a good sized white disturbance in the water to the south," Steve recalls. They thought it was a big whale. Heading over to take a look at it, they saw a single gray whale thrashing about, creating a lot of disturbance. The whale was throwing her head and flukes around, creating a huge foaming spot on the water. As they started to circle and drop in altitude, they noticed she had a calf with her; it was kind of hovering under the mother's belly. Then they noticed other animals in the water. They counted five killer whales, four adults and a younger one.

Steve describes the scene vividly:

"The killer whales were like a swarm of gnats or bees going in all directions — under, around and in between the female and calf. As we circled, we watched the killer whales separate the mother from her calf. The mother was just going bananas, swinging her head and hitting the killer whales on a couple of occasions. She also hit them with her flukes.

"In the meantime the calf just disappeared. We never saw it again. They must have drowned it, because we didn't see any blood in the water. Then the killer whales would dive and disappear for longer periods of time. The mother was just left on the surface, often doubling back on her track. It appeared to us that she was searching...looking. The killer whales surfaced again but not near her. She was swimming on the surface, not diving at all. Her blows were really labored. She looked exhausted and beat. Finally the killer whales just headed away."

A-5 POD AT REST

When at rest a resident killer whale family tends to stop their calling and shut down their echolocation (their active sonar). The pod comes together, keeping their position through touch and sight.

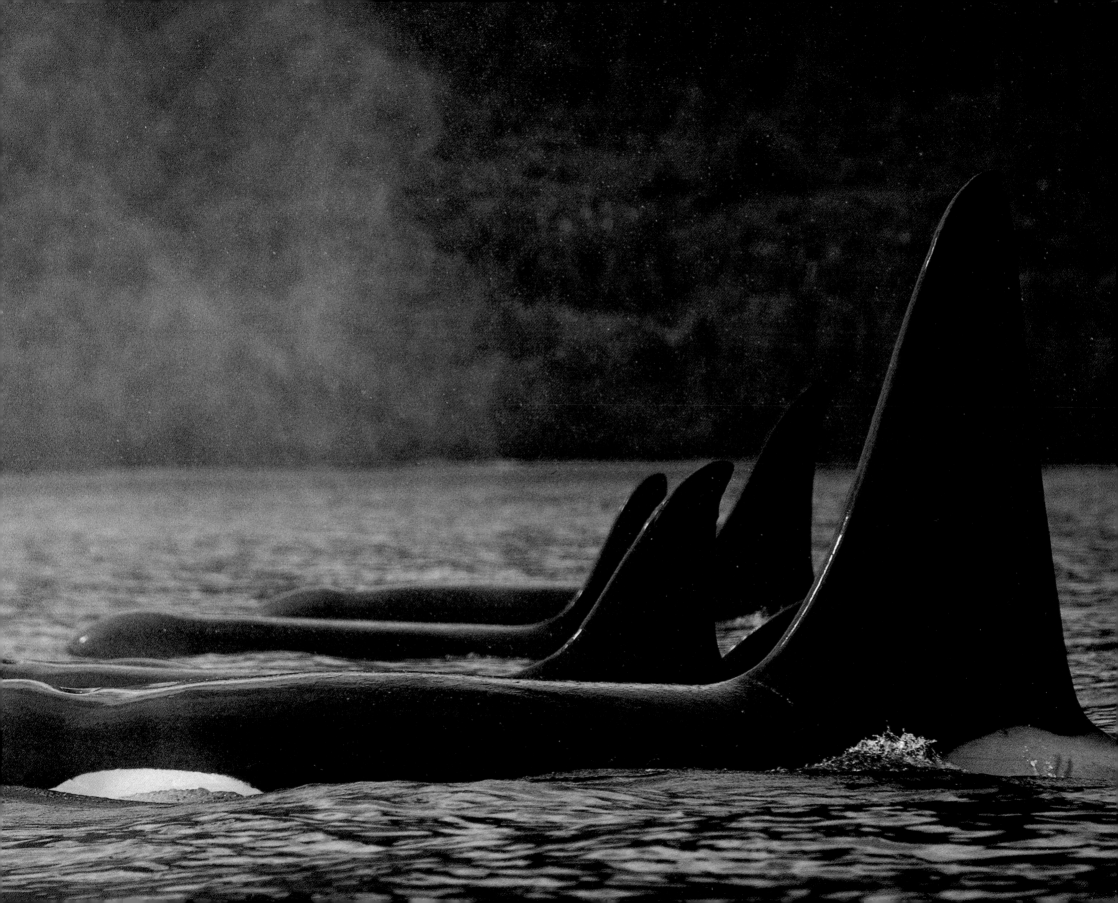

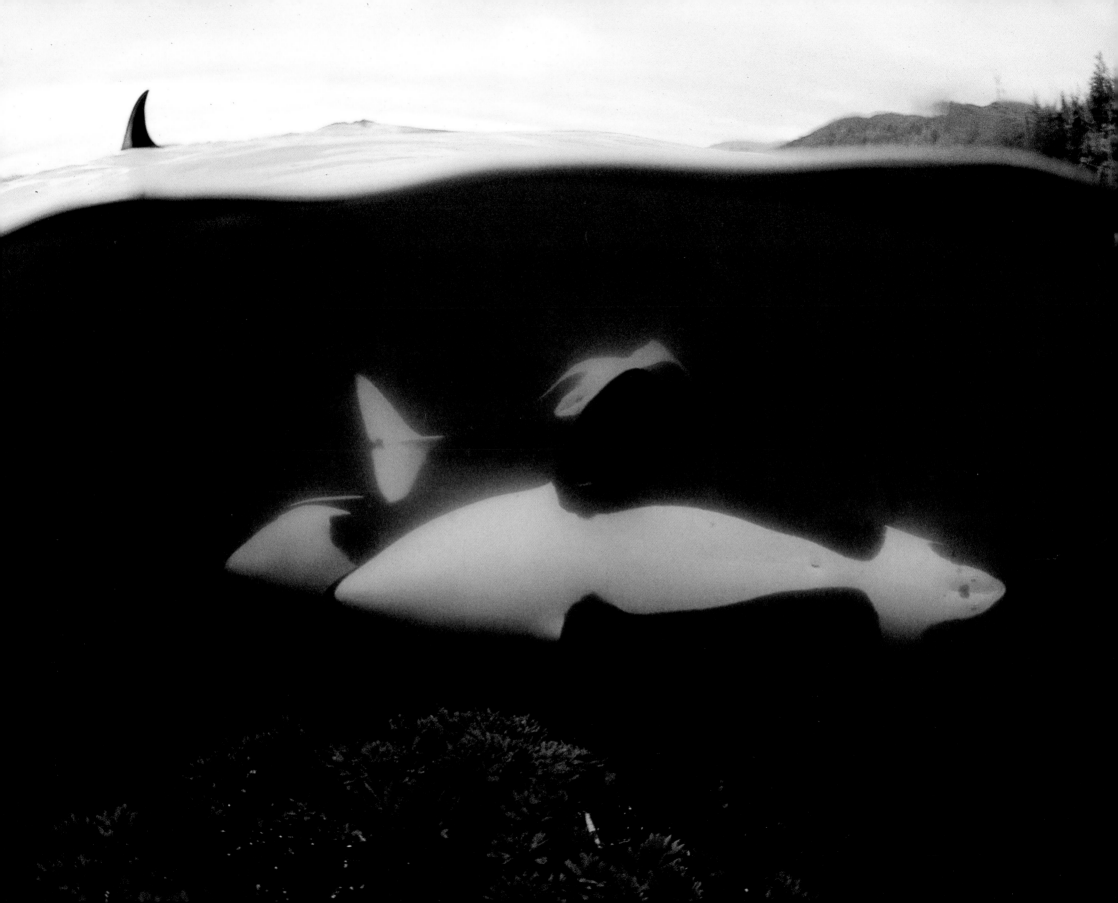

These killer whales are spending time at a rubbing beach. The pebbles on the bottom of this small cove are smooth and about the size of M&M candies. Here the whales can rub and socialize without scratching their smooth, somewhat vulnerable skin. At times this cove is full of whales.

In land mammals, antipredator behavior is related to its body size and habitat and, obviously, to the predator itself. Antipredator behavior can be avoidance of detection by the predator, fleeing under attack, or threatening, even attacking, the predator. The types of predators and options for avoidance have a definite effect on the optimum group size of the animals.

Like their land-based relatives, whales have different antipredator strategies. For a gray whale mother and calf, the best defense is to hide. If there is a kelp bed around, they will often swim into the kelp. Under attack, right whales also rush into shallow water, in an effort, at least, to protect their bellies.

Sperm whales have an entirely different response. Considering their offshore habitat, they don't have the option of reaching shallow water. In 1985, Hal Whitehead watched killer whales attack a school of sperm whales off the Galapagos Islands. With the attack, the sperm whales formed a tight cluster with a calf in the middle. They always kept their heads and jaws facing the killer whales, even if they were below them. The technique worked. The killer whales were not successful in this particular attack.

Observations in Alaska suggest that humpbacks may assist each other in defense against killer whales. Researcher Dan McSweeney watched four adult humpbacks rush to join a cow and calf under attack. The calf was protected while the humpbacks used their tails to fend off the killer whales. After the attack, one of the humpbacks had a strip of flesh stripped away and was bleeding badly; another had part of its tail torn off. The cow and calf appeared to be uninjured.

Even though defensive behaviors provide some insights into whale's social organizations, our overall understanding of whale societies is very general, especially for baleen whales. Some baleen whales live in loose associations of hundreds or thousands of animals. These groups usually migrate over long distances every year. Imagine the great herds of caribou, wildebeest or any other large-bodied migratory animal and you may have a fairly accurate picture of some whale societies. We know

so little, though, of the details. We believe the longest lasting bond in baleen whales is between mother and calf. It lasts a year or less. We are a long way from understanding the organization of baleen whale societies, but we see indications of complexity. Apparently long term associations exist between whales sharing specific feeding grounds, and it is possible these animals are lineage groups. There are fascinating hints, anecdotal at this time, of more sophisticated organization. Humpbacks rushing in to aid a cow and calf attacked by killer whales is one; possible cooperation of male right whales in mating is another.

In toothed whales, our understanding is deeper, perhaps because their societies are so much tighter and comparatively easier for us to observe. "If you are a resident killer whale, male or female, one of the laws of social organization is that you are going to stay with your mother throughout her life," explains Mike Bigg. Dispersal of individuals from the family unit is very limited. Resident killer whales in the Pacific Northwest live in communities of one hundred to two hundred individuals, composed of a number of cohesive, extended family groups known as pods. The pods consist of three generations of related whales of both sexes. A typical subgroup or lineage group might be a granny, her adult son, and one or two daughters and their offspring," explains Bigg. Several of these groups form a pod.

In killer whale, bottlenose dolphin and other toothed whale societies, the potential importance of learning and culture is significant. The emerging picture is one of societies run by cultural rules passed down through lineages rather than genetically controlled behavior patterns. This infers the possibility of a tremendous range and flexibility in behavior patterns of different populations of the same species.

John Ford states this principle clearly: "You can't go out and say this is how a killer whale behaves. You just can't do that. You have to say how this particular behavioral tradition, this lineage, this culture behaves. I don't know of any other mammal, except for some of the primates, where you are so far from the robotic, genetically controlled

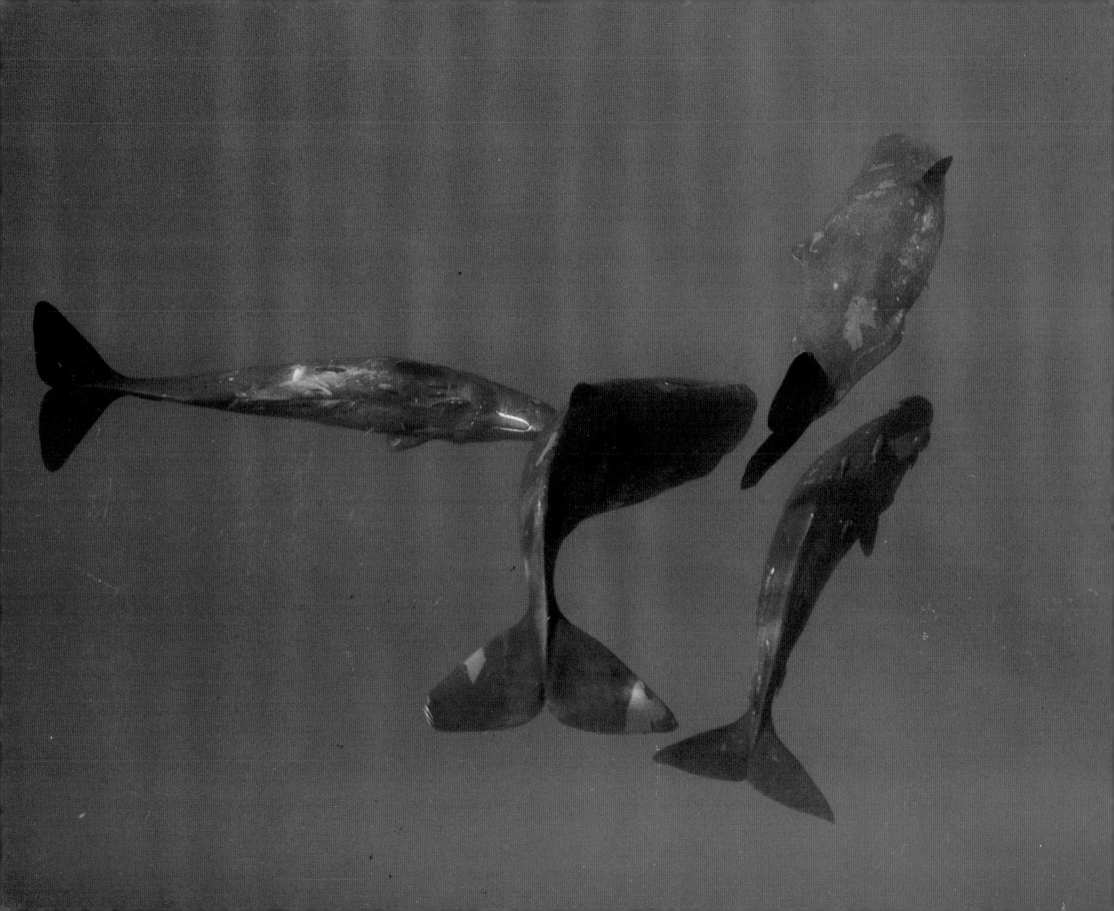

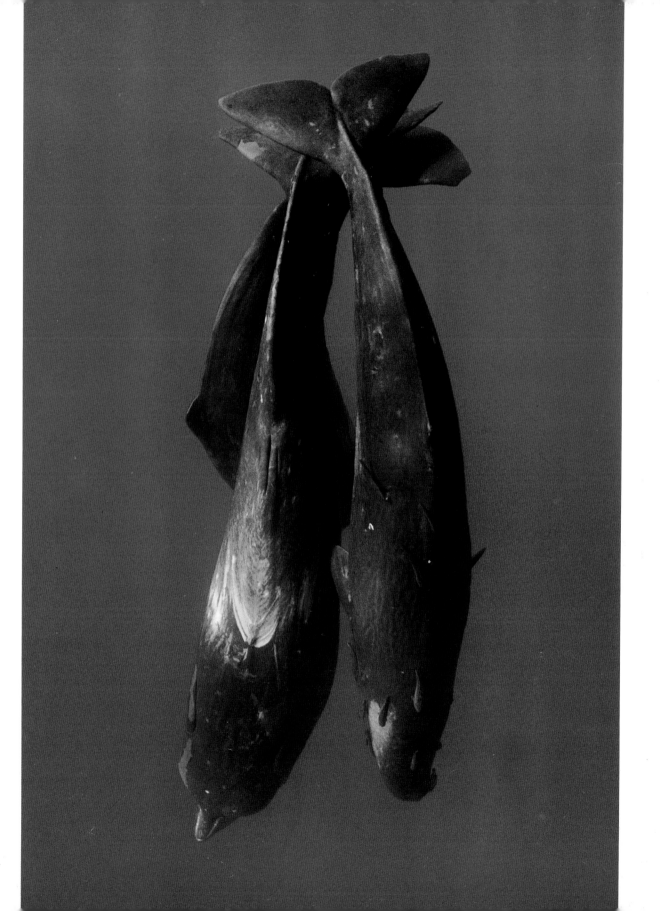

SPERM WHALE GROUP

Cow and calf groups of sperm whales
(left) seem very "social", spending
much of their time in close contact.
These sperm whales were
photographed in Hawaiian waters. I
was fascinated by their effortless
swimming style.

DIVING SPERM WHALES

Some pictures (right) just make me
wonder: what's going on here? Only
these three whales know what's
happening. And they're not telling.

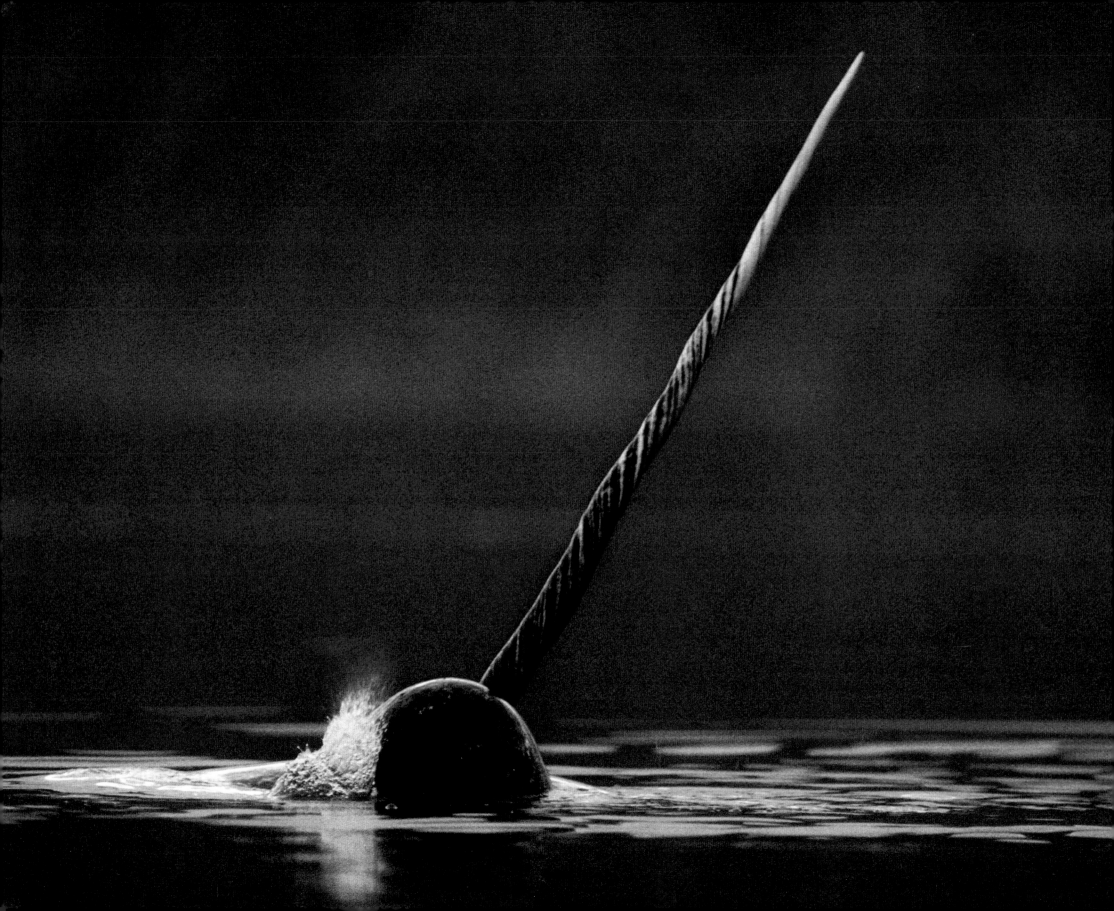

THE NARWHAL

The narwhal (left) is one of nature's improbable creatures, the unicorn of the deep. Why should a sixteen-foot whale have a nine-foot tusk? Here a lone male slowly waves eight feet of tusk above the surface. A group of segregated males (right) swims near the ice edge in Lancaster Sound. Each spring there are predictable movements of two distinct groups — cows and calves and tusked males.

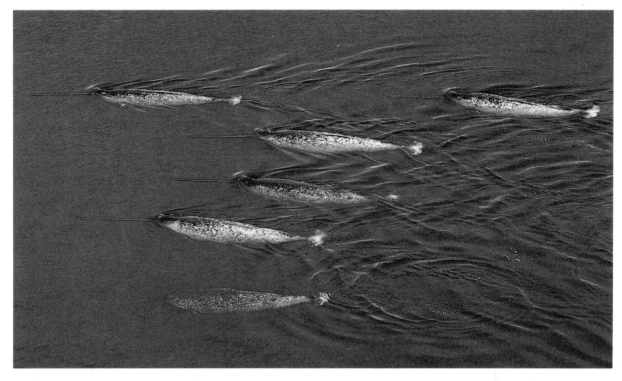

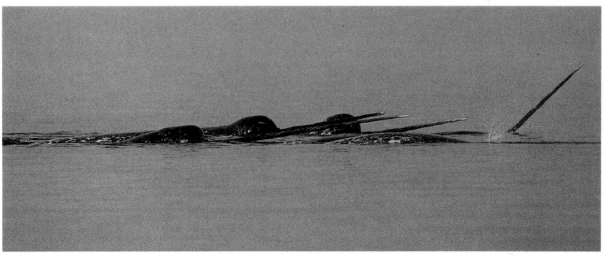

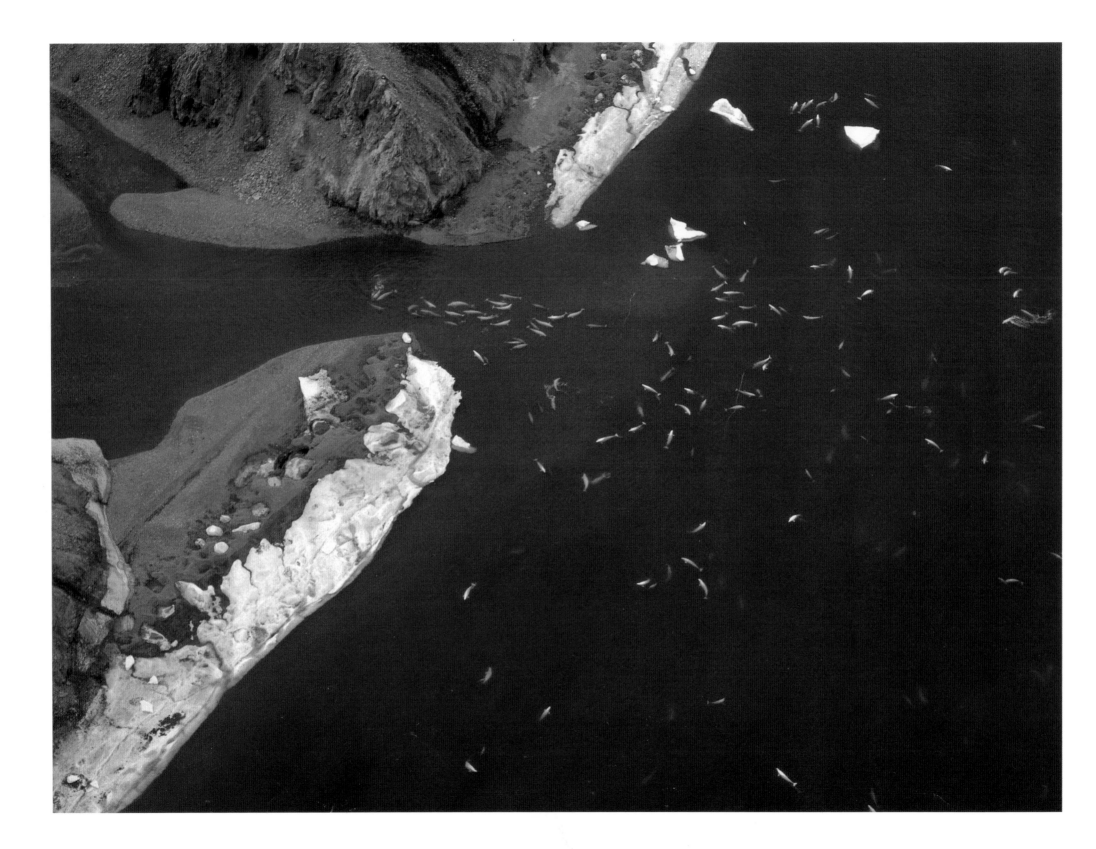

BELUGAS IN ESTUARY

In 1987 the ice stayed late in Lancaster Sound. Each year the beluga whales spend days in the estuaries. Standing on the cliffs or looking down from a helicopter, we could see groups of mothers and calves, gatherings of gray, adolescent belugas and probably adult males among the groups. As the ice began breaking up, the whales started to move out of their various congregations and followed the leads in the ice.

type that you have to couch everything by saying, 'I'm just referring to this particular highly adapted group.'"

Ken Norris has considered this question perhaps longer than any scientist working with whales. He believes the dolphins demonstrate cultural situations in their societies. He uses an example of bottlenose dolphins in San Diego Harbor that go down to a buoy every Friday to get the fish brought there by the navy dumping their garbage. For the dolphin to do that there has to be, according to Norris, a set of agreed upon elements that have nothing to do with genetics. It's something the dolphin decided to do in that particular location — it's part of a culture.

Our understanding of whale societies is still in its formative years. We have to wait for the vital bits of information to come from research. Some will take years to gather, but each new item will allow us a slightly better view of the fascinating social world of whales. The descriptions of a killer whale attack, a dolphin nursery school, a bowhead feeding strategy, or right whale mating behavior are big steps. When we put these together with future information, we will someday begin to grasp the nature of whale societies. We are just opening the door to understanding the lives of these animals.

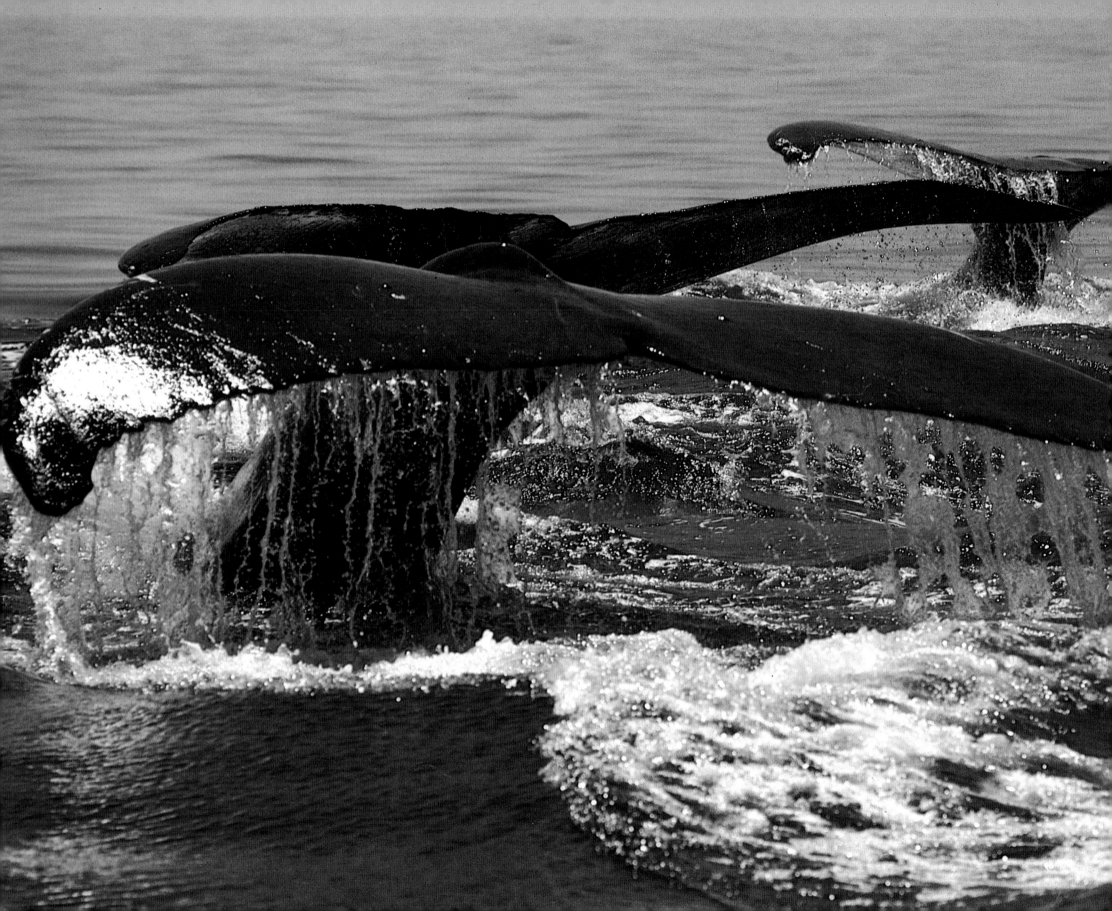

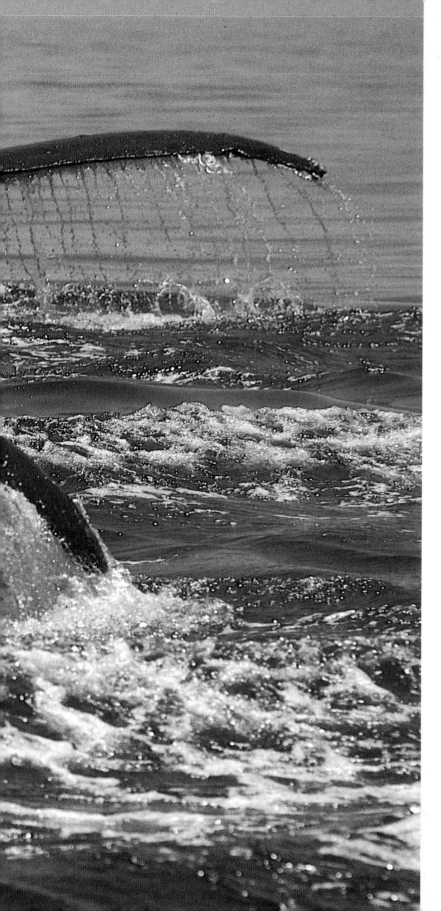

A FLUKE SALUTE

T *hree humpbacks dive off the coast of* *Maui.*

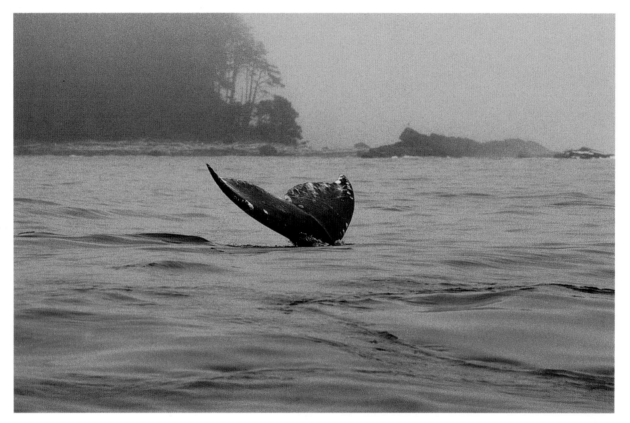

AT ONE WITH THE GRAYNESS

For some gray whales, the northern end of the migratory path is the area around Vancouver Island. Local whale watchers joke about the whales being "at one with the grayness" — the fog and the rains. Here they find a productive coast for summer feeding.

MEXICAN SPY HOP

For many gray whales (right), the warm, shallow waters of Mexico's San Ignacio Lagoon are the terminus of the southern migration. There they will mate, give birth, and spend the winter season.

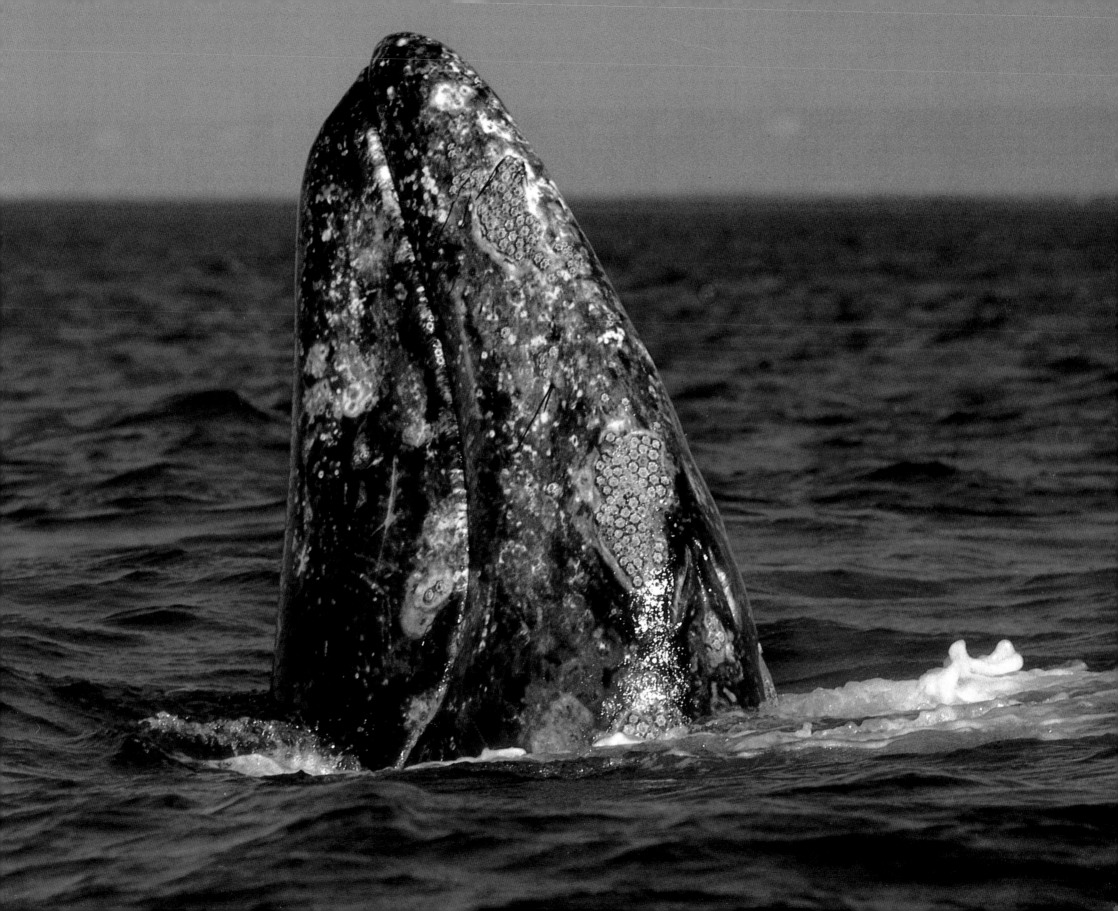

At The Rubbing Beach

I was treading water, trying to take a deep breath. John Ford stood on shore, yelling "They're coming! They're coming!" The killer whales were only ten feet away when I first saw them. There were three, close together, beginning to rub themselves on the small smooth stones as they swam by.

Soon others came from the opposite direction, coming as close as five feet, sliding past me. I heard two sounds — my pulse pounding in my ears and the high pitched squeaks of the black and white whales.

They rubbed their bellies, their sides, even their backs on the M&M sized pebbles. They all but ignored me. As the first trio began to come back, I realized I was still holding my breath. I really needed air. Although the water was only six feet deep and I was close to shore, I was confused. All around me, filling the cove, were rubbing killer whales. It was chaotic and unnerving.

Only a few pictures were taken. I wanted to get back to land. I went ashore. Between reaching land and John's first call, only a couple minutes had passed, but it seemed like hours. An unforgettable experience.

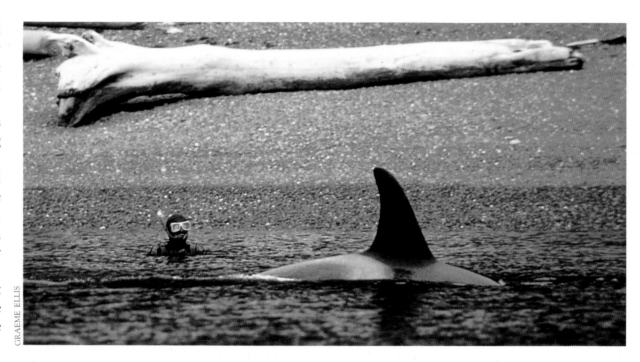

GRAEME ELLIS

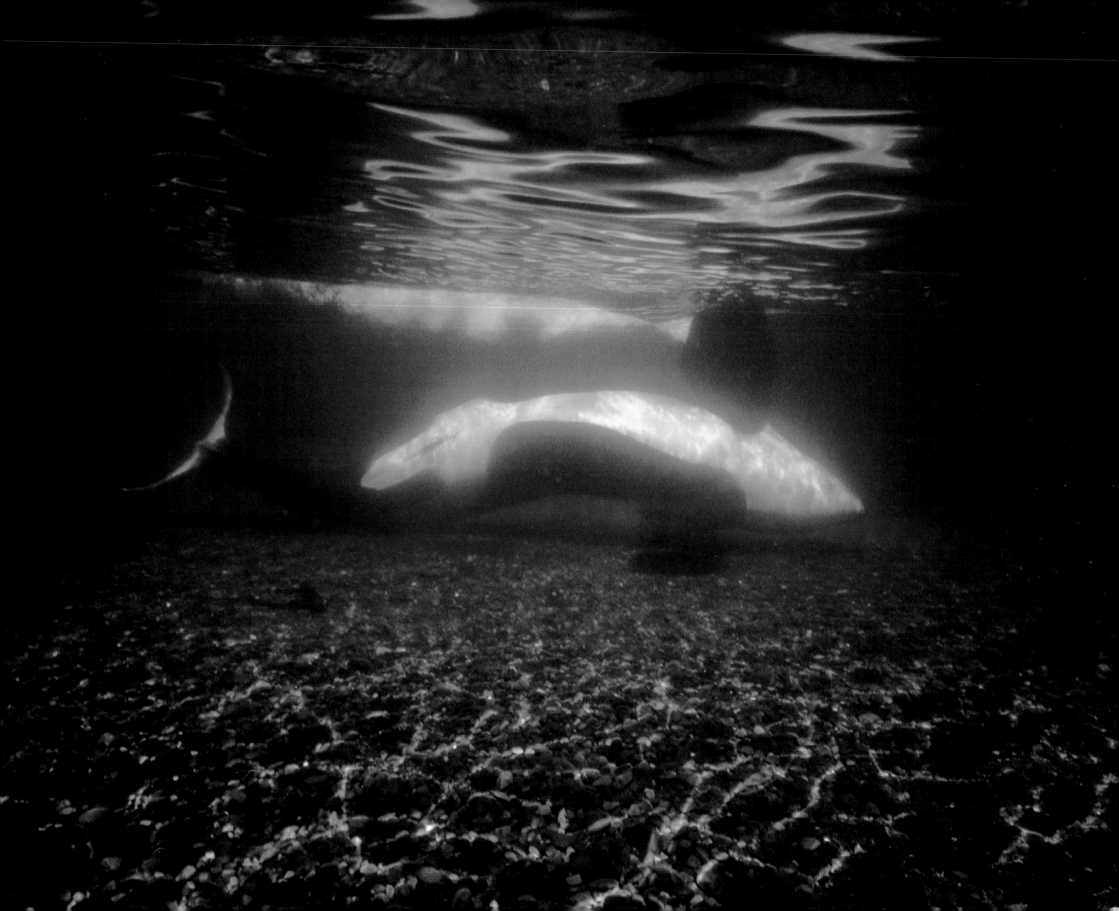

Feeding

West Coast surfer Ted Goodspeed recalls vividly an encounter with a killer whale. He was on his board looking out at the horizon when something caught his eye. It was a dorsal fin coming straight at him about thirty feet away. He knew the whale was moving rapidly because there were large ripples coming off the dorsal fin. When it was about fifteen feet away, it dove, still heading directly toward him. Kicking frantically to get out of the water and onto his surfboard, Goodspeed actually kicked the whale with his foot.

He thought the game was over. Lying on his board, he paddled away as fast as he could. By that time, the whale had circled back and was on its side looking straight up at him — a potential meal. "I could see it right under the surface of the water, right underneath me looking up," remembers Goodspeed. "It was big enough to engulf me if it wanted, but it went by me and just eyed me — I thought I was gone."

This story is not unusual. Killer whales and surfers along the west side of Vancouver Island share the same waters. In one encounter a whale knocked a surfer right off his board. Whether this type of whale behavior is curiosity, harassment or play, it leaves a lasting impression on the surfer.

"Transients," chuckles Mike Bigg, leader of a long-term study of killer whales in British Columbia. He knows killer whales prey on marine mammals and often work Goodspeed's surfing area looking for sea lions. "The whales could be confused," Bigg concedes, "but a close look at a surfer tells them that this 'sea lion' is different. These are very traditional feeders; they learn what they are going to eat at an early stage and are extremely conservative. It is unlikely they would ever experiment."

Mike Bigg has found that there are two types of killer whales in the Pacific Northwest. "Residents," as their name implies, live in specific areas in summer and fall, while "transients" appear to constantly move over a much larger range, including passing through residents' areas. The two types are quite different animals. The residents primarily eat fish, while the transients eat primarily marine mammals such as seals, sea lions and even other whales. "I think residents and transients probably represent different races," explains Bigg, "and their physical and behavioral differences may be ascribable to the differences in diet and feeding strategies."

Different types of whales have different feeding strategies. This is the key to the variables in whales. Feeding strategy governs the lifestyle of the animal, dictates distribution, behavior patterns, social organization, communication, and ultimately physical appearance. Whales are built to eat. What they are physically and behaviorally has been determined by their finding the best way to capture and most efficiently use their food. Only the extravagances of sex or the needs of self-protection break this rule.

There has been an evolutionary trend towards fewer teeth in toothed whales. Many, like the narwhal, have no functional teeth at all. Only narwhal males have a tooth. It erupts from the gum and grows in a spiral form up to ten feet in length — the narwhals famous tusk. For many of the beaked whales, teeth never protrude from the gums. How do they catch their food?

"It's a great mystery," observes Ken Norris. Watching healthy whales without teeth, along with other observations, led Ken Norris and Bertel Møhl to the somewhat controversial "Big Bang" hypothesis. Toothed whales have sophisticated sound production capabilities, as demonstrated by their use of echolocation with sonar clicks to locate and analyze food. According to Norris and Møhl, some toothed whales may also use sound pulses to actually debilitate or stun their prey. It's an unproven but fascinating hypothesis.

It's common to describe the toothed whales as "hunters" and the baleen whales as "grazers". For the baleen whales, however, it is a more complex picture than that of whales, like cows on a pasture, grazing across a field of blooming plankton. Baleen whales, too, must locate and capture their prey of small fish or plankton. And in very interesting ways.

FEEDING RIGHT WHALE

Right whales feed by skimming the ocean's surface for zooplankton.

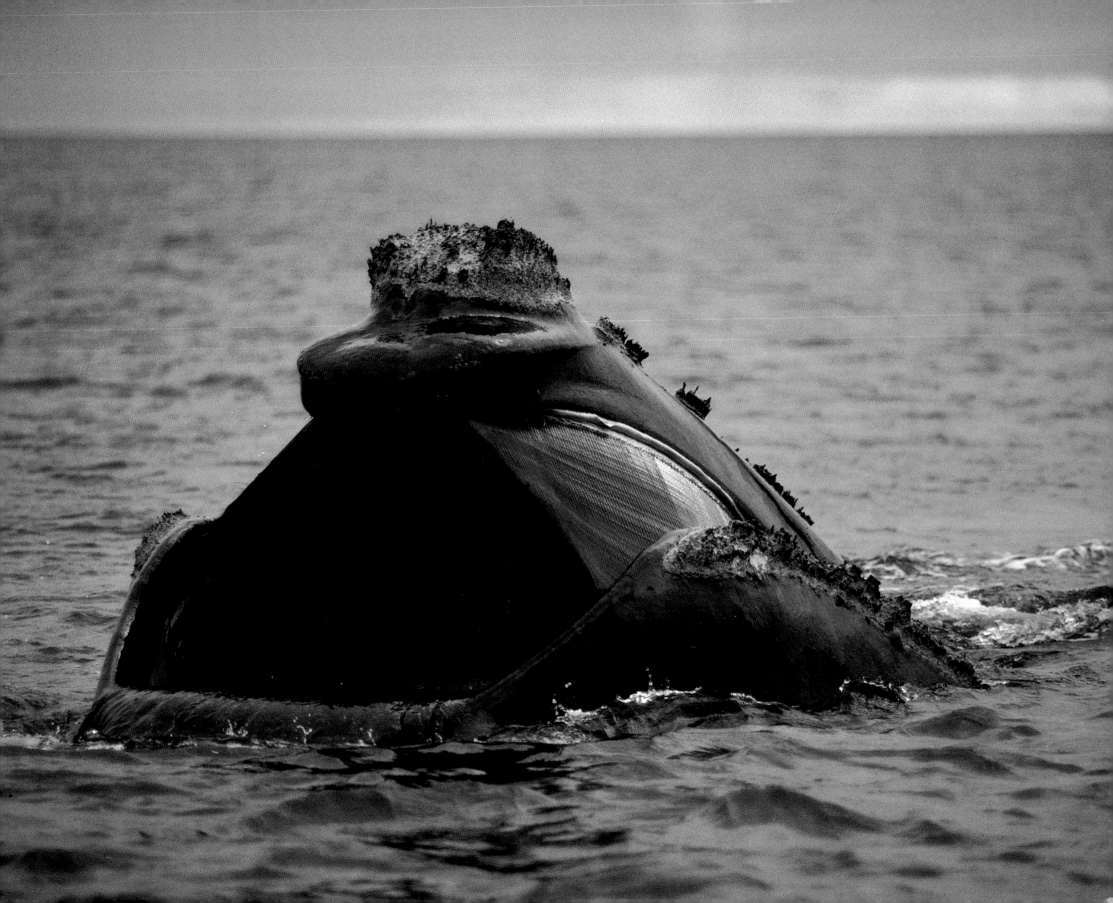

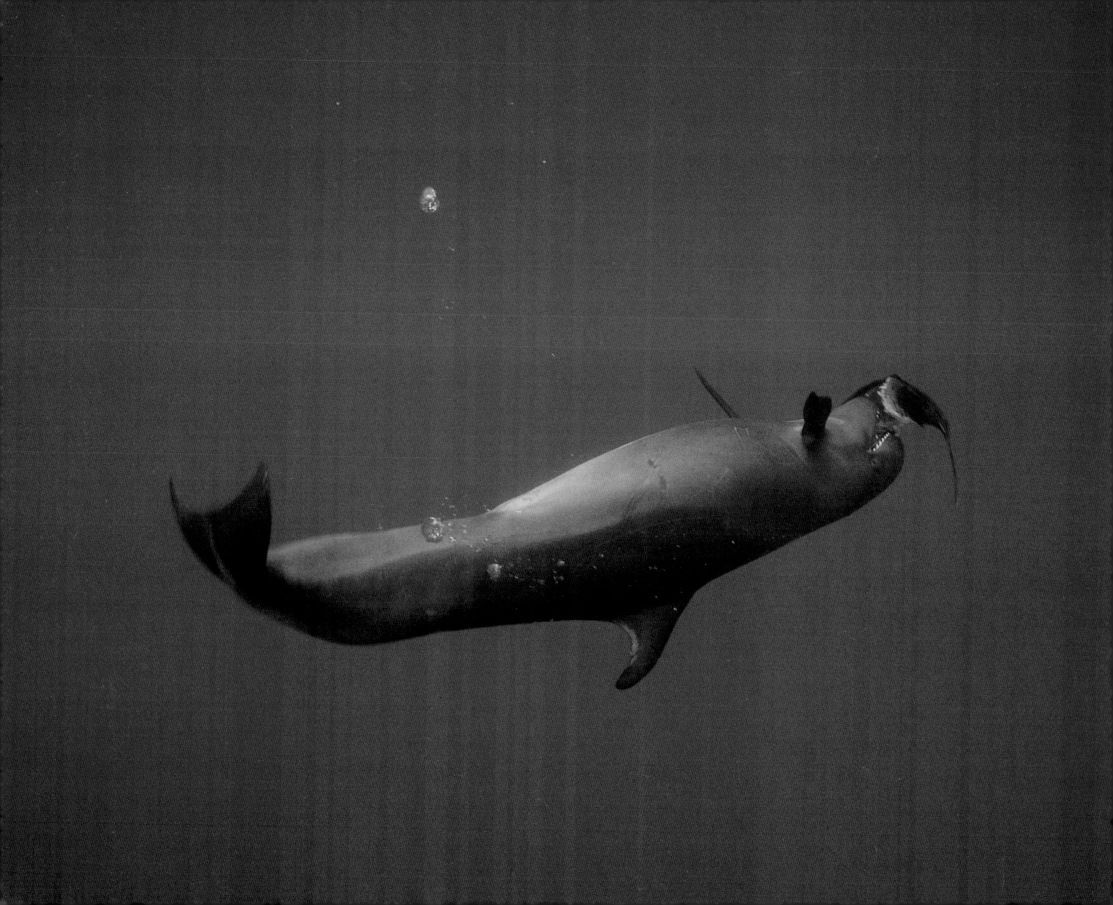

FALSE KILLER AND MAHI-MAHI

Here a false killer whale captures a mahi-mahi or dolphin fish. They feed mainly on squid and large fish and have a reputation for stealing the catches off fishermen's lines.

"Bubbles" was the key word as we drifted amongst the whales on perfect, glassy September days. Ours was the only boat in a huge Alaskan sound. Three of us, Dan McSweeney, Flip and I, were intent on watching all sides of the boat as two whales were bubble-netting nearby. The first indication of the activity was a six- or eight-inch bubble bursting at the surface, followed by a quickly closing circle of bubbles, followed by an explosion of an open-mouthed humpback whale through the center. The whales had successfully surrounded their prey, in this case small shrimp-like creatures known as euphasids, with a circular curtain of bubbles. While I had heard about bubble-nets ever since Chuck Jurasz first described them in Glacier Bay in the mid-1970s, I had never witnessed one before. The bubble-netting process is amazingly deliberate and methodical; coordination is required when more than one whale is involved with the same net. A patch of euphasids will move at the first sign of approaching turbulence, so humpback whales have developed this sophisticated netting behavior.

Other whales have other feeding techniques. The three different families of baleen whales employ three general feeding styles. Primarily bottom feeders, the gray whales plunge their heads into the mud, take a giant mouthful and filter the bottom-living organisms from the mud and water. Right and bowhead whales are skim feeders and essentially swim through swarms of plankton with their mouths open. The third group, including humpbacks, blues, fins and minkes, are generally known as gulpers, taking huge gulps of ocean and food and filtering it. These different feeding strategies reflect the type of food eaten. Of course, there are exceptions. At times gray whales feed quite efficiently in the water column, and bowheads have been observed apparently bottom feeding. Nature has few absolutes.

Many species have a range of techniques, a bag of tricks used to obtain food under different conditions. For example, humpbacks may bubble-net in one situation and lunge feed (simply lunging mouth open into a swarm of food) in another. In some situations bowheads may feed alone, and in other circumstances form an echelon. Whale researcher, Bernd Würsig, has observed V-shaped formations, echelons, of up to fourteen bowheads. With each whale moving forward with its mouth wide open, this is a pretty dramatic sight, according to Würsig. Apparently it is an effective corralling mechanism, especially for feeding on euphasids. Interestingly, Würsig has noticed that during a two-hour feeding session just about every whale in the echelon gets to be leader at least once.

In general whales have two basic feeding options. Either they migrate to seasonally rich feeding grounds or they find fertile oases in the ocean where food is available year-round and take up residence there. Phytoplankton, minute plants, are the base of the entire oceanic food chain. Slightly larger animal plankton, zooplankton, feed on the phytoplankton. Many of the larger baleen whales feed directly on the zooplankton, and fish and squid also feed on the zooplankton and in turn (either directly or through several stages of the food chain) become the food of the toothed whales. Phytoplankton require nutrients and light to grow, and when these two elements come together we get areas of high productivity. And that is where one will find whales.

In the high latitudes, long hours of summer light combine with dissolved nutrients that have accumulated over the winter to produce dense blooms of plankton. Lacking replenishment of nutrients, the system breaks down near the end of summer, and, with the loss of light, the plankton virtually dies in the winter, allowing nutrients to build up again for the following spring. Migrant whales exploit this seasonal productivity.

Our current understanding of the distribution and migrations of whales has come primarily from whaling era records and from extensive work with discovery tags — metal darts shot into an animal in one location and recovered in another location when the animal is killed. More recently, individual identification of animals through the use

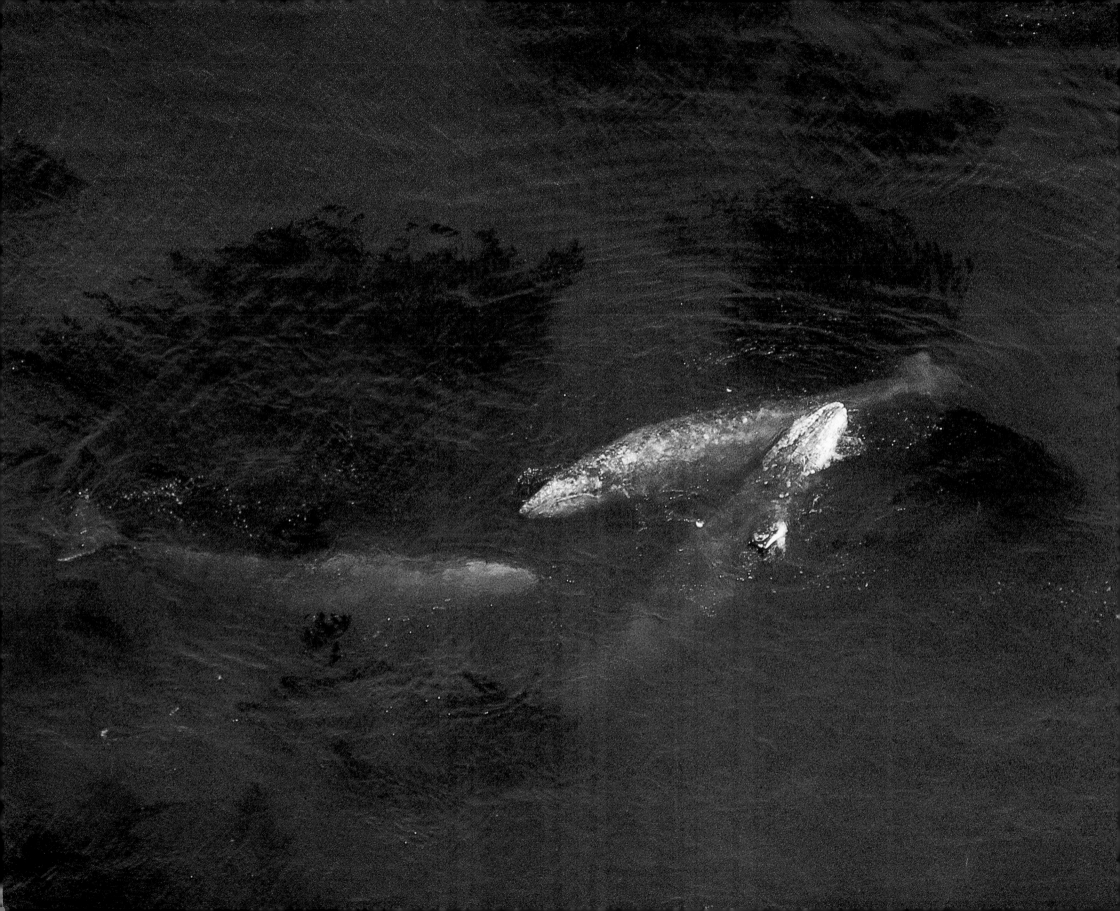

GRAY WHALES IN KELP

Gray whales (left) are very flexible in their feeding strategies. Grays are often seen in kelp beds feeding on mysids, a type of zooplankton.

FEEDING GRAY WHALE

Here is the gray whale (right), Quarternote, bottom feeding.

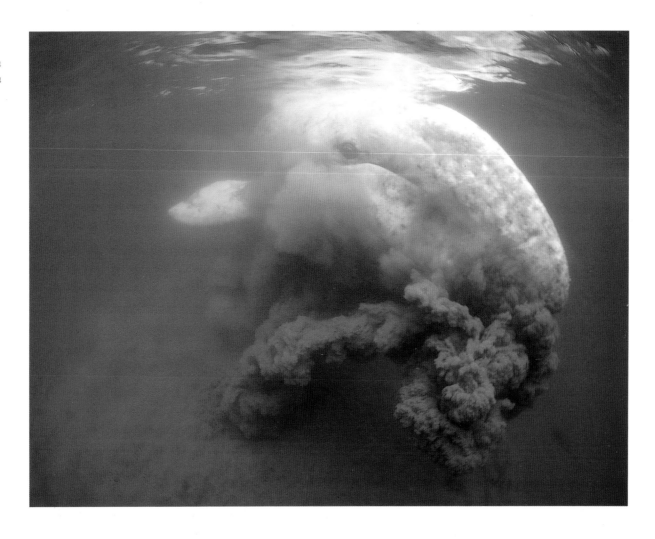

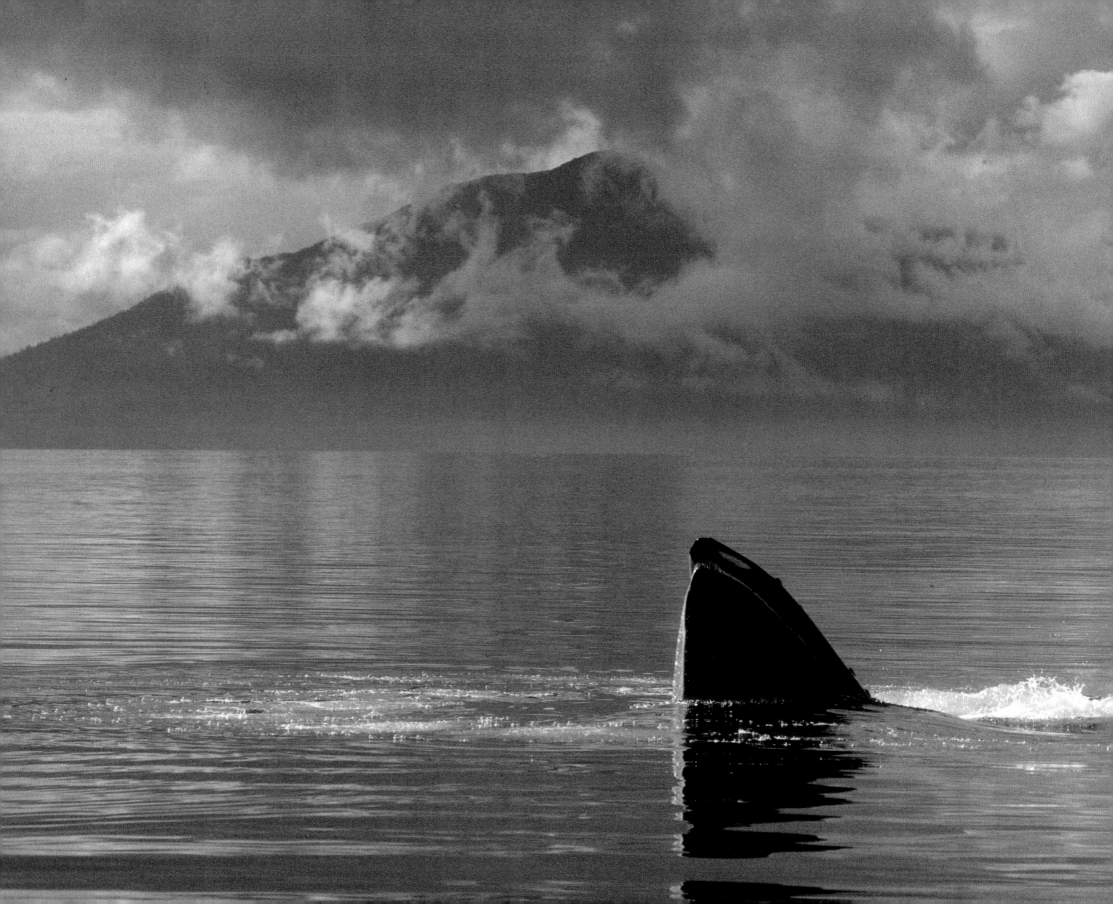

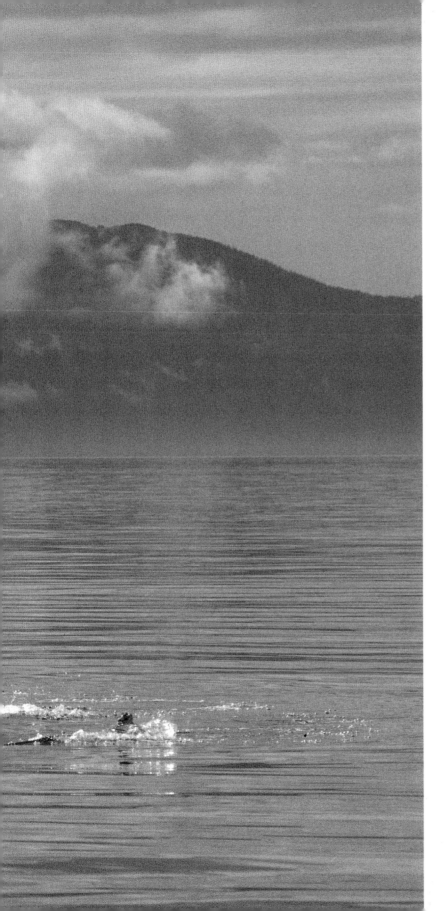

THE BUBBLENET

Humpbacks bubblenet singly as well as in groups. Here a solitary humpback in Southeast Alaska creates a bubblenet. This whale was probably feeding on herring. Once a cloud of bubbles surrounded our boat, and for a moment we thought we might be the prey at the top of a bubblenet. We held our breath and waited. Nothing, fortunately, surfaced but the bubbles.

PINK MOUTH

This humpback is using a bubblenet to feed on herring. The inside of the whale's mouth and the baleen is apparent.

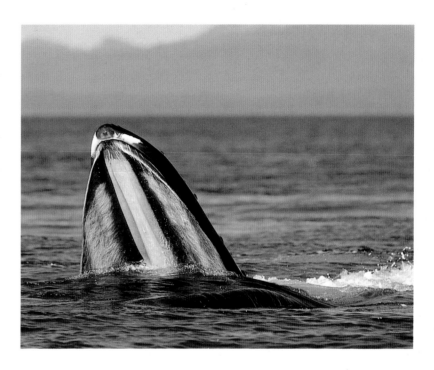

of photographs of natural markings has allowed us to recognize individual whales in different locations. Our knowledge of migratory and feeding behaviors has grown tremendously.

We know, for example, that gray whales move up and down the North American west coast moving between winter breeding areas in the south and summer feeding grounds in the north; humpback populations generally move northwards and southwards in all oceans for the same reason; bowheads, narwhals, and belugas move in and out of the Arctic with the ice; blue whales move between the Gulf of California and northern California waters; right whales migrate between waters off Florida and Georgia in winter and the Bay of Fundy area in summer. These are generalizations, for they don't define all whales, all the time.

When I watched blue whales feeding on mysids, a type of zooplankton, off equatorial Trincomalee, Sri Lanka, during the middle of the southern hemisphere summer, I could surrender my presumption that all large whales must migrate from near-tropical breeding grounds in winter to cold water feeding grounds in summer. While a few species really do migrate long distances between summer and winter grounds, the variation in this behavior is significant.

Most whales have preferred feeding grounds, territories, or home ranges. Some move away for part of the year, but generally return to the same area. The same individual grays return to Vancouver Island each spring to feed; the same humpbacks to Frederick Sound, Alaska, or Stellwagon Bank, New England; the same blue whales to the Gulf of St. Lawrence; the same minkes to Puget Sound; and the same killer whales return to the Johnstone Strait.

Some whales, like minke whales in Puget Sound, Washington, usually feed alone. Other whales are found in loose, single-species groups, such as fifty or more humpbacks in southeast Alaska or hundreds of bowheads off Hershel Island in the Beaufort Sea. Still others are found in mixed species groups.

Richard Sears' description of mixed species groups in the Gulf of St. Lawrence places minkes most often inshore, presumably feeding on sandlance, and humpbacks and finbacks occasionally inshore, staying there for only a week or ten days. According to Sears, offshore, for ten miles or more seaward, there are groups of twenty to thirty finbacks, ten to fifteen minkes, a couple of humpbacks, a few blue whales and, of course, dolphins. "Sometimes," he notes, "it seems the blue whales are separated from the finbacks and more spread out, and on other occasions they are right amongst them, all mixed together."

When a variety of species lives essentially in the same area, the relationships between them and their prey are complex and elusive. Undoubtedly, specialization of food types, flexibility and competition all contribute to the balance within the community. It's not just baleen whales that share neighborhoods.

For example, one of the most prolific areas in the world for whales is the Kona coast of the Big Island of Hawaii. In this area live a wide variety of toothed whales: bottlenose dolphin, spinner dolphins, spotted dolphins, rough-toothed dolphins, false killer whales, pygmy killer whales, dwarf sperm whales, giant sperm whales, Blainville's beaked whales, Cuvier's beaked whales, melon-headed whales, and pilot whales. Literally thousands of whales make a living in this fertile area.

Hints of how these animals manage to live together are just beginning to be observed. For example, the relationship of two species of sperm whale that live in the same area off the southeastern coast of the U.S. has been studied. Researcher Susan Candela found that pygmy sperm whales dive deeper and feed on larger squid while dwarf sperm whales make shallow dives and feed on smaller squid. Hal Whitehead, in a study of whales off the Newfoundland coast, found that minke whales apparently prefer one-to two-year-old immature capelin, a small fish, whereas humpbacks in the same area prefer two-to three-year-old capelin. Without stretching the imagination too far, we can see a corollary here to African ungulates sharing a common range, where different species actually eat different parts of a blade of grass. The complexity and balance in natural ecosystems is elegant but sometimes difficult for humans to even imagine.

DIVING SPERM WHALE

There are many questions about sperm whale feeding behavior, primarily because they are deep divers, often going 3,000 feet or more below the surface in search of squid, their primary food. Scientists are very curious about the ways these huge-headed creatures with teeth only on the lower jaw capture and hold their prey.

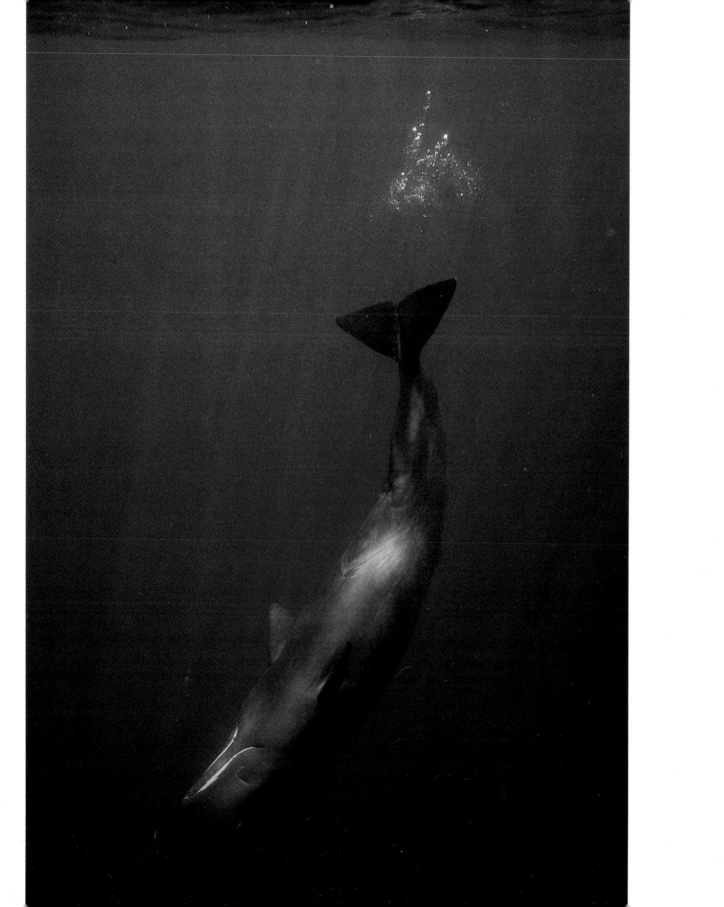

Feeding False Killer Whales

As the pod of false killer whales swam by, three stopped for a moment of quiet near where I was swimming, about four miles off Maui's western coast. Two were adults, one was a calf. After a glance my way, the mother and her young whale went to join the others in the distance.

The false killer whale that stayed with me held a large fish, a mahi-mahi, in its teeth. The whale and I stared at each other. Then he brought the fish within my reach and let go of it. I wasn't sure what to do, so I grabbed it. The whale stayed immobile, its eyes on the fish.

Meanwhile, I tried to set up a photograph, holding onto the fish while working with my strobe light and camera. The whale waited for me to get my act together. With the camera ready, I pushed the fish toward the whale. He didn't hesitate. He swam slowly forward, carefully took the fish back in its mouth, rolled once and took off toward his group.

What a wonderfully unique experience. Later I learned that Dan McSweeney had had the same thing happen to him off another Hawaiian coast.

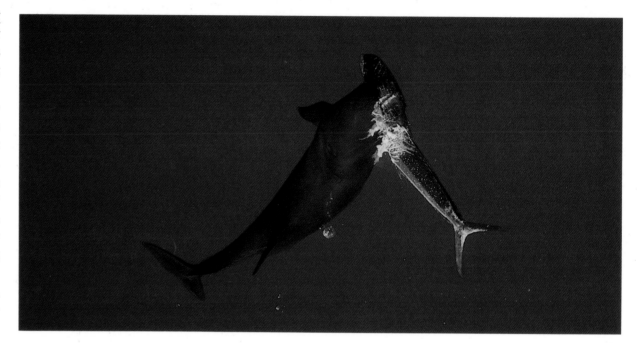

Flip Nicklin

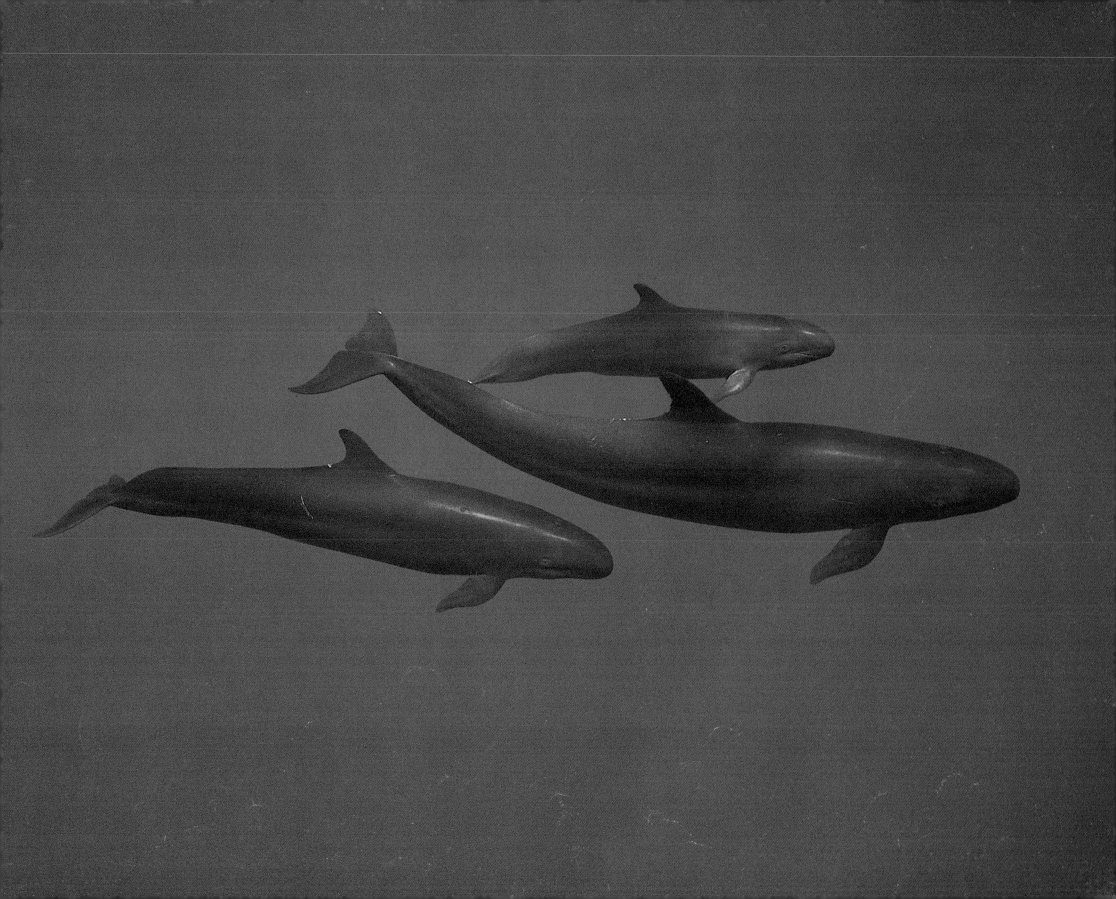

Mating Rituals

Being in the midst of a mating group of right whales is like being in the midst of a half dozen mating steam locomotives. They are about the same size, sound the same, and have about equal concern for onlookers. My friend, Micheal Bennet, after spending a day in the water assisting Flip Nicklin near a mating group, was prompted to write in his journal: "The experience changed profoundly my preconceived notion of these animals as gentle beasts who drift around the world's oceans placidly filtering sea water." As it does with most mammals, the procreative urge changes whales.

I spent that day with researcher Vicky Rowntree on a cliff 300 feet above Gulfo Nuevo, Peninsula Valdez, Patagonia. She was studying the interactions of cows with calves in the bay below. Behind us was an endless, dusty desert. In front was a great bight and below us, the whales, just yards from the beach. At high tide one could look almost straight down on the animals. Vicky was busy identifying and naming the cows and calves by the patterns of the callosities on their heads. I was looking for mating groups. I wanted to compare mating behavior in right whales with that of humpback whales.

Groups of whales, presumably males, were gathering around a single animal, presumably a female. There was a great deal of rolling, hugging, stroking and thrashing. I was looking for the typical humpback competition between the males for access to the estrus female. If it was happening, I didn't see it. What I did see was a spectacle of passion, urgency and power.

Every winter, southern right whales assemble at Peninsula Valdez to calf and mate. Migrations to traditional breeding and calving sites are typical of several species of baleen whales, including the well-known migrations of gray and humpback whales. Gray whales migrate to the protected lagoons along the coast of Baja Mexico. Humpbacks migrate to shallow banks in subtropical waters throughout the world such as the Hawaiian Islands or Silver Bank in the Caribbean. Due to the predictability of their winter assemblies, researchers have been able to study right, gray and humpback whales.

Winter grounds appear to be chosen more for physical rather than biological characteristics. Important factors in site selection seem to include what is best (in terms of energy conservation and protection from predators) for the mother and newborn. For this reason, the areas are warmer, shallower and more protected than summer feeding grounds. The winter migration and assembly also serves to bring together males and females who often separate in the summer. While the reason for the female's long journey is open to debate, there is no doubt about the males — they follow the females.

Usually, mating behavior in mammals involves competition among males for access to a female. Typically the female elicits this competition, which allows her to mate with the "best" male. Some whales, at least, appear to follow this pattern. Humpback whale mating behavior is classic in this regard. In any humpback winter assembly area, such as Hawaii, groups of whales ranging in numbers from three to fifteen can be seen charging around after a lead whale. Sometimes the lead whale is a single adult female, sometimes a cow with a calf. For years these were simply called "surface active groups" or "surface traveling groups." In fact, they are mating groups. The female has come into estrus and numerous males are competing for access to her. If humpback cows with a newborn calf come into estrus, similar mating groups form around them.

This competition over the female is not subtle. It ranges from a variety of male-to-male threats to full-blown brawls. The threats include bubbles streaming from the blowhole, explosive blowing under the surface, and gulping air and expanding the throat pouch, possibly to make a male look bigger. The fighting includes lashing or pummeling each other with tail flukes and gigantic collisions. The results are often bloody head wounds, wounds on dorsal fins and tail flukes.

The female appears to encourage this competition by swimming continually with the band of following males, ensuring that she will attract every available male within hearing distance. Males apparently cannot resist the sounds of a mating group. In theory, the most

RITUAL JOUSTING

Male narwhals often demonstrate a ritualistic jousting of tusks. This slow dueling is not particularly combative but appears to be a method of establishing dominance among males.

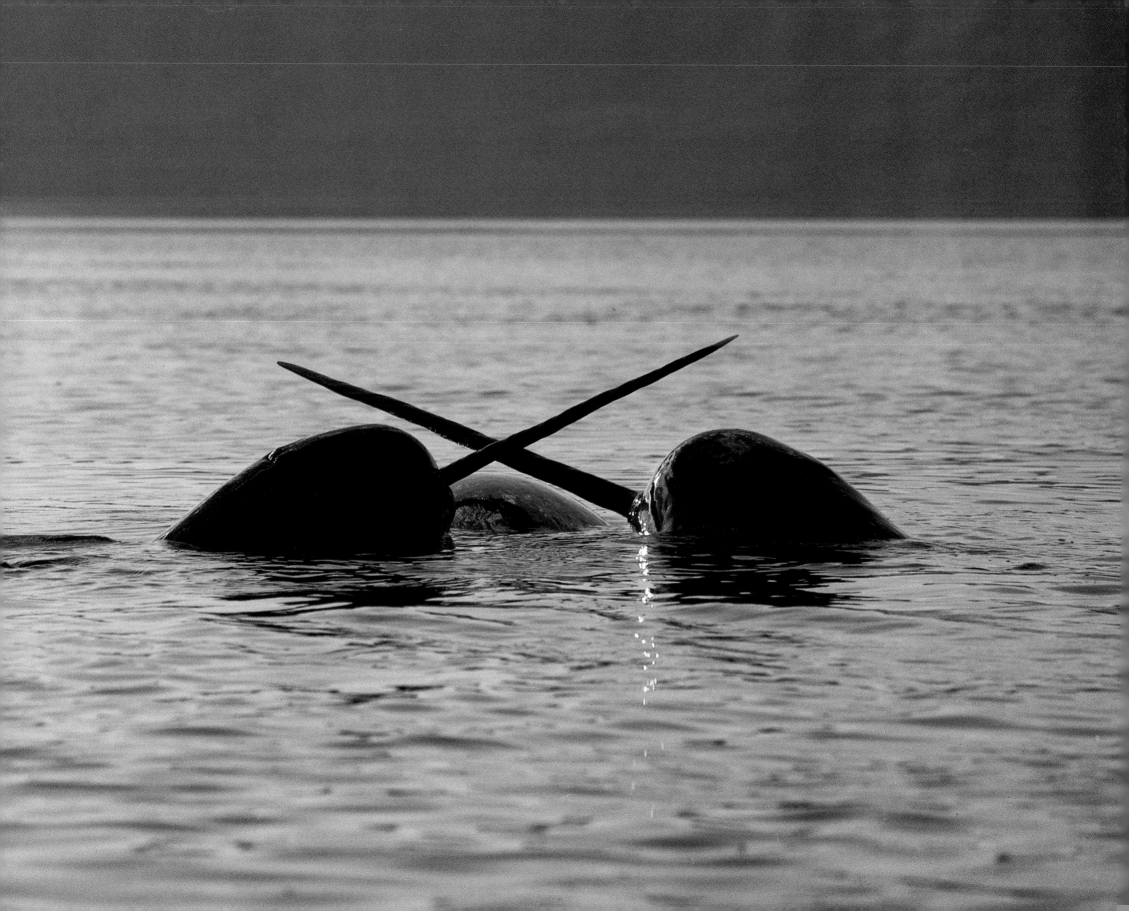

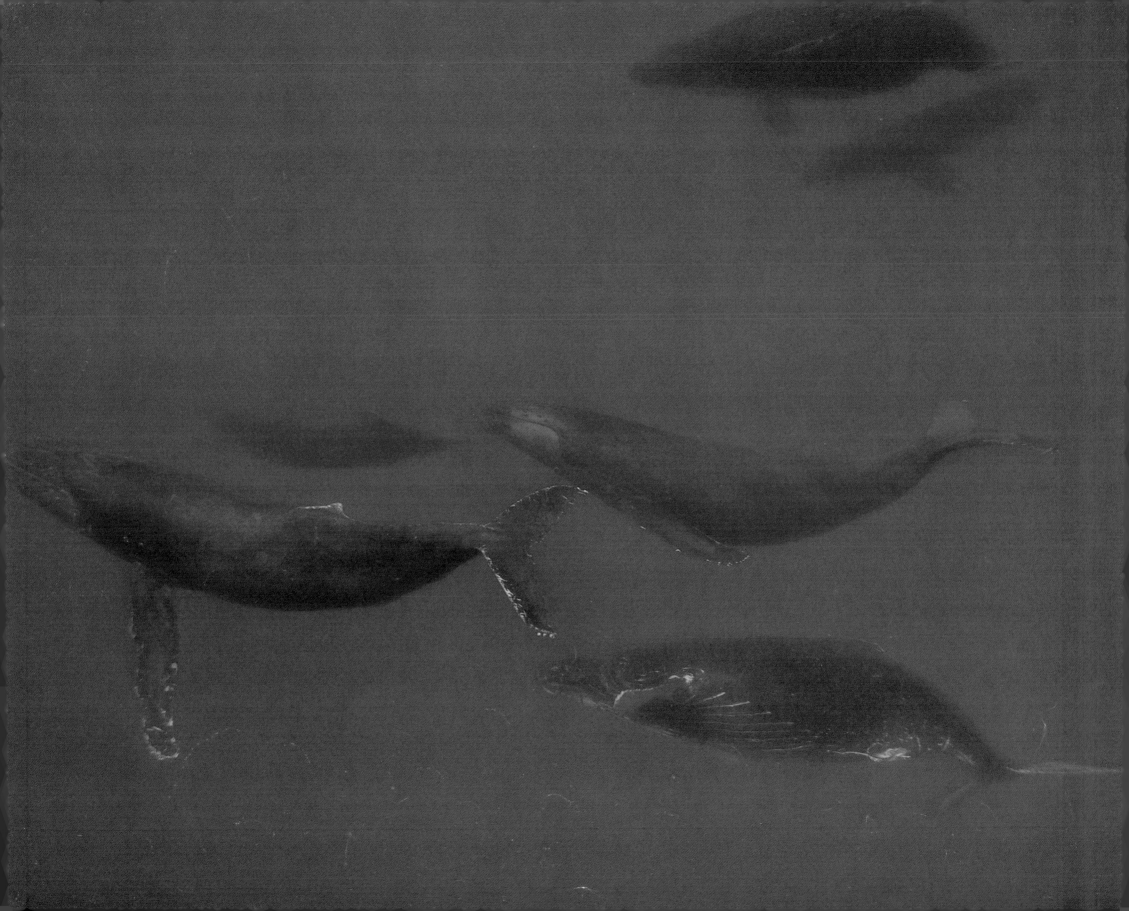

Humpbacks are not always gentle giants. When males compete for a female, they can be quite aggressive. I've sometimes seen a dozen anxious males colliding and battling underwater.

dominant or strongest male wins and mates with the female. Humpbacks appear to establish a dominance rank by display, their songs, and fighting. The humpback whale mating season may not be unlike the rut of many hoofed animals. Two rival bighorn sheep locking horns high in the Rockies and two humpbacks charging at each other off Maui have a lot in common.

If we treat whales as typical mammals, we would not expect the same mating behavior to occur in each species. Mating behavior is governed by the dispersal of females, which is governed by feeding strategy. Since the various whales follow a variety of different feeding strategies, their distribution varies accordingly. We should see different mating patterns and we do.

Steve Swartz and Mary Lou Jones spent over five hundred hours watching gray whale mating behavior from a tower on the shore above the entrance to San Ignacio Lagoon in Baja Mexico. "Nobody excludes anyone else," says Steve. This seems to be the key to gray whale mating behavior. Swartz and Jones saw no fighting between males. Even with up to eighteen animals in a group, there was little conflict. By counting heads, or the whales' penises, they were certain that groups had more than one male and more than one female. It was clearly promiscuous breeding. Females were repeatedly seen copulating with more than one male during the same mating bout. "The males seem to be taking turns," Swartz concluded, and explained that "sperm competition" can account for the gray whale's behavior.

Instead of overt fighting by males to win access to a female, such as in humpback whales, the real competition occurs after copulation. The male with the largest testes, producing the largest amount of sperm, dilutes and displaces the sperm of rival males and becomes the successful mate. This type of sperm competition occurs in other mammals as well.

Sperm competition also seems to be of paramount importance in the right whale. According to Roger Payne, the relative testes size in right whales, weighing literally a metric ton, implies incredible sperm competition. Since a female will mate with a series of males, each mating male has to remove what was contributed by the previous male and replace it with his own sperm.

Groups of two to a dozen males will form around a female right whale. Roger Payne suggests a level of cooperation rather than competition may occur in these mating groups. A lone male, he believes, cannot mate with an uncooperative female; she simply keeps her back to him. However, if more than one male is involved, the chances of any one male succeeding in mating with a female are much greater. A lone male's chances are essentially zero, but if he is with a group he at least has a chance. No matter which way the female rolls, a male is present. When this male "cooperation" is combined with female choice, testes size, and the value of mating last in a series of males, the complexity of right whale reproduction becomes apparent.

Scott Kraus' description of North Atlantic right whales is apt: "Females initiate all these surface active groups. They lie on their backs and call. We see males coming in from miles away. They travel at a speed of eight knots for five miles to join a courtship group. They are traveling a long way to get into the action. By the time they arrive, they are ready to mate. The female is lying there, everything exposed and out of the males' way. The males are all around her, pushing and shoving, trying to be the closest to her so when she rolls over to get a breath of air, the nearest one can get to her and copulate."

We actually know little about mating behavior in baleen whales, but we know even less about toothed whales. Since most toothed whales do not migrate to winter mating and calving areas, researchers must rely on opportunistic observations to piece together mating behavior patterns. It's tough detective work, but we have destroyed a few myths, such as the stories of giant male sperm whales battling with each other and defending harems of females.

"Rubbish," says Hal Whitehead, having studied sperm whales for weeks at a time off the Galapagos Islands. He observed males

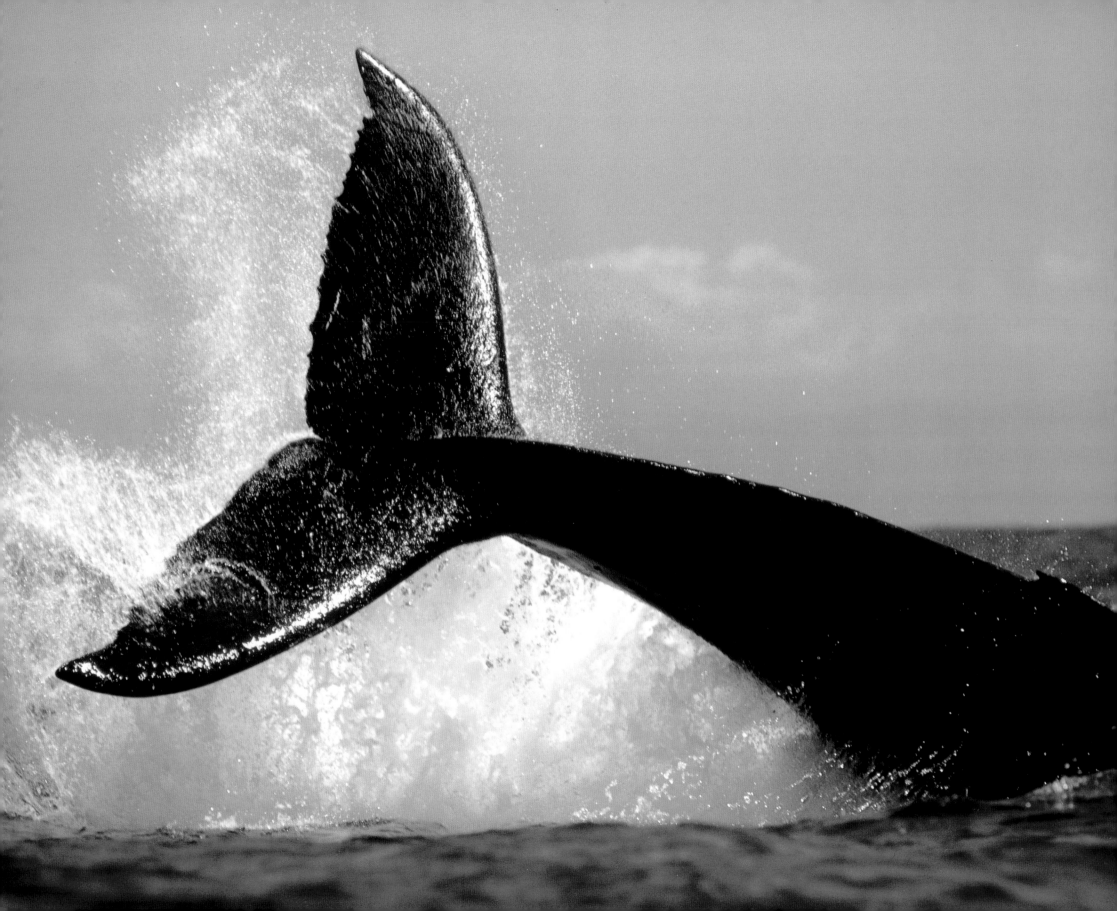

HUMPBACK TAIL LASH

HUMPBACK TAIL LASH

Violent tail lashes (left) are part of surface active groups battling for a female. Male humpbacks chasing a female provide a wild sight.

HUMPBACK FLIPPER SLAP

The flipper slap (right) of a male humpback whale is typical behavior of the surface active battle.

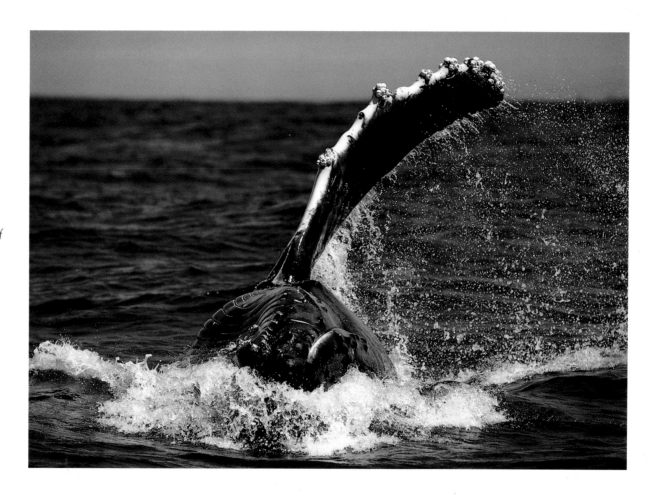

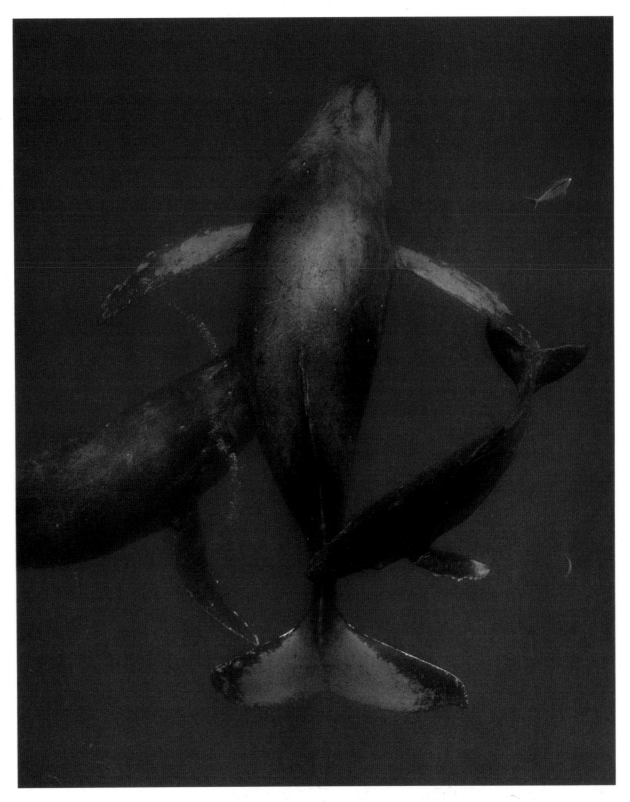

HUMPBACK INTERACTION

While taking these photographs, I saw a female with a calf underneath her. Another large humpback (escorts are males) swam under the cow and the calf moved above the female. The male started blowing bubbles. The cow and the other whale swam off with the male blowing bubbles the whole time. The calf came to the surface for about ten minutes and then the other two returned. The two large whales swam synchronously as the calf was left to follow.

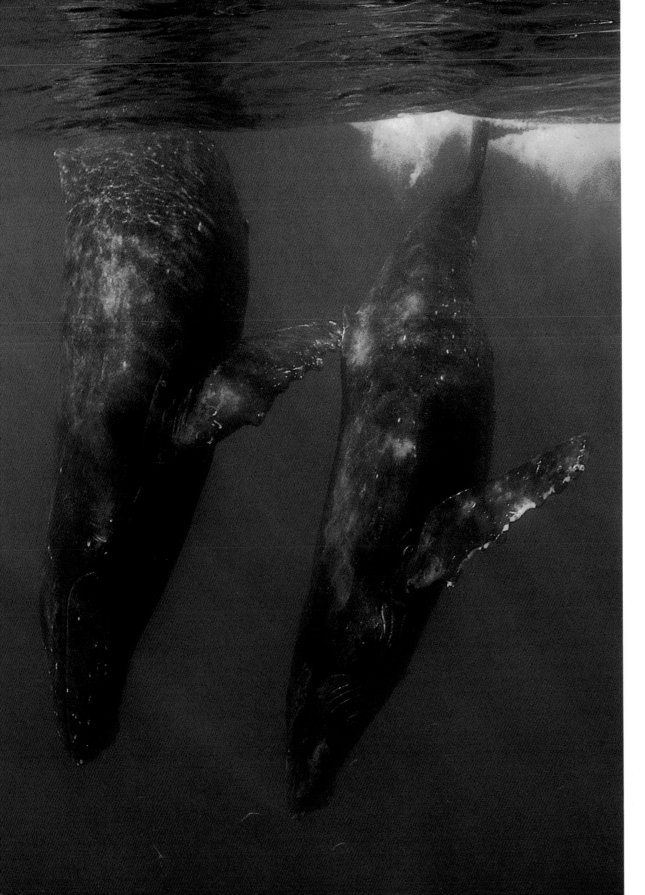
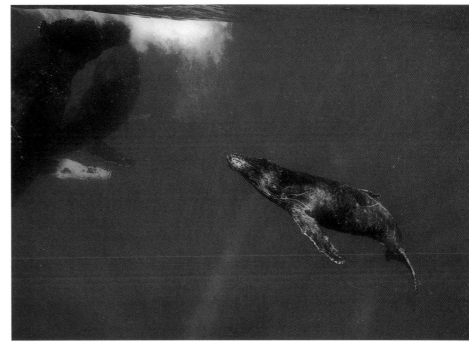

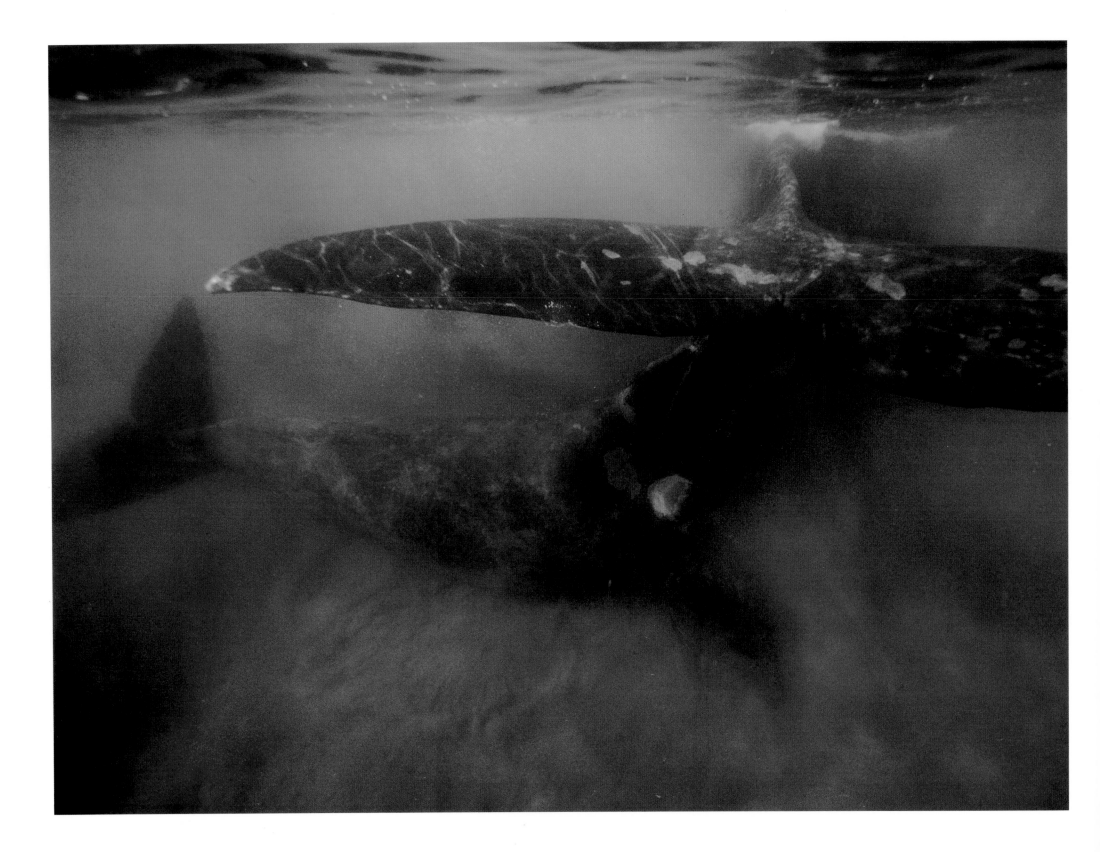

When a small calf got in the way of mating right whales, as it attempted to stay close to its mother, the males actually pounded the calf into the sand.

associating with groups of females for only a few hours, then moving along to another group of females. Sometimes he saw two or three males with a group of females but never saw them fight. He believes the males were moving between the groups of females looking for an estrus female. If they found one, they would stick with her. If another male comes along then, in Whitehead's words, "all hell might break loose." He saw, though, "no real possession of females, and no defense of harems." It seemed "very similar to elephants," explains Whitehead.

These sperm whale observations seem to fit with the mating behavior of other toothed whales — males temporarily joining female groups in search of a female in estrus.

After spending eighteen years studying a dolphin population off Sarasota, Florida, Randy Wells feels the mating system of wild dolphins still defies full description, but he believes he is getting closer. Wells' dolphin society is made up of stable groups of related females and their young, bachelor groups, and small groups of mature males. Males are not involved with the rearing of the young. Males probably mate with multiple females in estrus. Males move frequently from one female school to another during the breeding season, searching for mating opportunities. Physical competition or sperm competition may occur.

Narwhals are a toothed whale with an obvious secondary sexual characteristic, the ten-foot-long tusk of the males. "They seem to live in segregated groups, the males separate from females and young," says John Ford, who has spent several summers watching them in the Arctic. He has watched narwhals jousting with their tusks, tapping them together in a ritualized manner. He feels the tusk may be partly a display and partly a weapon. The scarring on the heads of males suggest that they do sometimes actually fight, maybe just at breeding time. Considering the tusk as a secondary sexual characteristic, the increased body size of males over females, and the segregation of sexes, we can infer that the mating system involves dominance ranking among males and competition for access to estrus females, much like

in humpbacks.

We are only beginning to understand the mating behavior of whales. Of the seventy-seven species, only six have been mentioned here. The remainder, we now assume, have similar mating behavior patterns, but we have little first-hand knowledge to confirm that supposition. However, the progress to date has convinced us of one significant point: whale mating patterns are similar to those of land mammals we do know much more about.

RIGHT WHALE WRESTLING

Right whale males (right) have their own version of "thumb" or "wrist" wrestling. They do it with their tails. Rights attempt to wrap their tail stocks over the female's tail to control her while mating in the shallow waters of the lagoon. The tails do not move in slow motion. They whip about with almost unbelievable speed.

MATING RIGHT WHALES

When the water is cloudy, as it can be in the shallow Gulpho Nuevo of Argentina, it is necessary to get extremely close. Here (opposite page) it was exciting to be near three right whales involved in mating. A male can be seen with the female, while a second male awaits his chance in the distance.

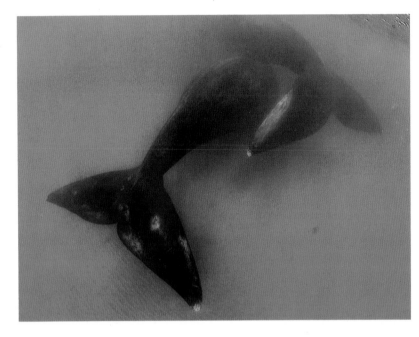

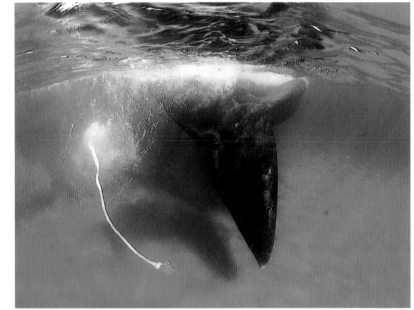

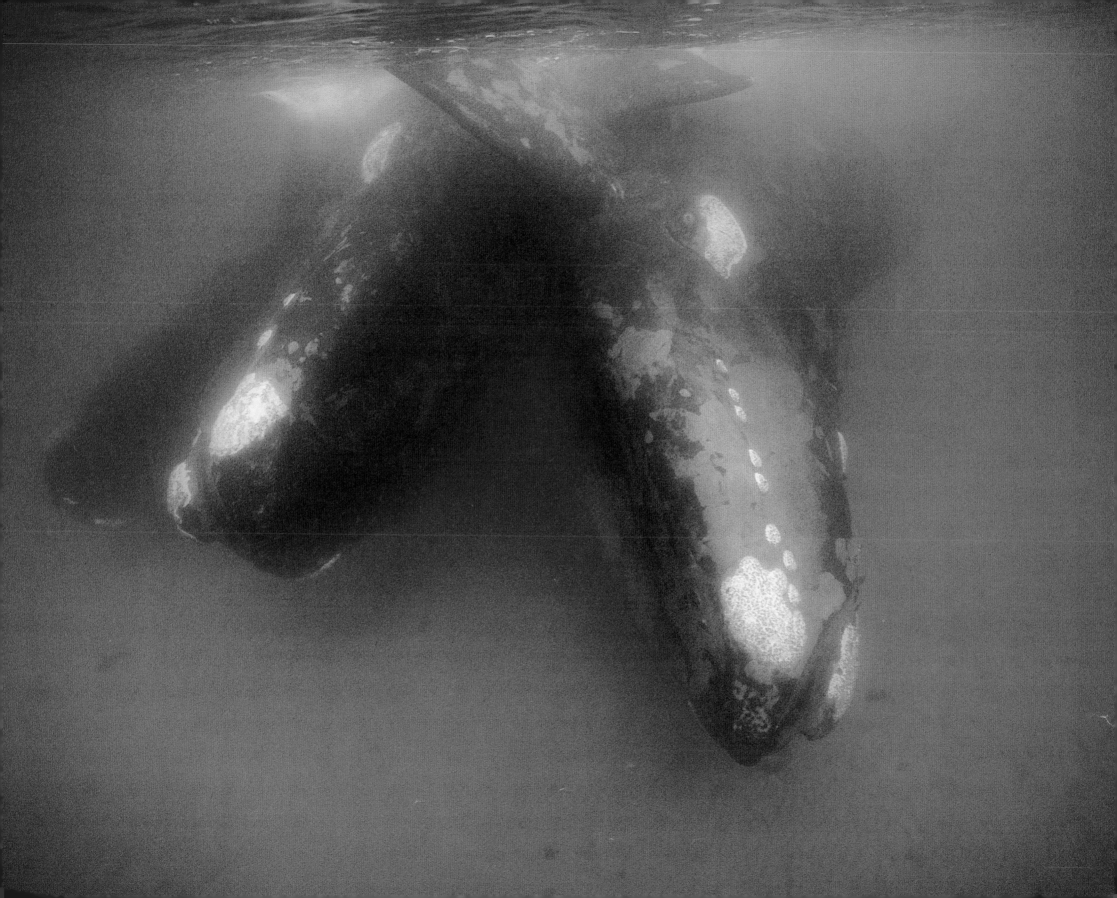

In Arctic Waters

For five hours, two male narwhals drove away dozens of other males. The pair was protecting a fatally injured female that was still desired by the male party of tusked narwhals. Rick Geissier paddled our kayak towards the fight scene, dropping me from the bow. We saw as many as five tusks break the water at the same time. It was wild. Underwater it was even more intense. I could see narwhals throwing body blows and raking their tusks across each other's backs. Pictures were hurriedly taken.

Suddenly, I saw one of the defending narwhals turn and swim toward me. His tusk pointed right at my chest. He stopped eighteen inches away. I could feel his sonic clicks. He stared at me for a moment then turned and swam back to his partner and the fighting.

When the action finally ended, seven hours had passed.

We had spent four months trying to get close to the creature that inspired the myth of the unicorn but had few photographic opportunities. Then on the last calm day at camp, we witnessed this long and curious battle.

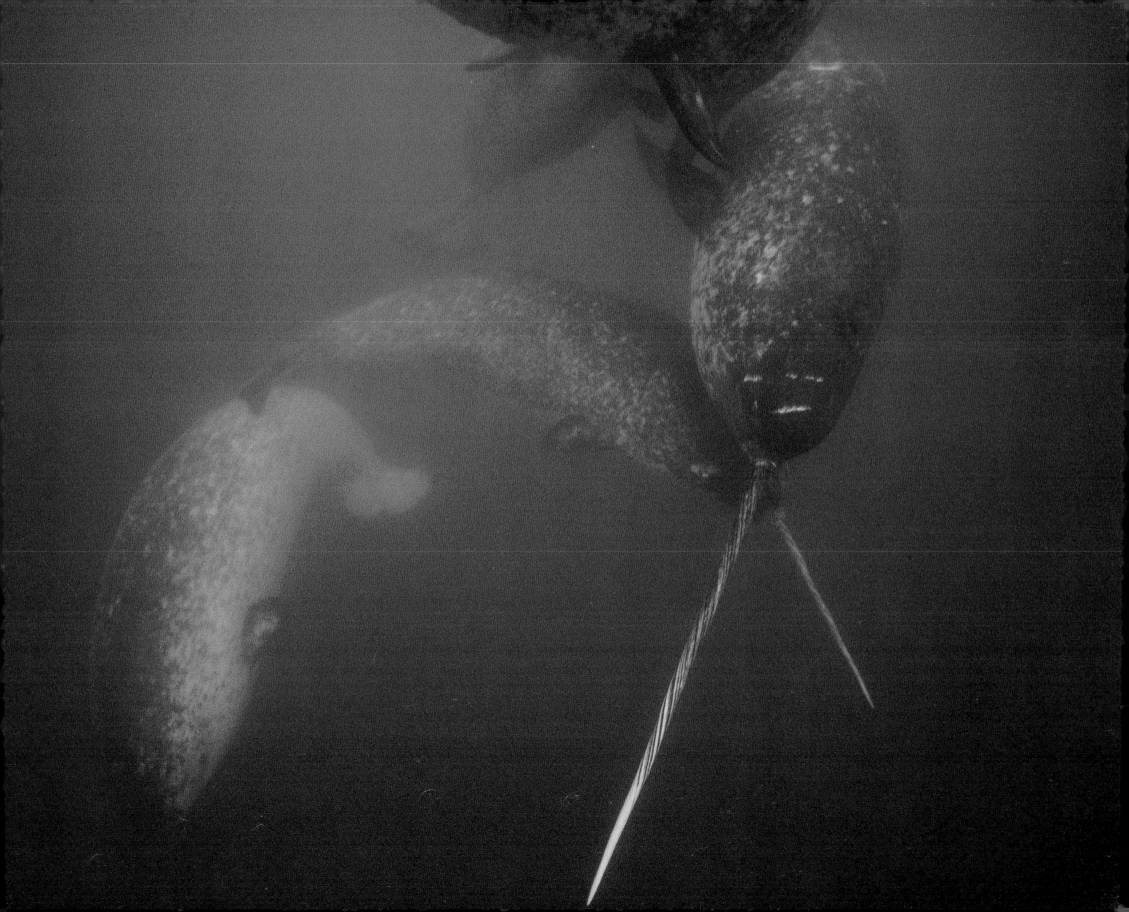

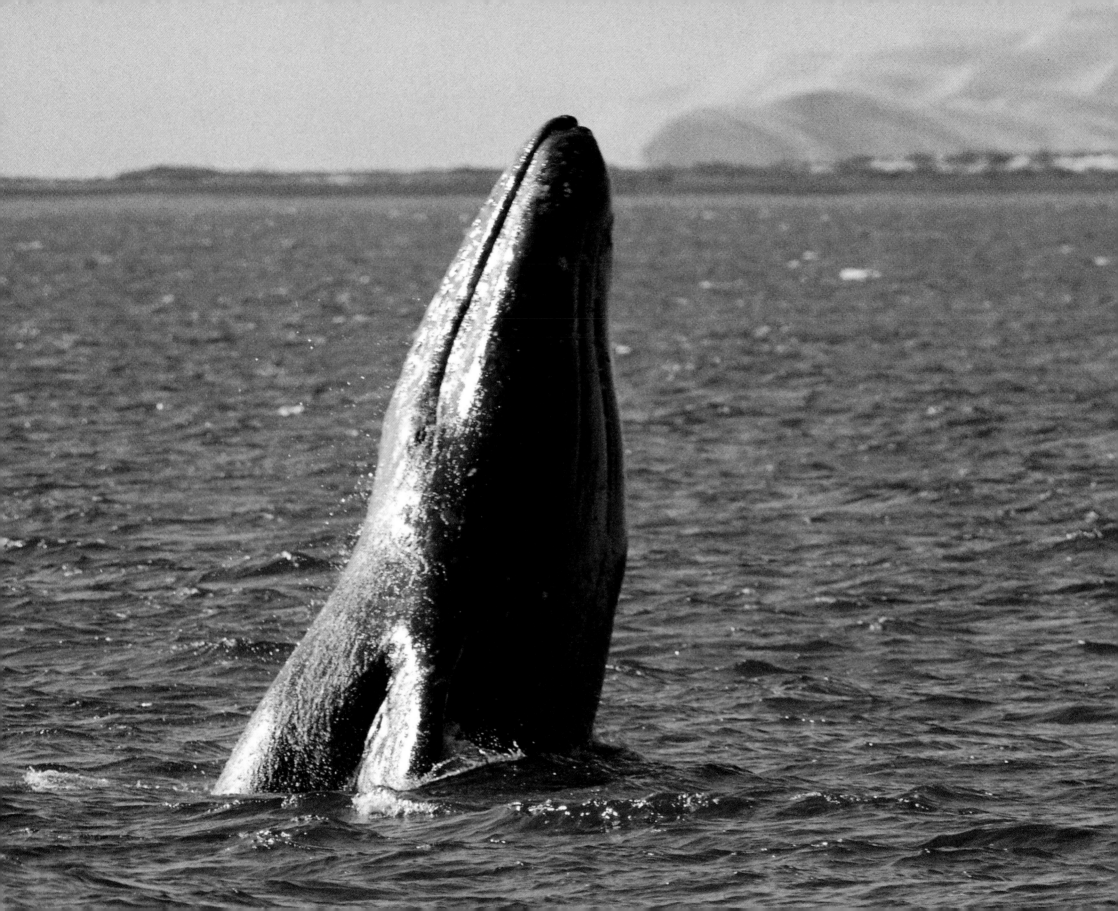

GRAY WHALE IN SAN IGNACIO
 LAGOON

Sometimes the whales come so close to the shore that researchers and photographers do not need a boat. There were dozens of whales in this small bay in Baja California. We watched mating groups and cows with newborn calves, observed and took photographs. We saw this gray whale execute a move that was somewhere between a spy-hop and a breach.

The Maternal Mandate

"It was September 20, 1980," remembers Jim Borrowman of Telegraph Cove, on the northeast corner of Vancouver Island:

"We'd been with the killer whales all day, a good twenty animals, the A4 and A5 pods. We went down by the rubbing beaches, through Robson Bight, and worked our way back up the Vancouver Island shoreline. Suddenly we saw this slapping and splashing. It looked a little bit out of the ordinary. As we got closer, we could see a female's tail come out of the water with what we thought was kelp. We quickly realized it was a baby whale hanging out of the mother. We were watching a whale being born. The baby came out with its dorsal fin bent over on its back.

"Immediately all the members of the pod took turns in trying to push the whale up so it would breathe. About fifteen minutes after the whale was born, the baby got flipped quite close to shore and it got into the kelp bed. It was in very shallow water and it got upside down and couldn't right itself. Just as we began to wade in the water to turn it over, it managed to right itself without our help and swam into a little deeper water. The mother came in and managed to get underneath it and gave it a good flip out to deeper water. From then on, it was easy street. The pod members spent some time keeping the animal buoyed above the surface; I guess they were teaching it how to breathe."

Few scientists have observed births of wild whales. Hal Whitehead and Linda Weilgart were lucky. In October, 1983, they were off Trincomalee, Sri Lanka. They were sitting one morning in their sailboat's cockpit, trying to wake up with their morning tea. They saw a whale about two hundred yards away. It stuck its head and flukes out, then its back, like it was flexing. They watched it roll on its side. Then there was a gush of blood and suddenly a black object appeared. It was a baby.

"It happened so quickly," Hal recalls, "and with such ease. It was alone for awhile but very soon afterwards other whales showed up and started jostling the calf. The calf was actually being pushed around by several adults. Some would lift it out of the water and let it slide off their heads while another would push in front of it. It was really extraordinary," Whitehead concluded, "like bouncing the baby in the air or something to get it to breathe."

These are two rare eyewitness accounts of the birth of a whale in the wild. Even in calving areas with many whales congregated, a birth is virtually never seen. Most of my experience with calves has been after the infant stage.

Each calf is different. While some are intensely curious and even brave when their mother is nearby, others are very shy, keeping their distance at all times. Still others are very nervous and can be severely frightened by an unexpected sound or action. One can easily see similarities to other young mammals, including young humans, in whale calves.

Toothed whales and baleen whales follow different strategies for raising offspring. In general the toothed whales have fewer young but nurture the young for a longer time. Baleen whales give birth more often, but wean their young relatively quickly. As an example of Baleen whales, humpback females may have their first calf when about five years old. "She conceived at the age of four and had her first calf at the age of five," says Carol Carlson about Beltain, a well-known humpback from the Gulf of Maine. It was identified at birth and then spotted and identified each year until it gave birth in its fifth year. Humpbacks may produce a number of calves very quickly. "Spot," observed in southeast Alaska and Hawaii, by Dan McSweeney, had a new calf every summer for four years in a row. "Daisy" had a new calf in six of eight years, according to Debbie Glockner-Ferrari, who has noted an average birthing cycle for Hawaiian humpbacks once every two years. But we don't know when humpback females stop breeding, and we have only very general estimates of the longevity of the animals — forty to seventy years.

In contrast to humpbacks, killer whales, as example of toothed

THE CAMERA CALF

The curiosity of some whale calves is often amusing. Here a young humpback pauses to consider the camera and the camera holder. The mother was gently protective. When its baby strayed too close to us, she would swim under the calf, pick it up on her back and swim a distance away.

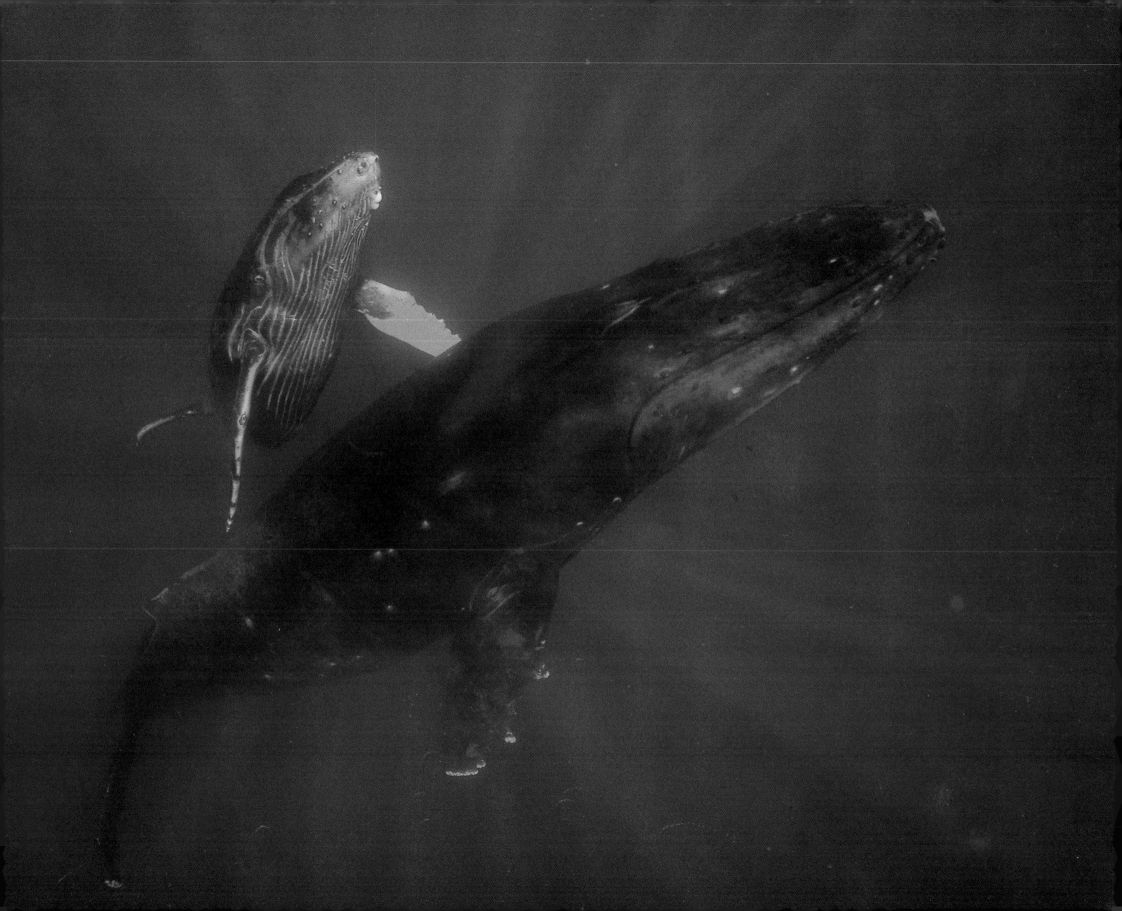

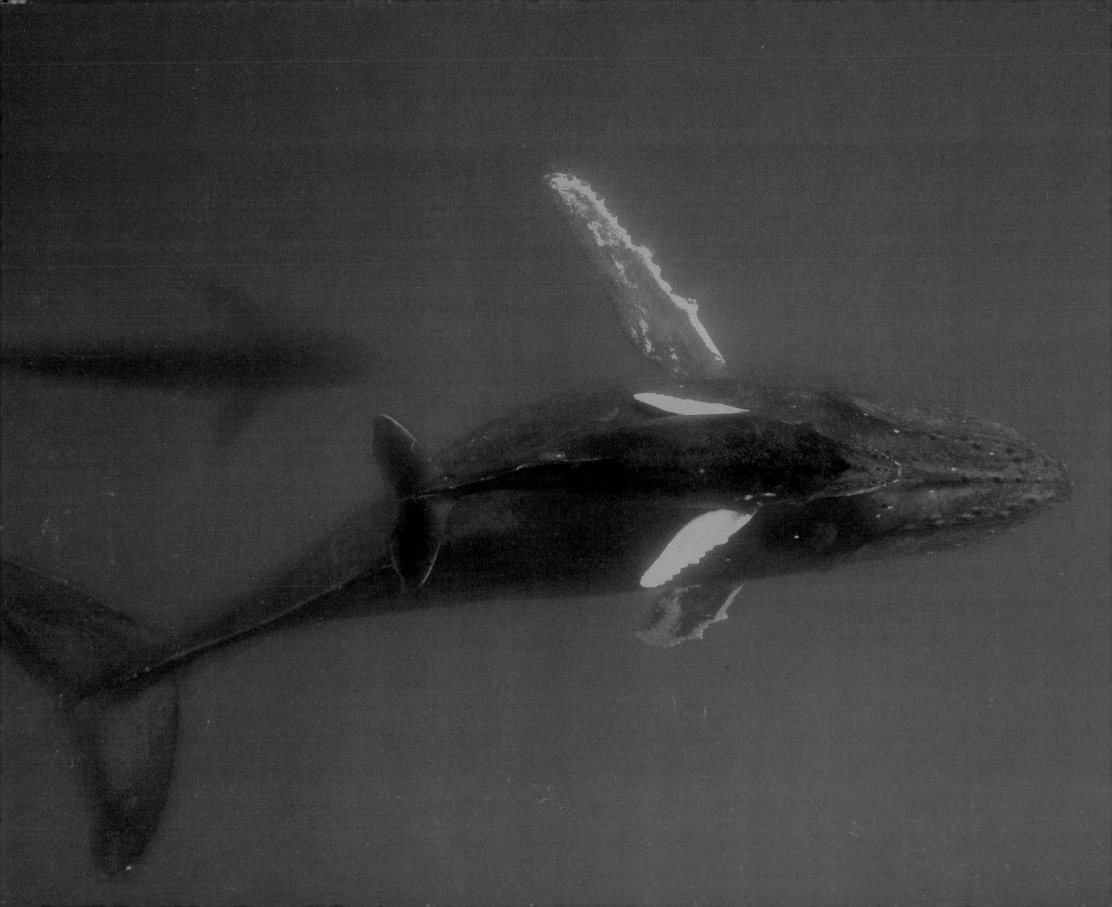

Mother whales often "carry" their young with them as they travel. This humpback is creating a pressure wave as she swims, and the young calf is effortlessly taking a ride. Very young calves do not swim much faster than a human diver with swimfins. However, they learn early in life that hitching a ride on the pressure wave permits them to stay up with the adult whales.

whales, do not start breeding until their mid-teens, according to Mike Bigg. Most start around age twelve and end around eighteen. After that, on the average, a female will have a calf every four years, until they are about thirty. After they are thirty, their birth rate declines. At about forty-five years of age, they stop breeding. Females live in the sixty-year to seventy-year range, with some living to be one hundred. Resident killer whale offspring, both male and female, stay with their mothers throughout their lives. Killer whales are unusual in this regard. Most toothed whale male offspring appear to leave their mothers upon maturity.

Some insights into mother-young behavior in toothed whales are generated from bottlenose dolphin communities, where the calf is born into a nursery school composed largely of related females. Randy Wells has noted that females with newborn calves associate with each other more than with other females in the group. Females with young often swim together. The nursery school appears to provide a protected environment within which early development and learning occur. While traveling, the mothers in these subgroups will form "play pens" by positioning themselves in U-shapes or L-shapes. In the center of these open areas created by the mothers will be two or three calves rubbing and playing with each other. Eventually, according to Wells, the calves will sort themselves out and reunite with their mothers. A type of baby-sitting behavior may occur in these groups. From time to time one female will take more than one calf, allowing the mother to feed or interact with others in the school.

Bottlenose dolphin calves spend a lot of time with their mothers. Weaning typically occurs at eighteen to twenty months, however. The minimum association in the wild appears to last three years, but often it is three to six years and sometimes as long as ten years. This time beyond weaning is probably used for learning.

After several years in the nursery school, the immature males leave to form bachelor schools. Young females usually remain within their mothers' group, but occasionally will swim with groups of males. As they begin to raise their own calves, they will become regular members of a female-young group.

This is a generalized, toothed whale pattern. Evidence suggests that sperm whales, belugas, and narwhals follow patterns similar to dolphins. Pilot whale young and killer whale young, both male and female, apparently stay with the mother's group much longer than young dolphins do with their maternal group, and in some cases permanently.

The extended period of close association between mother and calf suggests that the bond is based on more than simply the nutritional needs of the calf. Led by Ken Norris, a number of researchers over recent years have discussed the importance of learning for toothed whales. Norris says, "Many, if not most, of the activities of every day dolphin life appear to have a learned component. The three year or longer time period of the mother-calf bond is most likely the time when calves learn to refine their knowledge of such things as echolocation, other individual and group feeding techniques, recognition of the hundred or so other community members, home-range features and limits, recognition of adjacent communities, resource distribution, predator avoidance, patterns of social interaction, and sensory integration with other school members."

In marked contrast to the toothed whales, the calves of baleen whales essentially separate from their mother in a year or less, although there may be some continuing geographic association. Gray whales leave their young alone at six or seven months while in their summer feeding grounds. Humpbacks and right whale calves stay with their mothers only for the first year and full migratory cycle. For the baleen whales, then, the first months are very critical to the survival of the young. For example, right whale calves, born in the winter, will stay in the shallow waters of the nursery for a few months before migrating with their mothers to the deeper ocean feeding grounds. With their mothers, some will return as yearlings in the same group and then

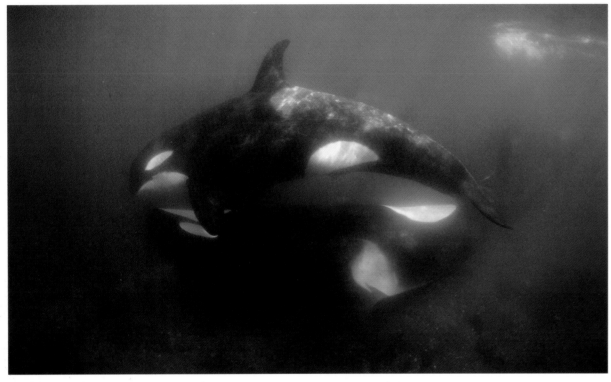

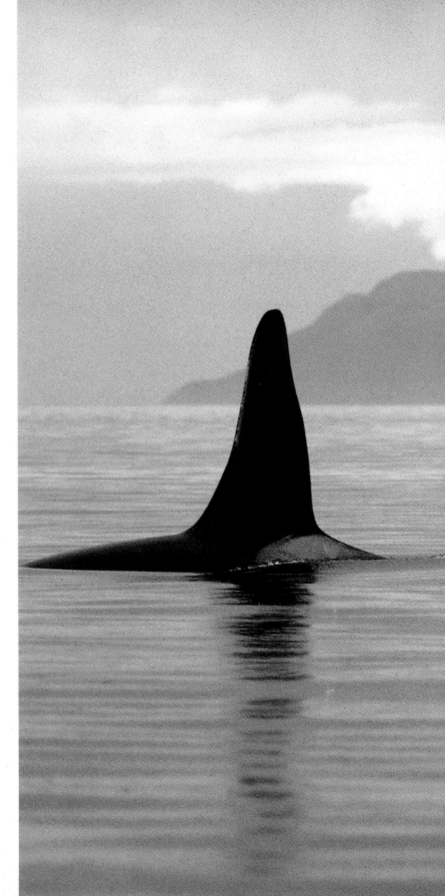

SIBLINGS AT RUBBING BEACH

Rubbing beaches (left) can be a playground. These active siblings belong to pod A-5, of British Columbia's Johnstone Straits. Young killer whales spend a considerable amount of time apparently playing together.

YOUNG KILLER WITH ADULT MALE

Off the coast of Alaska a young killer whale (right) travels close to an adult male. These are both resident whales of the same pod.

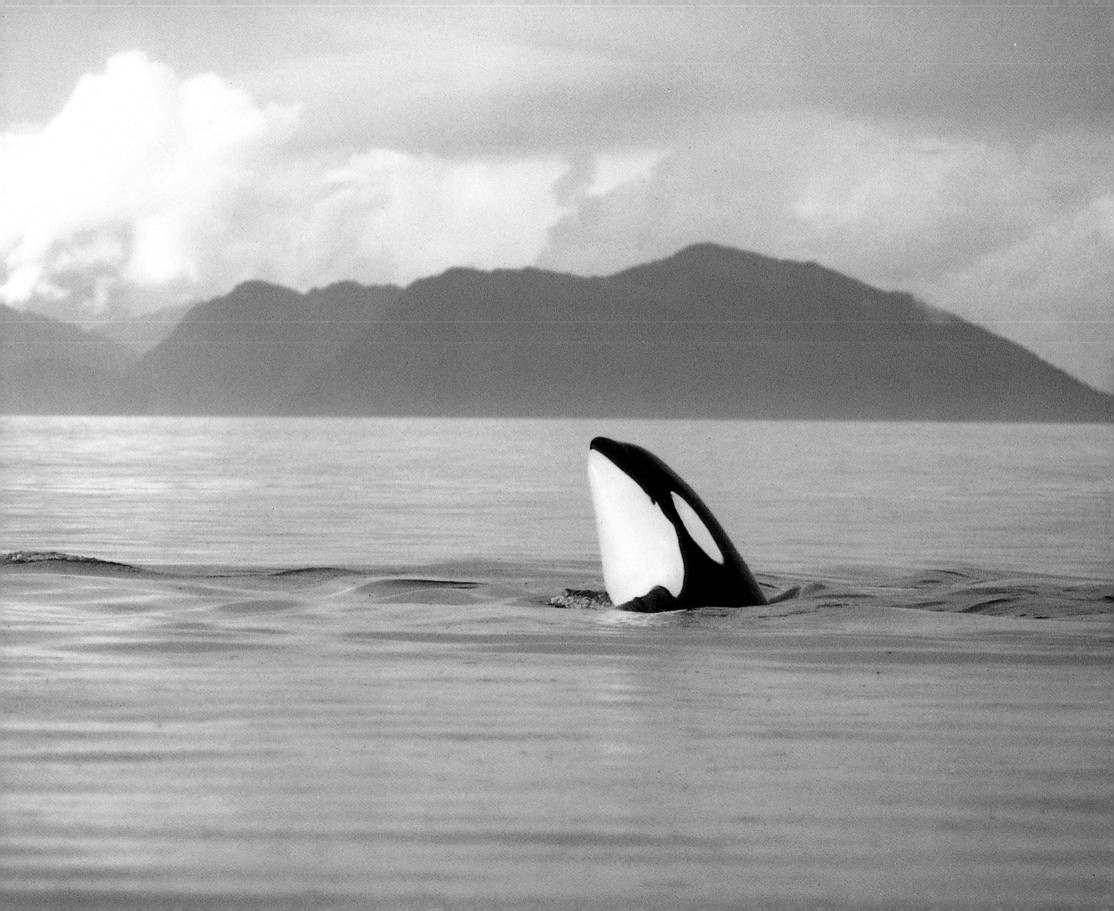

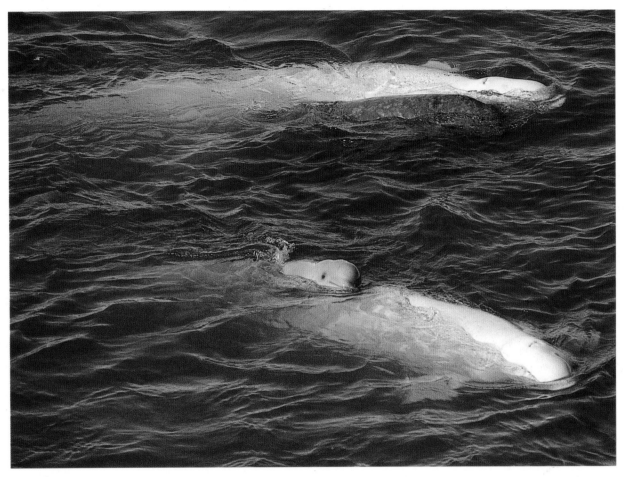

BABY BELUGA CLINGS TO MOTHER

Young belugas (left) cling to the backs of their mothers in the estuaries of Canada's Borden Peninsula. Beluga young change color as they mature.

BELUGA NURSERY

Looking at this large nursery of beluga whales (right), it can be observed that there are calves of various sizes and ages. This means that belugas conceive and give birth at varying times of the year, not in one particular season.

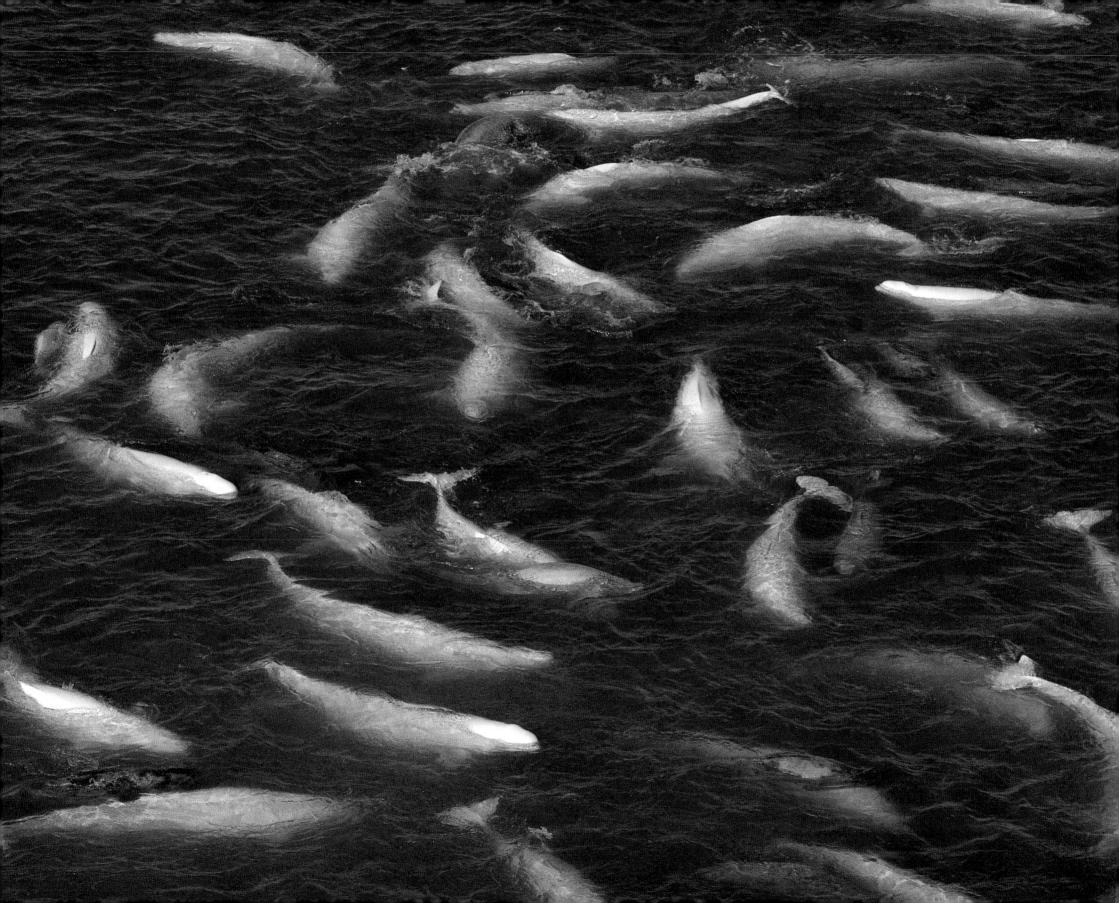

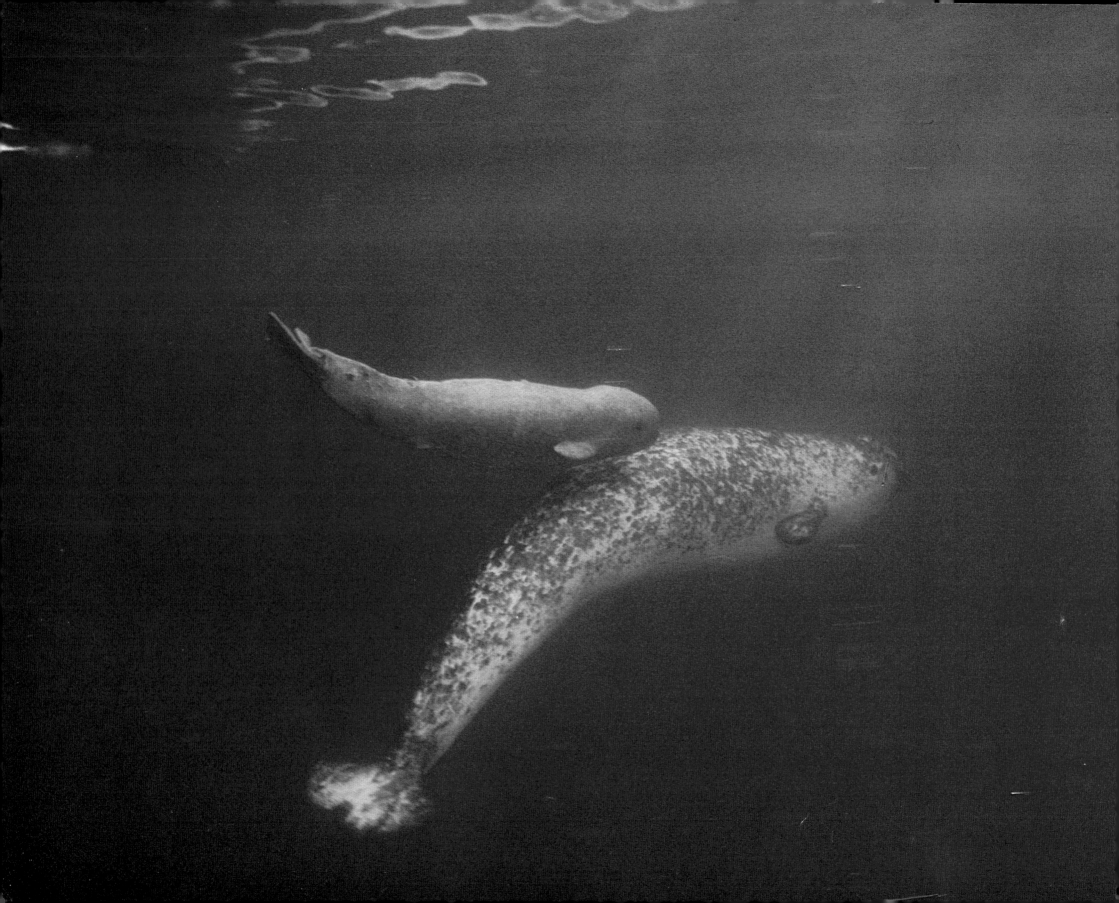

Newborn calves need their mother's help to swim. Here a newborn narwhal travels with its mother in Canada's Kaluctoo Bay. Between the time I first spied the newborn and put on my drysuit and snorkeling gear, and swam out to the drifting whale, it had already gained strength and grace. Its mother watched below. In a very short time, the calf was able to swim on its own, slowly, with its mother's constant guidance along the way.

separate permanently.

Peter Thomas and Sara Taber studied right whale mother-calf behavior on the Peninsula Valdes calving grounds. Travel was the predominant activity of both mothers and calves during the entire infant period. Play was the second most common calf activity. Thomas and Taber divided calf development into three basic periods. In the beginning, the calves are kept in constant motion by their mothers for about the first month of their lives. Thomas speculates "they are born too skinny to float. They have to be made to travel forward, just to keep their blowholes above the surface."

The second stage of calf development is devoted more to play. Thomas and Taber observed mothers trying to calm down overactive calves, perhaps to decrease the energy use by the calf and to lessen the mother's burden. Some mothers would roll over to quiet their young, holding their calves to their stomachs with their flippers.

The third stage of right whale calf development is what is called the premigratory stage. At this time, generally a week or so before migration takes place, there is a sudden change of behavior in the nursery area. There is a sharp decrease in play activities and resting and a greater emphasis on travel and coordinated movement between calf and mother in apparent preparation for the migration ahead.

Whale babies have much in common with all other mammal babies. Thomas and Taber watched one right whale mother roll belly up, apparently to avoid nursing. Her calf threw a tantrum. Opening and closing her mouth repeatedly, the calf rolled, and shinnied up on her mother, draping her body across the wrist of her mother's tail near the exposed nipples. Then the calf lunged onto its mother repeatedly, twenty-two times. She also rolled to bring the rough surface of her upper jaw against her mother's back. After twenty minutes of this, the mother rolled right side up, raised her tail, and the calf began to nurse, winning the battle of persistence.

Gulls are another problem right whale mothers guiding their babies through those first critical months must encounter. Gulls land on the backs of whales and peck painfully at their skin, usually harassing mothers with calves in shallow water. In areas with many resting whales, Peter Thomas has watched a gull fly off the beach and hover over one mother whale, land on her back, causing the mother to flinch and submerge. The gull would then go to the next whale and repeat the harassment. Thomas describes the result: "Where five minutes before you had calm, absolute tranquility, now you've got six disturbed mothers and calves just racing around. It would take fifteen or twenty minutes for them to settle down again, if they ever did. Some days it would go on long enough to force all the whales out of Whale Bay." Peter suspects reacting to these attacks could have a significant effect on the mother's energy conservation, and by driving them from shallow areas, increase their vulnerability to killer whale attacks.

Whatever challenges face them, whales appear to be among nature's most patient and protective mothers. The bond of mother and offspring is strong and more enduring than most animals. If we as a species could only leave whales and their ocean environment alone, we could stop worrying about their future.

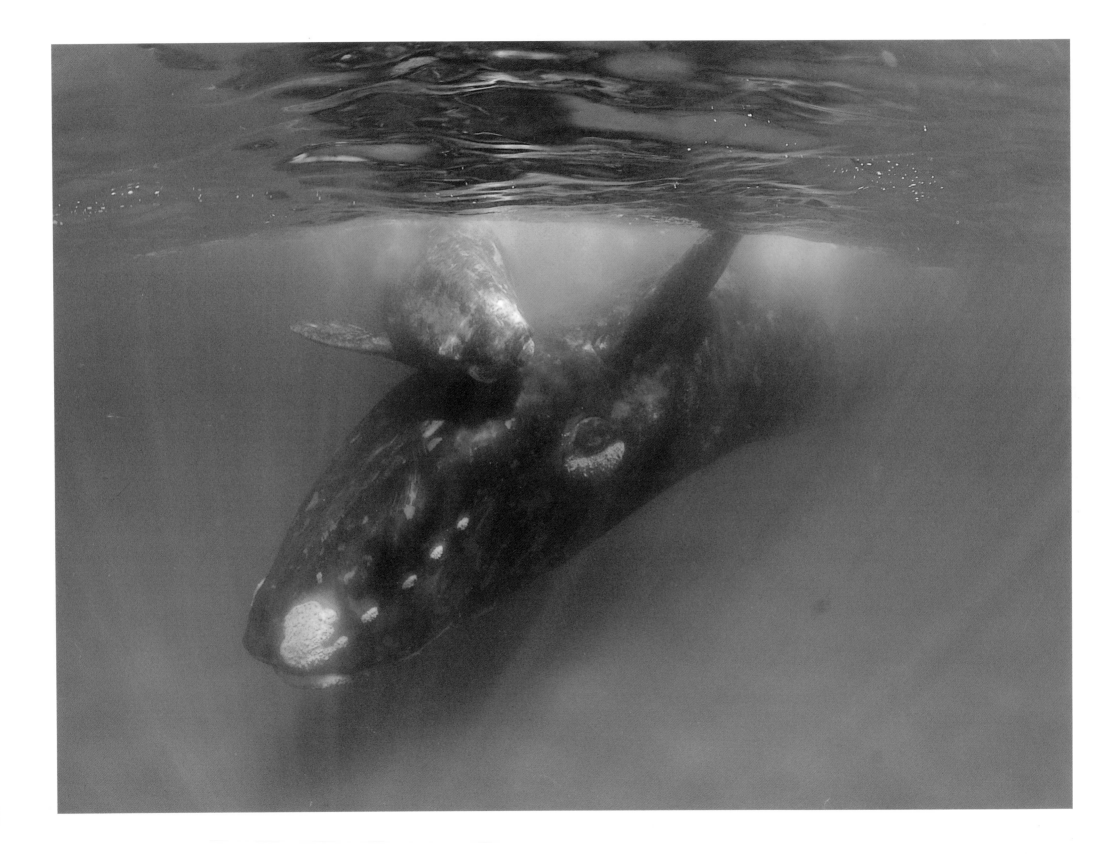

UPSIDE DOWN RIGHT WHALE CALF
AND MOTHER

Whale calves sometimes need to be
controlled or calmed down. Diana and
her baby (left) provide a picture of
mother-calf interaction.

TIME TO EAT

One baby whale (right) knew how to
let its mother know it was time to
wake up and feed a hungry infant:
cover up the mother's blowhole with its
tail. We also witnessed calves
delivering miniature tail slaps on their
mothers, as well as executing small
breaches on their mothers' backs.

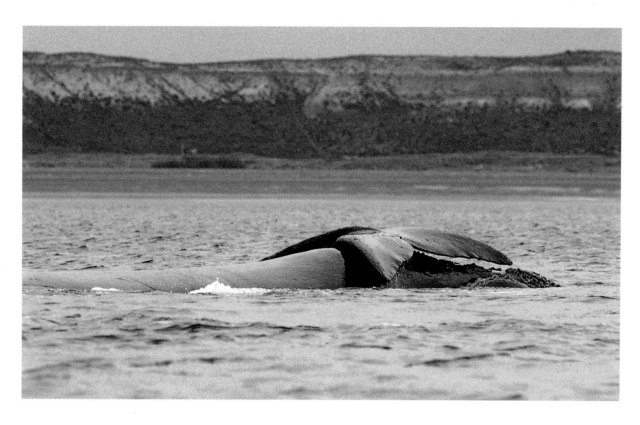

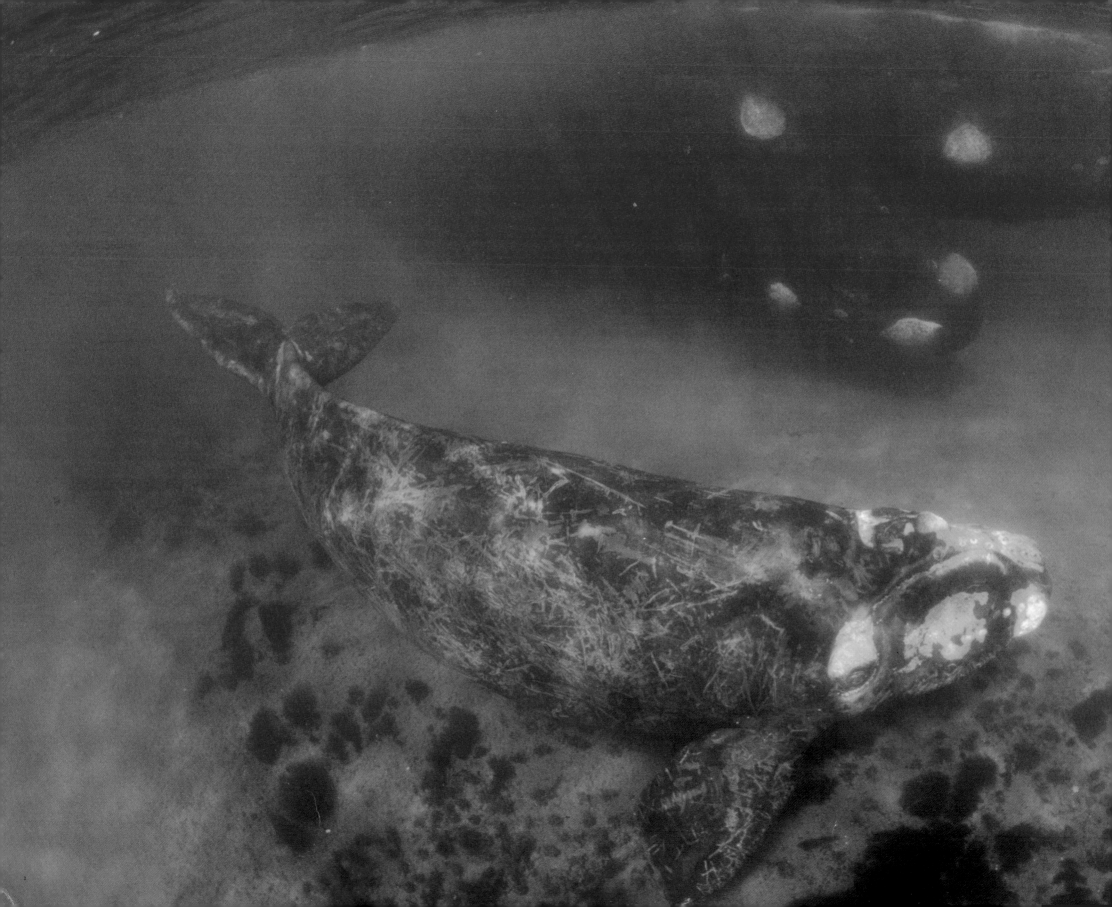

RIGHT WHALE CALF LEFT OUT

As calves grow and mating pressures increase, calves become scuffed by the tails and pectorals of their mothers and the courting males. Calves try to stay with their mothers but are forced away by the more powerful adult males. The calf stays close but becomes cautious around mating groups.

An Oceanic Language

The *Sophi*, a 35-foot wooden cruiser, was drifting through the Indian Ocean night, carried by the currents off the coast of Sri Lanka. I was standing watch alone, as everyone else aboard was sleeping below. It was calm and quiet. Against the dark horizon I could see the open, flickering fires on the decks of dozens of local fishing boats.

I heard what I first passed off to be a distant foghorn. But there was no fog, nor any passing ships. Then I heard the muted, eerie tone again. It reminded me of the lighthouse foghorn near my home on Vancouver Island. It was impossible to determine its source until I realized it was emanating from the sea. Blue whales were calling to one another.

Since the late 1940s, the calls of many species of whales including those of the blue whale have been described and recorded. Whale researchers now recognize the canary-like "chirps" of belugas, the "clicks" of sperm whales, the "moos" of bowheads, "groans" of right whales and the cacophony of sounds made by humpbacks on their mating grounds. Describing whale sounds is one thing; however, understanding the meaning and function of the sounds is quite another.

Whales use sounds for two general purposes. First, toothed whales use sound pulses for echolocation, primarily to locate prey. This use of sound has not been found in baleen whales.

In fact, there are other differences in the acoustic abilities of toothed and baleen whales. Sophisticated communication abilities probably developed along with the predatory strategies of tightly knit hunting societies of some toothed whales. Baleen whales, however, with their loose, herd-like groupings, generally require less sophisticated feeding strategies, and should thus require different, if not less-sophisticated, communications systems.

The second way whales use sounds is to communicate such things as the location of the caller, the state of excitement, disturbance or alarm of the caller, the physical condition of the caller, the identity of the caller or the group it belongs to, and the identity of the whale being called. If there are more complex communications occurring when whales call, they are not yet understood by cetologists.

Humpback whale songs are probably the most famous, intriguing and least typical sounds made by whales. They are also the whale sounds I know best. First described by Roger Payne and Scott McVay in 1971, the basic characteristics of the song have been clearly defined, thanks to nearly two decades of intensive study.

The songs, approximately ten to fifteen minutes in duration, are sequences of sounds repeated over and over again. The song gradually changes or evolves in a fairly orderly manner as it is being sung. All the singers in a particular population sing basically the same version at any one time. Singing is a primary activity of humpbacks in their winter breeding grounds. It is heard occasionally in late summer and in fall in their feeding grounds.

The first step in my study included locating the singing whale and determining its sex. To determine the singer's sex, the whale had to be found underwater and its genital region photographed. It turned out that the typical singer was usually a lone adult male. When singing, the whale would be motionless, head down at about a forty-five degree angle, about fifty to seventy-five feet below the surface. The whale would sing for about ten to fifteen minutes, surface, take three or four breaths, then dive and return to the singing position. It might repeat this sequence for hours at a time.

After spending days watching the behavior patterns of individual singers, we discovered that whales sing until one of two situations arises — either a mating group moves into the vicinity and the singer rushes to join it, or a lone whale approaches and joins the singer. In the latter case the pair would usually split up again very quickly, sometimes after thrashing on the surface. After they separated, sometimes both would start singing. We also learned that the lone whales approaching singers were males.

These were the clues we had to determine the function of the song. It appeared to be a display, or a component of a display, produced by

SPERM WHALE HEAD

The sperm whale gets its name from the spermaceti organ which also gives the mammal its box-like cranial structure. Researchers believe that the head's shape aids in the whale's communication process. This docile whale paid me little attention, but I could hear sonic clicks. It was sunset, and I was out of film. I knew I could not reload and return before dark, so I swam alongside the sperm whale, next to its head. Its small, dark brown eye watched me. I reached out and touched the smooth, rubberlike skin. It did not object. This was the first wild whale I ever touched.

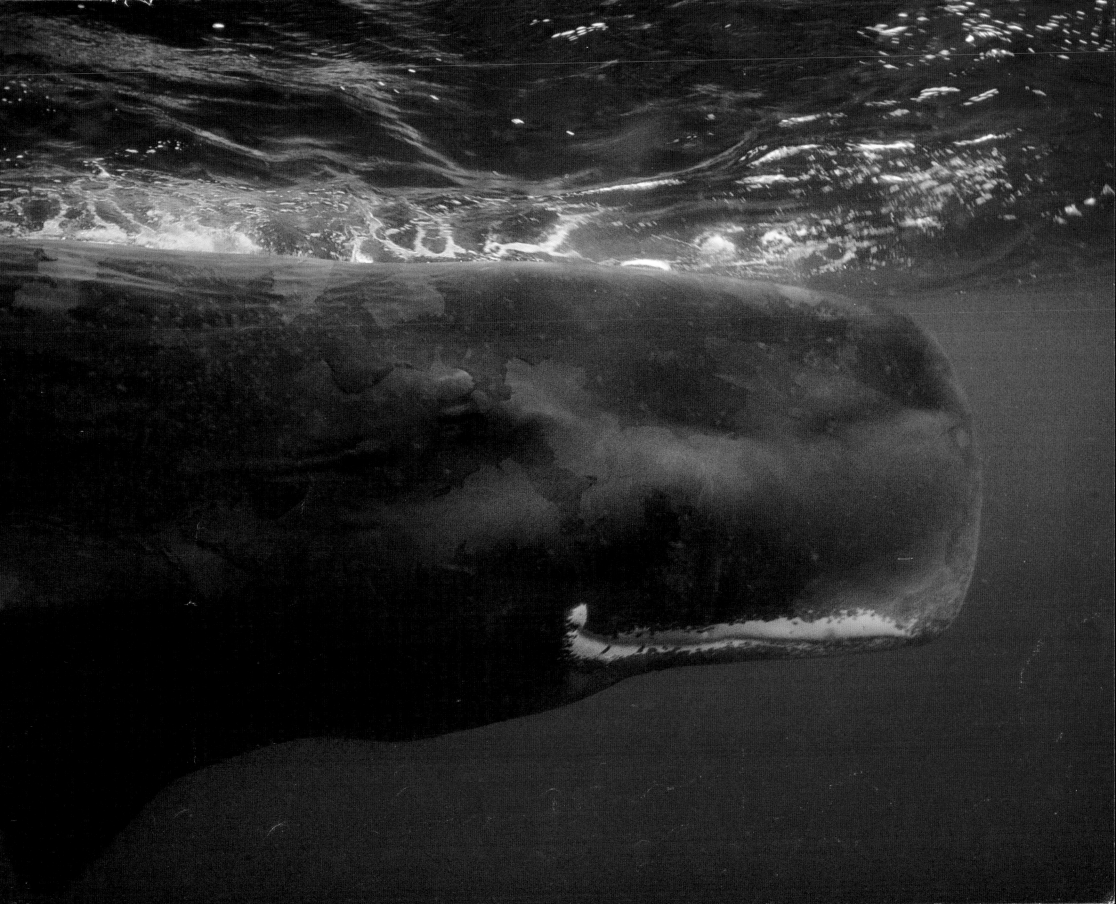

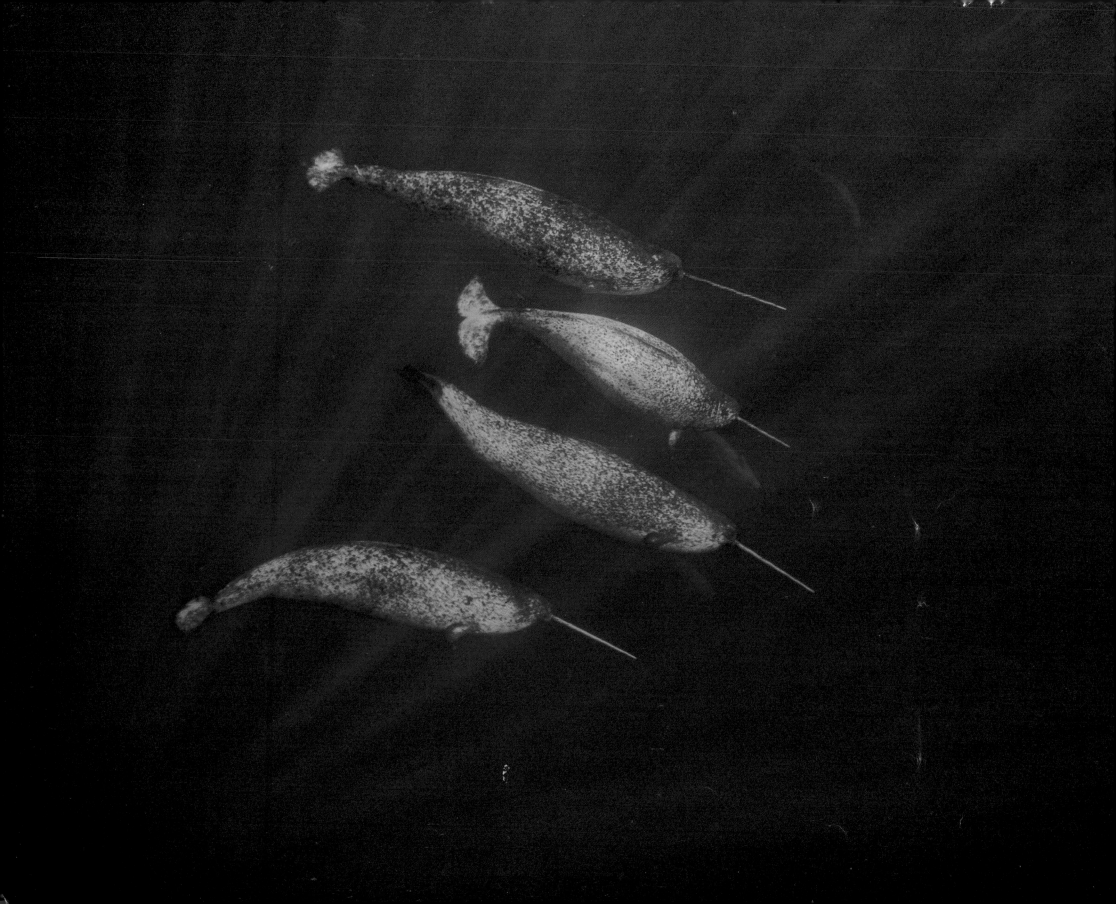

In three seasons of photographing narwhals on the ice edge, only once have I been close in clear water. I could actually hear the clicking of these four males long before they came into sight. They came within fifteen feet and vanished. Female narwhals are more curious.

males and directed toward other males, primarily in the breeding season.

For the longest time, I couldn't fit the characteristics of the behavior with any proposed function. Then one day I was idly looking at a picture of a bighorn mountain sheep, and the idea came to me: The humpback's song, like the horns or antlers of hoofed animals or even the tail feathers of a male peacock, could be a component of the male's display of physical prowess or dominance, an acoustic component rather than a visual one.

It could be that just as antlers or horns change through growth with the age of an ungulate, the song display of the humpback changes. Just as antlers or horns change in a recognizable pattern on individuals within a genetically mixing population so does an individual humpback's song. This hypothesis could account for some of the observations of singing humpbacks, but it also suggests that there should be differences in the songs of whales of different ages. Although there are differences, the details are not yet understood.

Most whale sounds relate to specific circumstances, similar to our own use of sounds. With years of whale research behind him, Chris Clark reflects on the complexity of whale vocalizations: "The more I listened and the more I watched, the greater the variety and the greater the richness in the repertoire of the sound was revealed; it was much more so than I ever anticipated." Clark conducted an extensive study of the sounds made by southern right whales in their winter grounds at Peninsula Valdes, Argentina. By conducting experiments where the recorded sounds of a whale are played back to the whale by an underwater speaker and studying sounds made in specific social and behavioral situations, he was able to demonstrate how these animals made a variety of sounds which could be correlated with the group's activity, size, and sexual composition.

Clark made important strides in isolating elements of the right whale's language. The low growling or moaning sounds are created through the blowhole and are essentially threats warning other animals of the whale's disturbed state. The long-moan blow sounds of resting whales indicate that the animal does not want to be disturbed. Another call, termed by Clark an "up call," is the most common sound made by the whale; it is a contact call that functions as a long distance signal that helps to bring the whales together. The opposite, a "down call," is a type of contact signal made by a moderately excited whale. It serves to keep whales in acoustic contact but does not bring whales into physical contact. Right whales also use a "high call" when interacting on the surface. As the level of surface activity increases, the number of high calls made by the group increases. High calls are indicative of a general level of excitement.

Two other calls, the "hybrid call" and a "pulsive call," are made almost exclusively by interacting groups and sexually active groups containing both males and females. Clark believes the high calls indicate excitement; hybrid and pulsive calls probably function as signals of aggression.

The research on communicative function is becoming even more interesting. Chris Clark has recently developed a system for remote tracking of individual bowhead whales by listening to their sounds. While he was monitoring one group of whales, he noticed that the lead, or "scout," whales increased their call rate as they got within a half kilometer of a massive ice floe. As they detoured around the ice, the whales following several kilometers behind them did not increase their calling but started to detour sooner. To Clark, it seemed as if they were listening to the scouts in front and getting some kind of signal that told them to adjust their course. According to Clark, we're just beginning to get glimpses of whales' abilities to communicate.

Our understanding of toothed whale communication is equally limited. As with baleen whales, research on just a few species has given us our best insights into the sophistication and function of the calls. The sounds of killer whales are some of the best understood.

In British Columbia, resident killer whales live in stable, extended

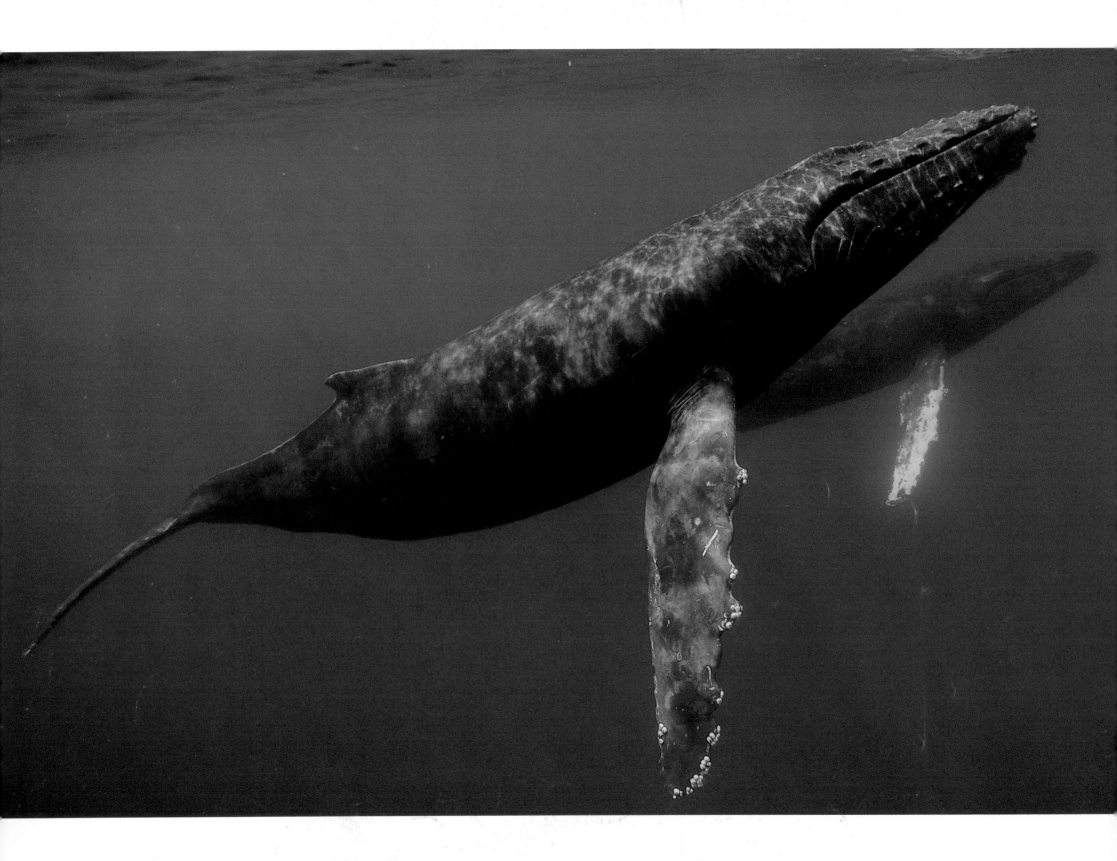

THE MUSIC OF THE SEA

Humpback whales make different
sounds in different situations. Surface
active groups (left) make a variety of
"social sounds." Singers (right) produce
the more recognizable humpback
"song." Sexing singers and determining
that they are indeed males was the first
work Jim Darling and I did together.

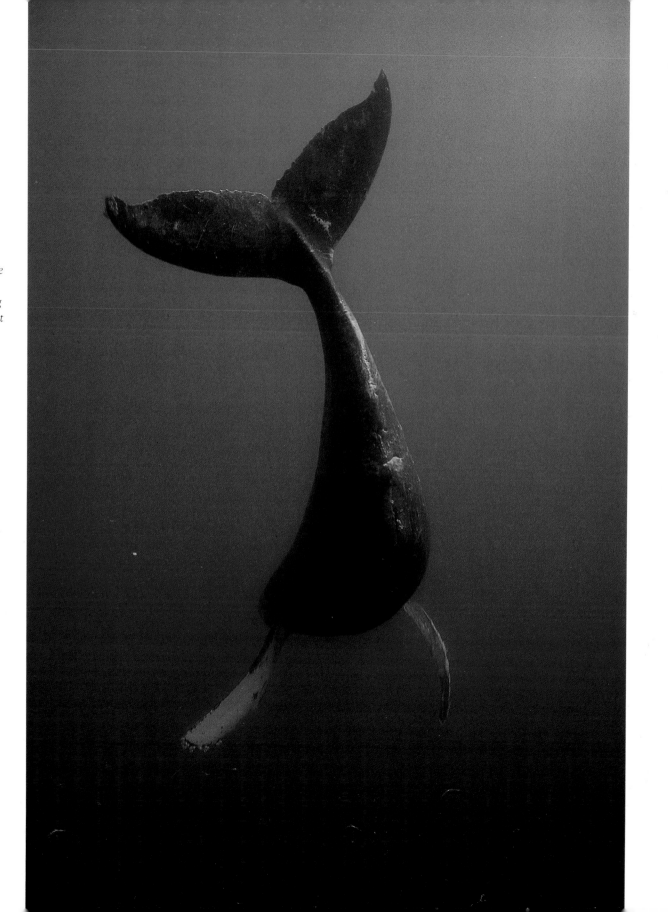

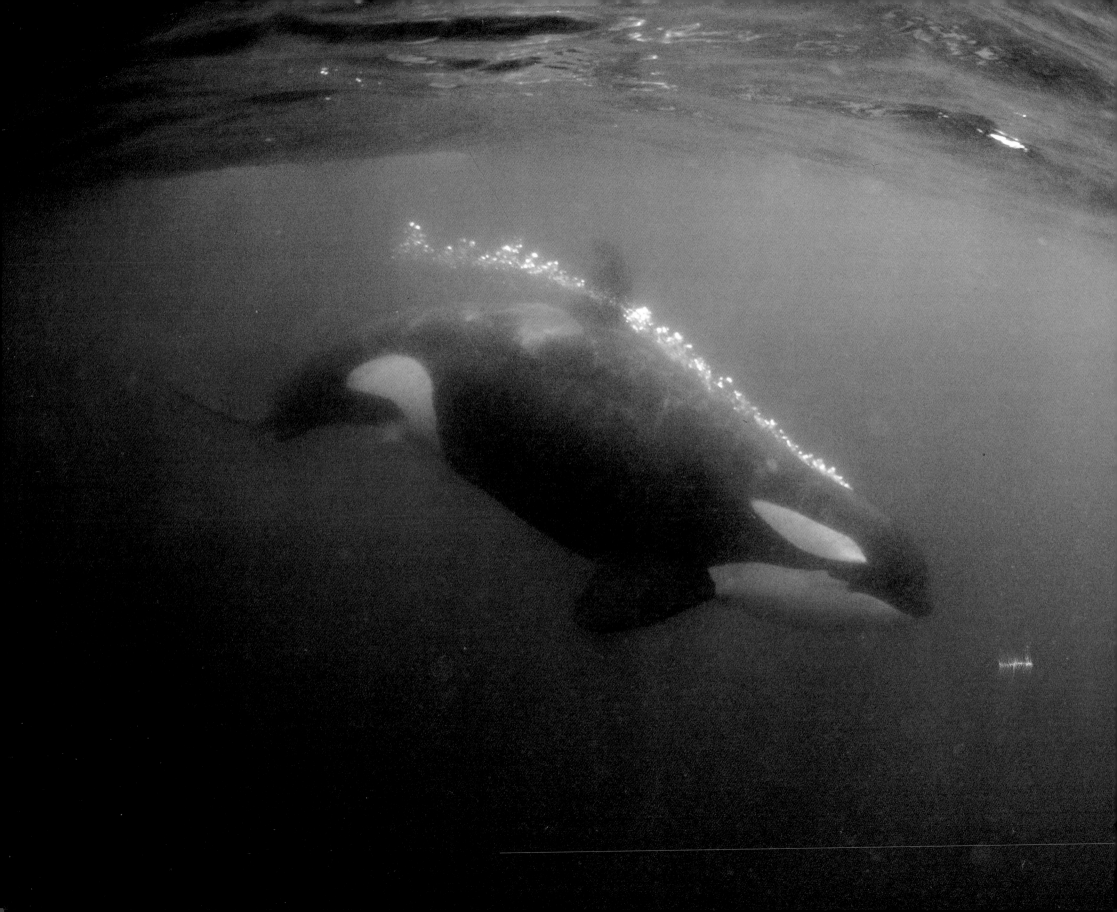

KILLER WHALE BUBBLES

This picture (left) was taken as a killer whale swam so close to our boat that I only had to lean over the gunwale and shoot. Killer whale call identification has become very useful. Researcher John Ford has become so adept at recognizing specific calls that when he hears whales coming (via strategically placed hydrophones) he can tell which pod it is by their dialect.

B-3 BREACH

This adult male, B-3, spent this day breaching (right) and spy-hopping. One reason for these aerial displays may be communication. These jumps are a demonstration of power and grace.

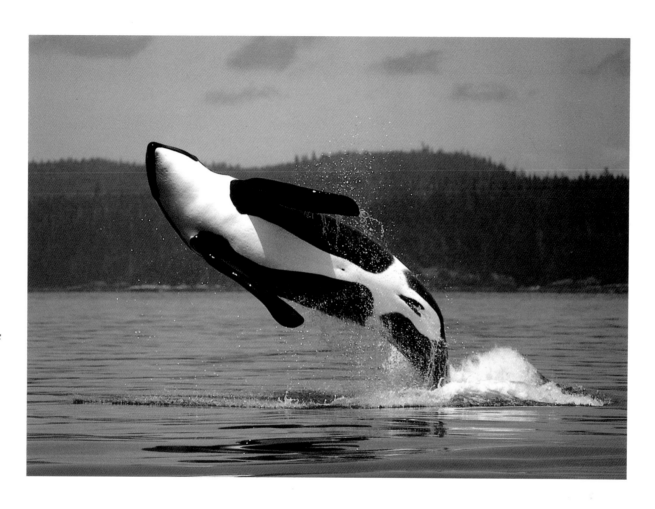

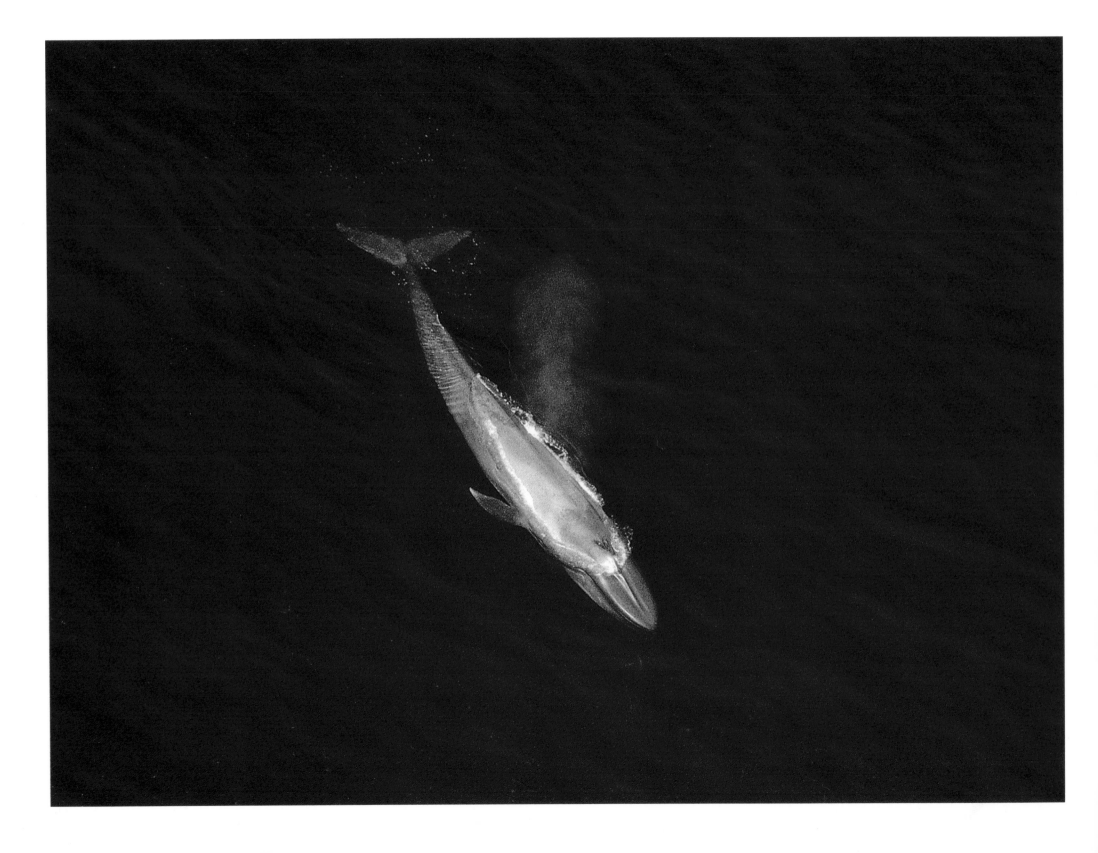

Aerial portrait of the largest animal on earth. A large blue whale can weigh as much as thirty elephants. A newborn can weigh seven tons. Fewer than 10,000 blue whales now roam the seven seas.

family groups known as pods. John Ford has shown that each family or pod of resident killer whales has a specific set of calls, known as its dialect. Shared by all members of a group, a dialect will be different from those of all other pods. In killer whale communication the first function of the calls is, Ford believes, to convey the message "I belong to this family." The next most important message is "I am an individual in this family," and the next is "this is how I feel."

Because killer whales spend much of their time traveling and feeding, often out of sight of each other, their exchanges of calls may maintain spacing and behavior patterns. Each pod's specific dialect keeps members of the family group in touch with the others.

Whereas the sounds of a particular family, as well as a specific individual in that family, are unique, John Ford believes the modifications of sounds indicating emotion are common to all killer whales. Even a whale of a different lineage, using completely different sounds, can probably understand calls from unrelated pods.

Researchers are now seeing a linkage between the communication system of a species and its social organization. For example, resident killer whales living in permanent groups have group-specific sounds, individual identity sounds and emotional signals. Because bottlenose dolphin groups are not as stable, they have individual sounds and emotional signals, but no group-specific sounds.

There is an endless intrigue with the variety of sounds whales make. We have only clues to their communicative function. Sperm whales produce series of clicking sounds, called codas, which are individually unique and probably contain social information. Dolphins produce "signature whistles" unique to individuals and can perhaps mimic other dolphin whistles. Bowhead whales produce a song reminiscent of that of the humpback. A variety of sounds including whistles, squeaks and groans, known as "social sound," emanating from humpback mating groups attract other males. Fin and blue whales make extraordinarily loud, low-frequency sounds that may potentially carry over hundreds of miles.

Whales must have a detailed understanding, based upon acoustics, of their associates and of their environment. They probably carry an acoustic map of their environment in their heads, much like we have a visual one in ours. Research is now starting to show us just how sophisticated whale language can be. We still have a lot to learn, but we continue to listen.

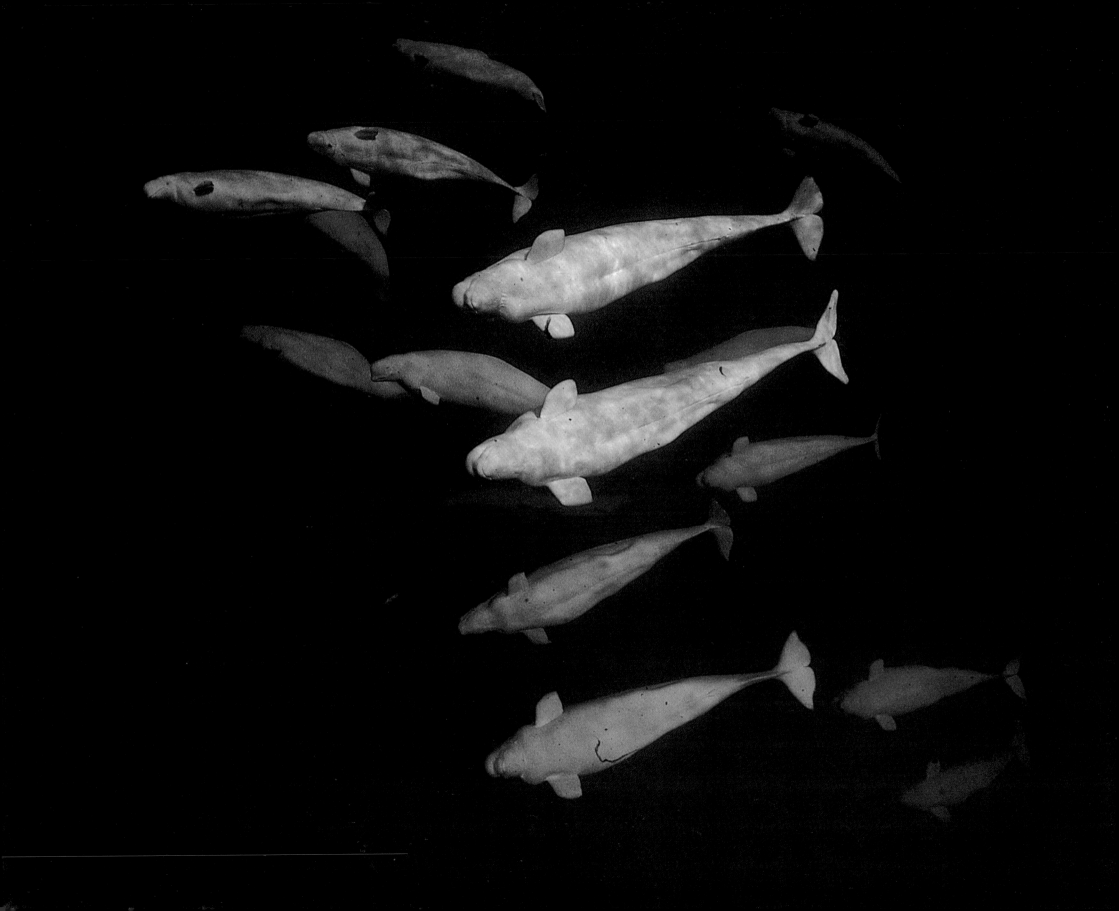

BUNCH OF BELUGAS

Belugas (left) were the first whales whose voices were recorded. As early as the 1940s they were called the "canaries of the sea." The beluga's melon changes shape as they call. Friendly, curious belugas tend to gather around a newcomer.

BELUGA TAIL SLAP

Belugas, like other whales, are known to use tail slaps (right) as a possible means of communicating.

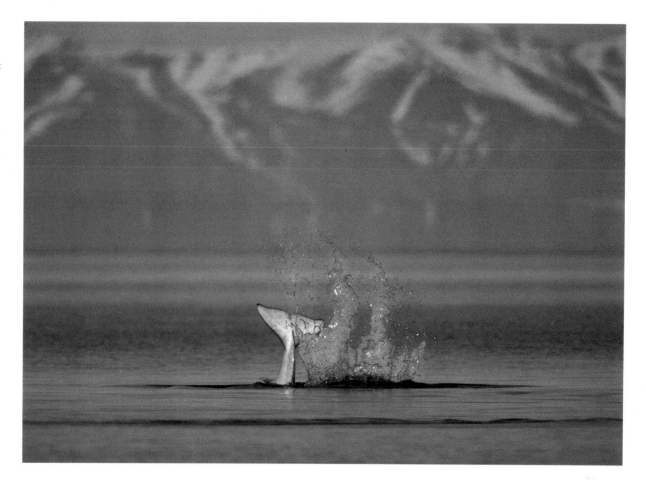

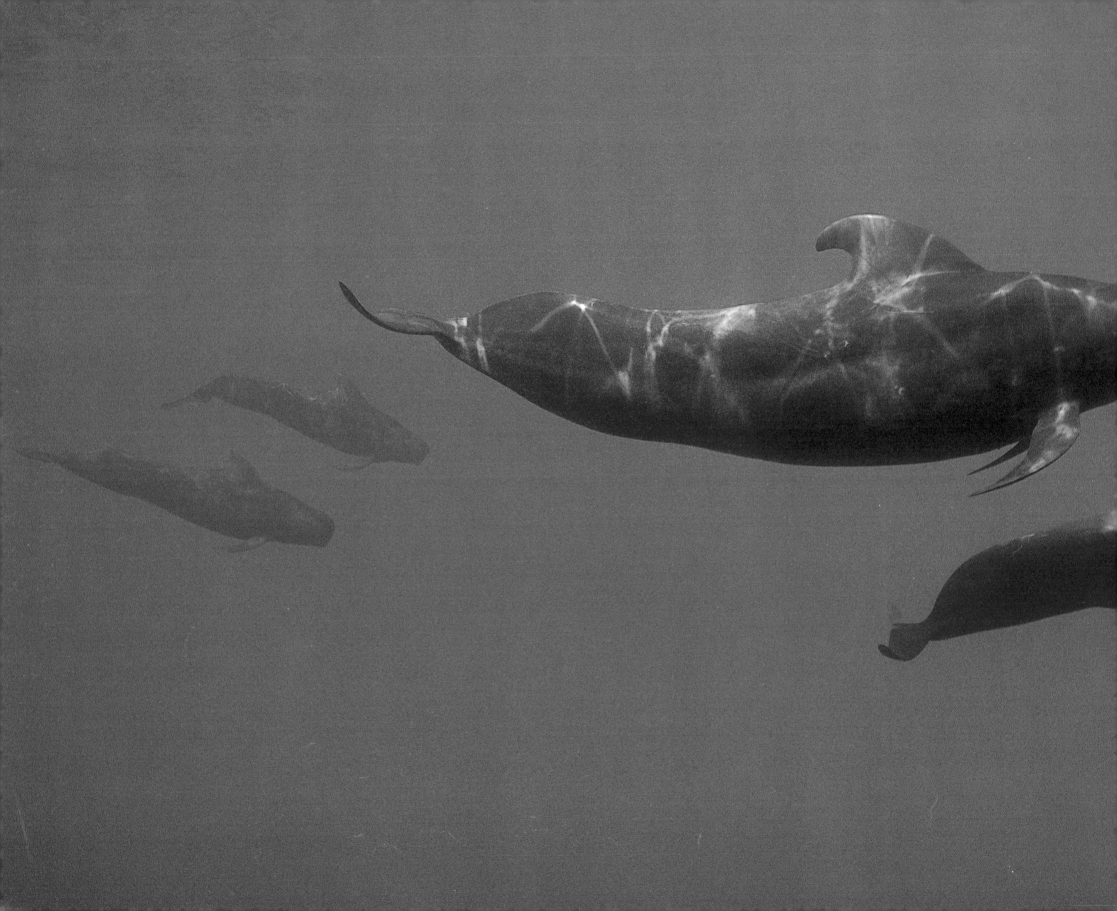

PASSING PILOTS

Pilot whales swim side by side, it is
thought, to avoid interfering with each
other's sonic system. All toothed
whales have specific traveling patterns.
The size of the group varies according
to the activity: resting, feeding,
traveling or socializing.

The Whale Tomorrow?

In 1983 one of the first field tests using satellites to track the movements of whales hinted at the future of whale research. Bruce Mate tells the story: "We cut free the last rope holding the whale and off we went into the mist, not knowing how long the tag would stay on." Mate picked up ten locations over a six day period. This animal moved seven hundred kilometers, or over four hundred miles, from the Newfoundland tagging site to reach the convergence of the Labrador Current and the Gulf Stream where humpbacks were seen just a week before.

A transmitter attached to a whale can send signals to a satellite, which then returns a signal to scientists, allowing them to precisely locate the animal. Although land animals have long been tracked by satellite, the use of this technology for the study of whales has taken years to develop due primarily to the challenge of attaching the transmitter to a wild whale and keeping it attached. Whales simply cannot be tranquilized like land animals.

Each year a few humpback whales get tangled in fishing nets off the Newfoundland coast, often drowning in the process. In recent years, major efforts have been made on the part of biologists and fishermen to reach the whales and cut them loose, saving both the animal and the net. Bruce Mate decided to see if he could place a satellite tag on a trapped whale before its release.

"We got the call in the afternoon," he recalls, "and drove all night to get there." Fortunately the animal was still alive. The whale was tangled in a gillnet in Bonavista Bay. Mate and his wife headed out into five-foot swells and fog to find the whale. He found the whale and readied his equipment. The satellite attachment was at the end of a five-meter pole. It takes only three ounces of pressure to deploy it. Mate managed to get the tag on the whale in spite of the heavy swells. The tag went on but not tightly. He could see it wobble around, and unfortunately it didn't release from the applicator. He describes the scene: "All of a sudden there is a whale attached to a tag attached to the applicator attached to the pole attached to my boat, a little Zodiac,

and we are way offshore, and I'm going 'Oh my God!'." A little nylon screw was supposed to shear. Mate had to put a knife between his teeth, go hand over hand down this five-meter pole-vaulting pole and cut the nylon screw holding everything together. Amazingly the whale let him.

This tagging effort was a success, and as with any success, it raised interesting questions. The whale went from an inshore feeding area to the only other concentration of humpbacks around, a long ways away. How do whales do that? Do they know a spot from previous experience and go to it using some form of navigation, or do they hear other whales and home in on them by dead reckoning, or do they sense the oceanographic features that are important in concentrating prey and just find the other whales by that process? All we know is that this animal went straight out and intersected the Gulf Stream-Labrador Current convergence, then turned right.

Satellite tracking will certainly provide tremendous insights into the migratory behavior of whales. Recently developed molecular-genetic techniques such as DNA fingerprinting, requiring only a small sample of skin or blood, will also provide valuable data on paternities, breeding systems and social structures. Satellite tracking and genetic "fingerprint" studies are the leading edge of a new wave of whale research now cresting after two decades of remarkable progress.

Understanding whales is a very long process. There are no shortcuts, but the ten-year and twenty-year studies are beginning to tell us the whale's story. There is hope in the whale research community today. Given time, we can learn enough about these animals to ensure their survival despite the increasing pressures from human population and industry.

It will not be easy. There is, unfortunately, a point where the noble goals of research and conservation collide with the reality of our global society and its huge social problems, economics, politics and values. Can research possibly produce the wisdom necessary to ensure the preservation of the great whales?

BLUE BLOW

If whales are to prosper they will need a clean, productive sea. Here a blue whale blows off the California Coast.

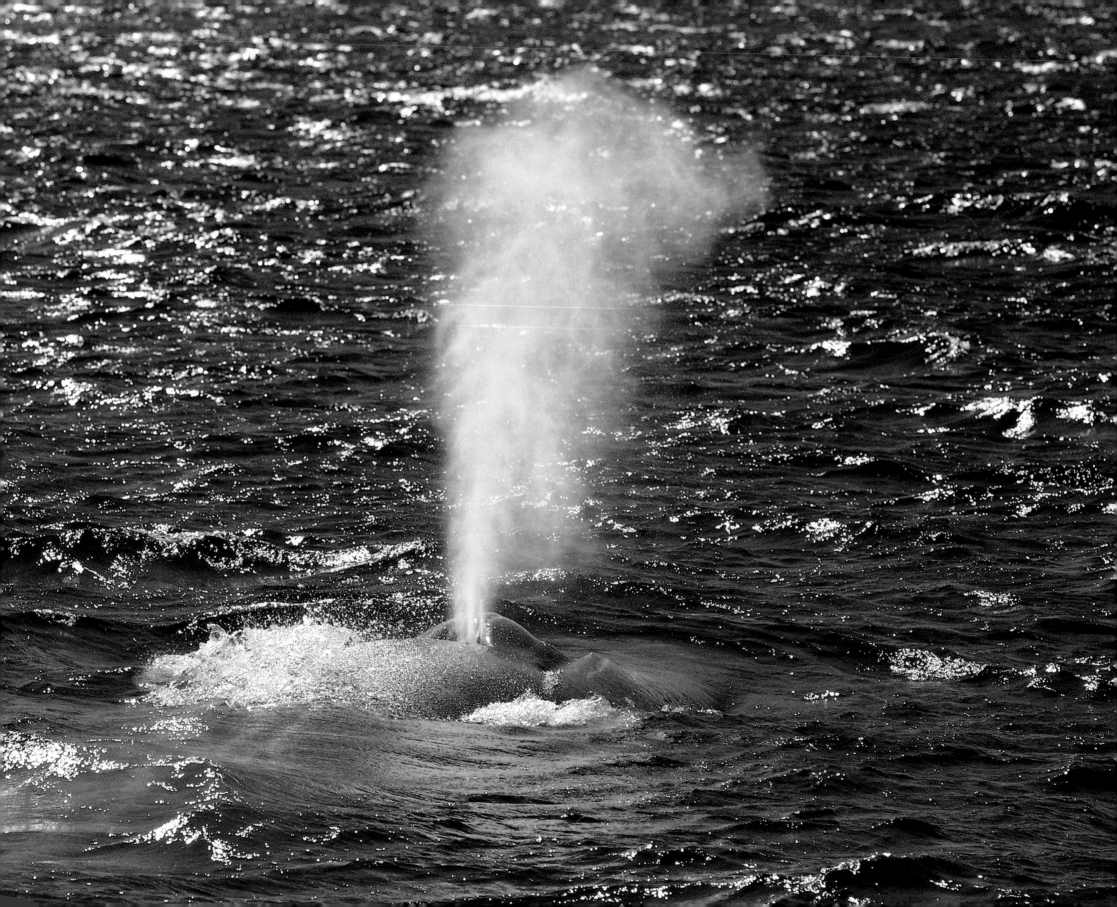

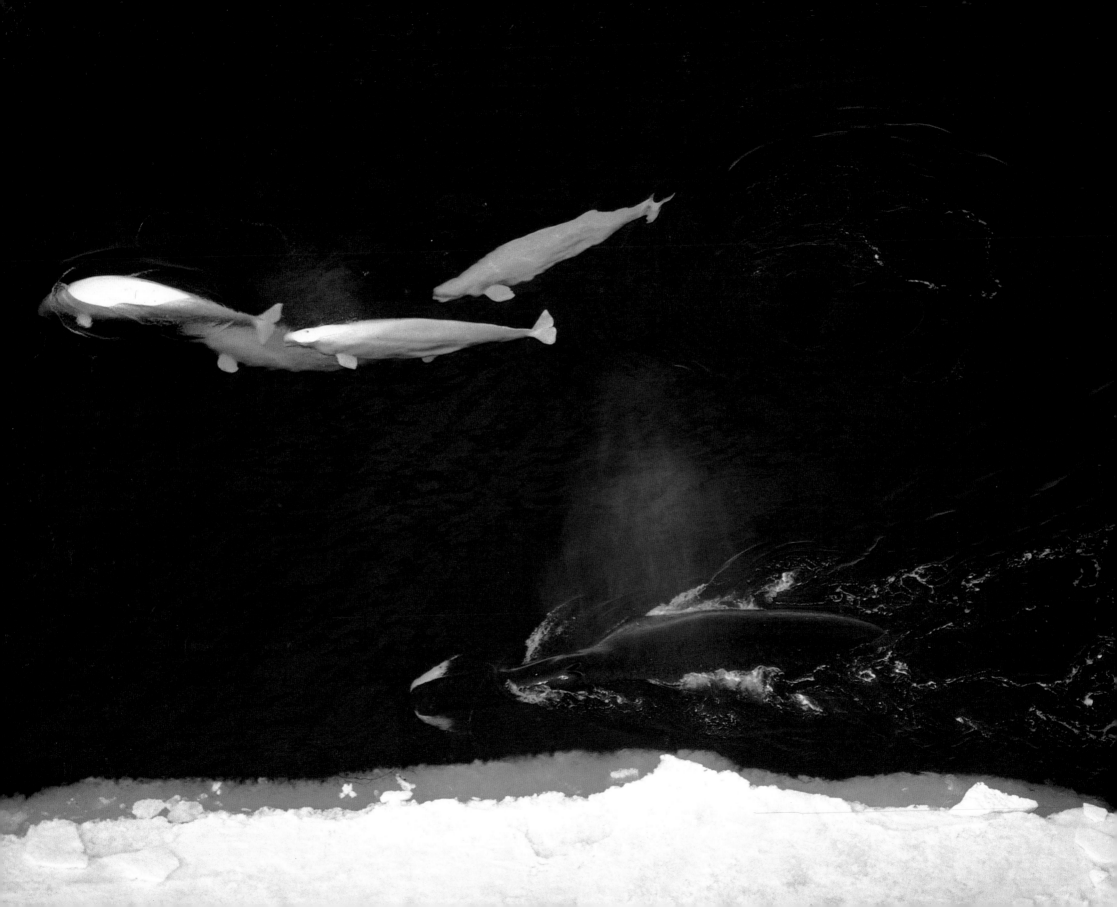

The eastern bowhead whale is rare. They are protected from all hunting. On this day we flew looking for narwhal, but were lucky to find this single bowhead and group of belugas passing near our camp.

Today, human relationships with whales are diverse, at times incomprehensible. We are training dolphins to go to war for us. We are capturing whales so they might entertain us. We are hunting them for tradition, for food, and for profit. We are shooting them because they compete with us for food. We are drowning them incidentally in our fish nets. We are slowly killing them with pollution.

Ironically, these are animals we love. Whales have become worldwide symbols of wildlife conservation. Each year millions of people risk seasickness just to catch a glimpse of them in the wild. The concern society can show for whales verges on phenomenal, illustrated by the enormous effort expended in the rescue of three gray whales trapped in the Arctic ice in the fall of 1988. Imagine someone from another planet trying to analyze our relationships with these animals.

There are serious ethical questions at play. Dolphins are one of the most loved of animals, yet we are sending them to war. The U.S. military contends they are only used to search for mines and will not be hurt. But if I were on the "other side," I'd probably want to shoot every dolphin I saw.

We capture and hold whales in captivity for entertainment and profit, while we simultaneously oppose commercial whaling. For all biological purposes, these captive animals are killed. The loss to the wild population is the same whether the animal is eaten, cut up for fertilizer or kept in a pen. We say it is justifiable for educational purposes. This is not a new controversy; it has existed as long as there have been zoological displays and research institutions.

Traditional hunting by aboriginal peoples kill a few whales each year. Some of the hunters view the hunt, the killing, and the whales with a degree of respect lost on the modern world. Others simply participate in massacres with modern weapons, a sign of a disintegrating culture.

While the three issues just mentioned are emotional, none are likely to cause the ultimate demise of whale populations. There are more serious threats.

Although much reduced from the 1960s and 1970s, commercial whaling continues into the 1990s. Time will tell if these are the last gasps of the commercial whaling industry or if it's only a lull, as some whales again become economical to pursue. The political forum of the International Whaling Commission continues to try to manage whaling, but too often finds itself mired in inconclusive arguments about population models, sustainable yields, and interpretation of agreements. The latest loophole found by the whaling nations to get around IWC restrictions is something called "scientific whaling," which allows the killing of whales for the purpose of scientific research. It makes a political game of the Commission and a mockery of research. Scientifically, it is no longer necessary to kill whales to learn about them. That era has passed.

At the same time, whale watching has become a major "industry" throughout North America and is developing in other parts of the world. Whale watching has created tremendous public awareness and educational opportunities and has focused attention on the issues concerning whales and their environment. Japan, one of the last strongholds of the commercial whaling industry, conducted its first-ever whale watching trip in 1988. Organized by Japanese naturalists, forty-eight people took a twenty-eight hour boat trip to the Oqasawara Islands seven hundred miles southeast of Tokyo and spent a week with the humpbacks. I was fortunate enough to be there at the time, involved in a study of whales. The trip was a huge success. The whaling industry might be a little concerned. Living whales are being perceived as having greater value than dead ones.

Unquestionably, there has been a significant worldwide change in public attitudes about whaling. Just as the whales and their advocates seem to be winning on one front, however, they may be defeated on another. The very real problems whales face today and in the foreseeable future are conflicts with human industry over food supplies and habitat. This is a far more difficult and ominous battle than fighting with the whaling companies. Now we are fighting ourselves.

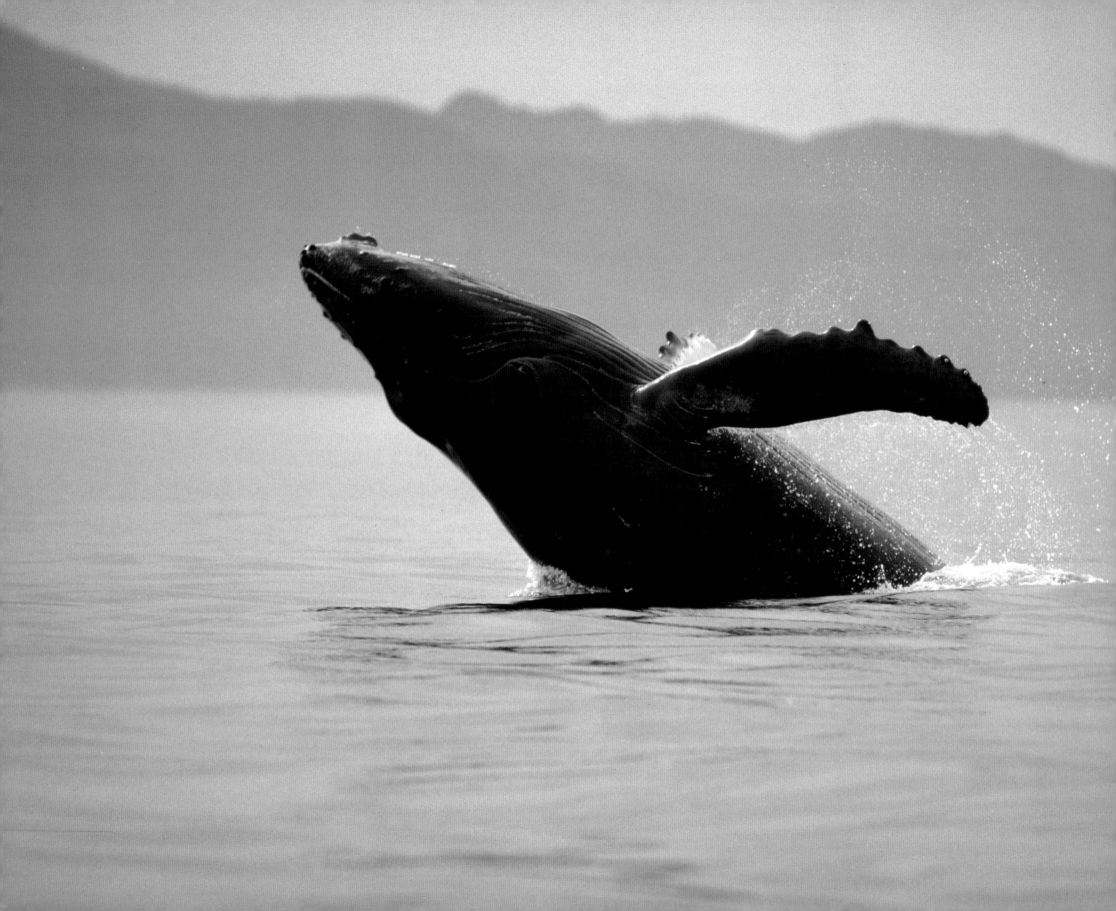

HEADS AND TAILS

A young humpback (left) breaches near our boat. A whale breach is rare and exciting. Most of the time whales just show a large tail as they sound (right). In Southeast Alaska we would see whales sleep or rest for hours at a time.

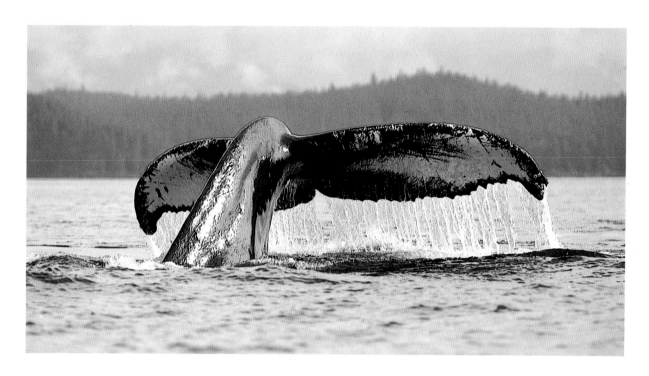

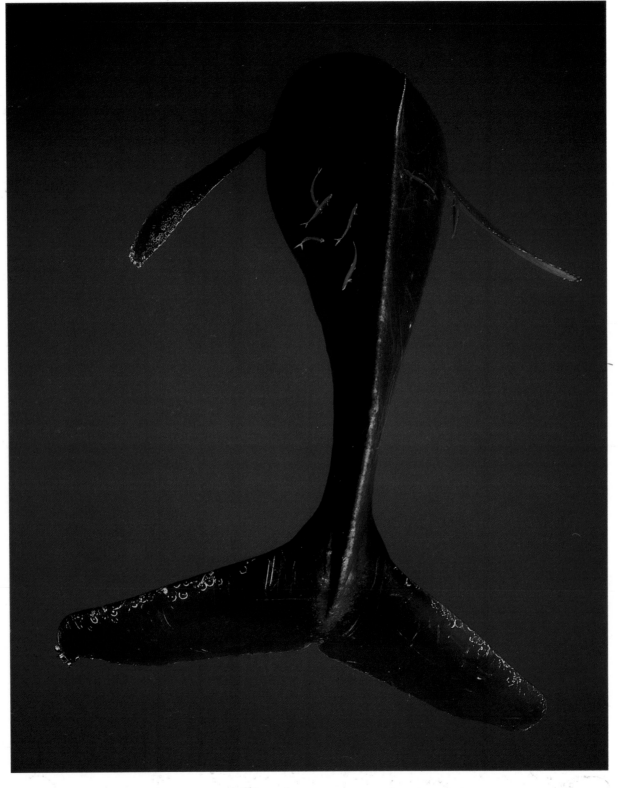

HUMPBACKS

While this singing humpback (left) remains still, a group of small jacks graze on his loose skin. He showed no reaction to their activity. A cow, calf and escort male humpback (right) surface near Maui.

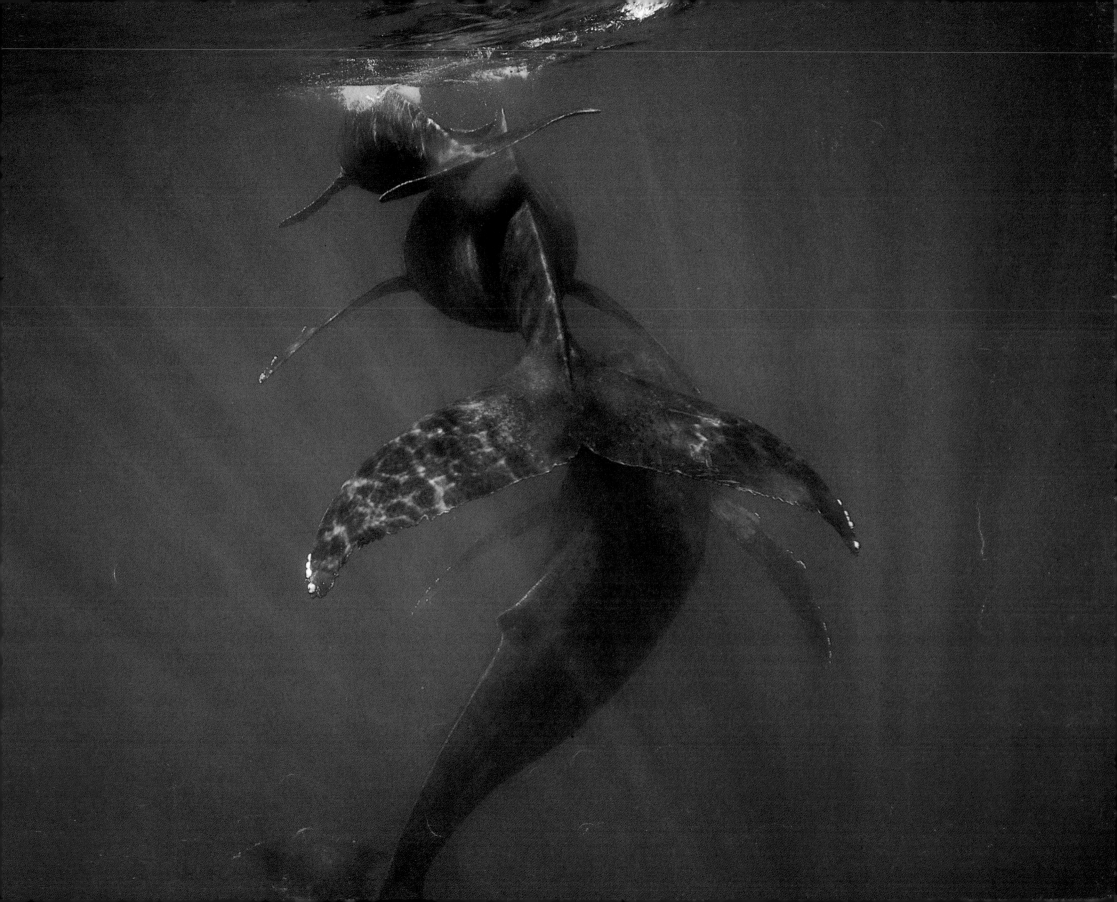

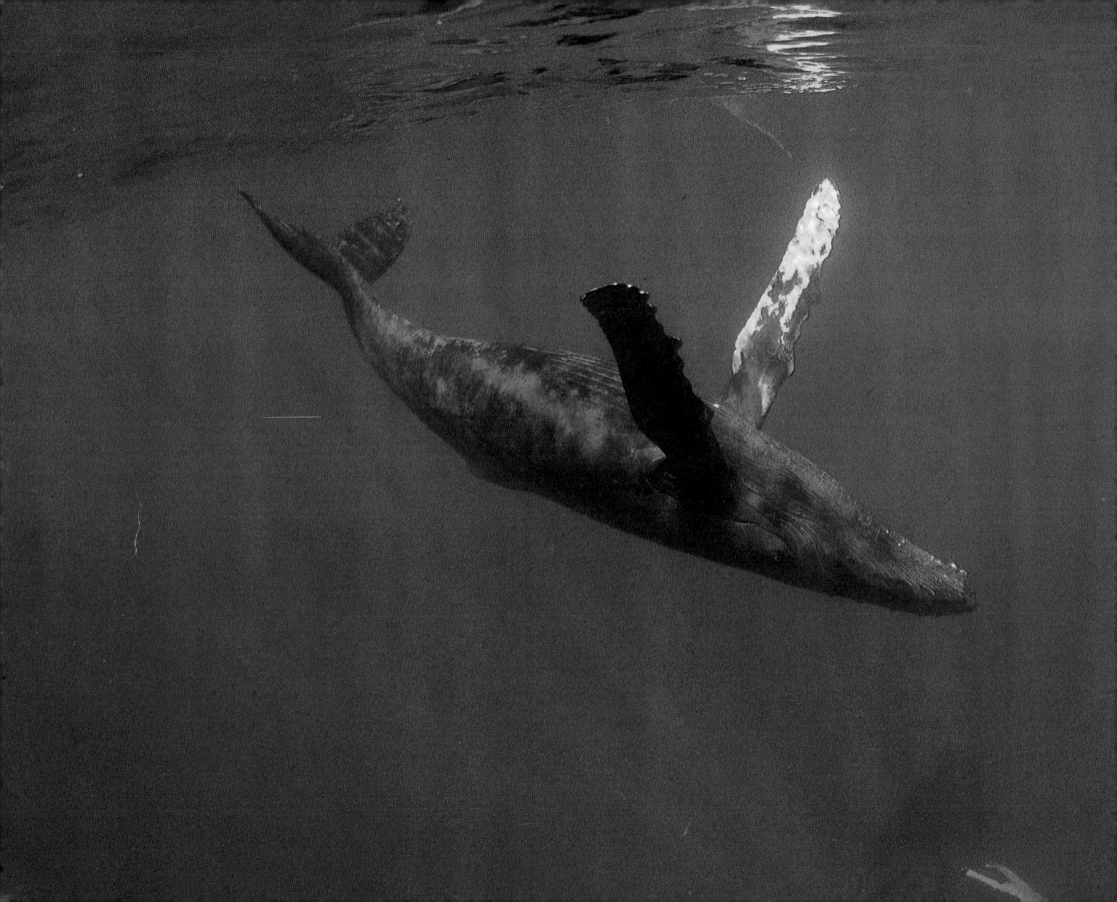

A young, playful humpback whale calf swims upside down just below the surface in Hawaii.

According to Stormy Mayo, what needs to be told in the most elegant fashion is that the future of whales and the future of life on earth depends on our stewardship of all ecosystems. Stopping whale hunting is not enough. Now the real cultural battle begins. "It is much more difficult to marshal the masses behind this battle: *it* is the fight over the ecosystem, the battle over habitat," Mayo states.

Some fishermen believe that whales are eating too many fish. The solution, they feel, is to start shooting them. The only question remaining about fishery-whale interactions in general is: can an all-out war be averted? Skirmishes are increasing worldwide. In the 1990s as the competition for fish and habitat intensifies, we are killing whales and dolphins on a scale exceeding the worst years of commercial whaling. While scattered incidences of whales picking fish off fishermen's lines occur worldwide, often resulting in the death of the whales, these problems are minor compared to the incidental kill in net fisheries.

For years the deep sea tuna fishery has caused a significant death toll of dolphins, estimated at up to 400,000 animals a year. Dolphins, often traveling with a tuna school, get caught with the fish and can't escape. Even with fishing techniques and gear designed to let the dolphins escape, the "allowable quota" is still 20,500 dolphins a year for U.S. boats. The pressure on pelagic spinner, spotted and common dolphins is phenomenal. It's difficult to see how they can continue to take it.

Then there are the drift nets. Hanging like invisible fences across the ocean, these nets, sometimes twenty-five miles or more in length, annually capture hundreds of thousands of whales, dolphins, other marine mammals and birds that simply run into the fine nylon monofilament net, get caught, and drown. Called the "by-catch," the incidental catch of other animals while fishing for salmon, squid or other fish is taking a heavy toll. A two-month "test fishery" conducted in 1987 by two boats off the west coast of Canada killed ninety marine

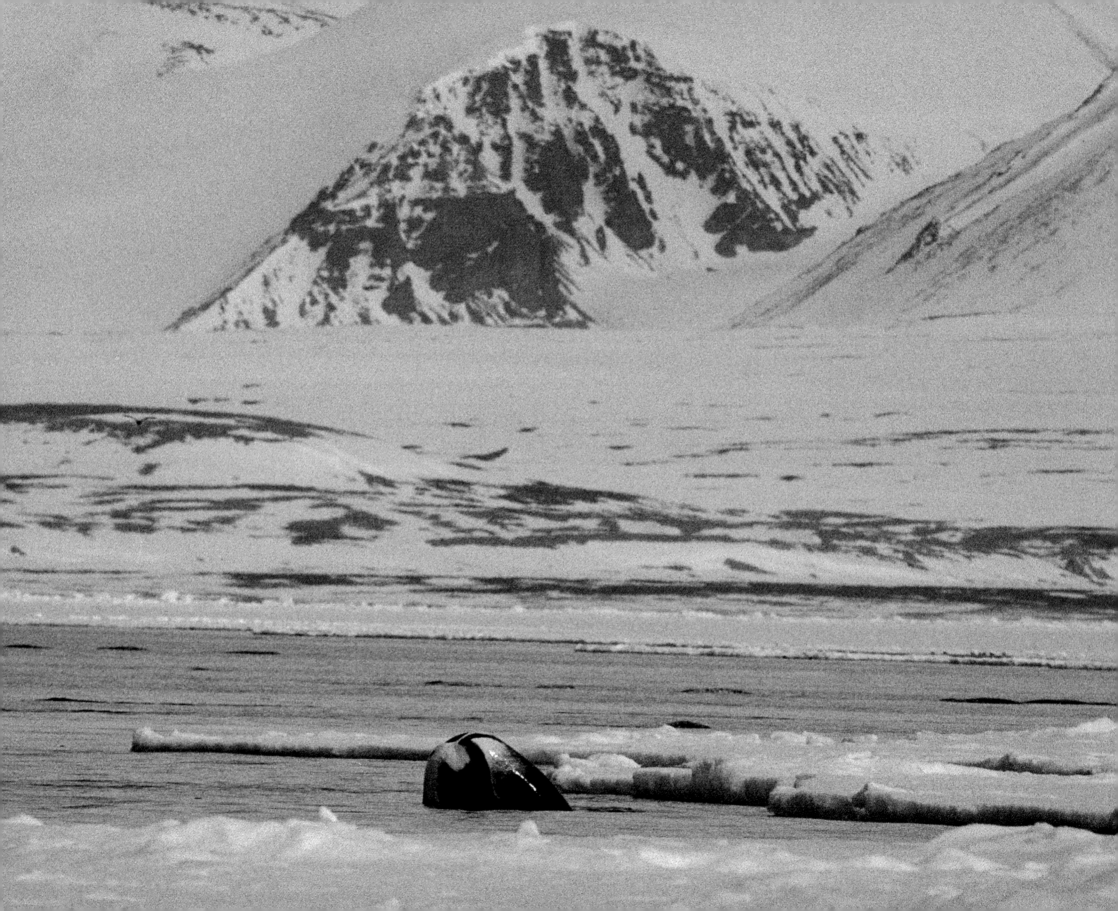

BOWHEAD NOSE

An eastern bowhead (left) gently surfaces in the wilderness of ice in Lancaster Sound.

NARWHAL

The whale is especially important to Inuit people. They see more clearly than most that their future and the future of their culture is tied to the health of their environment and the wise management of their resources.

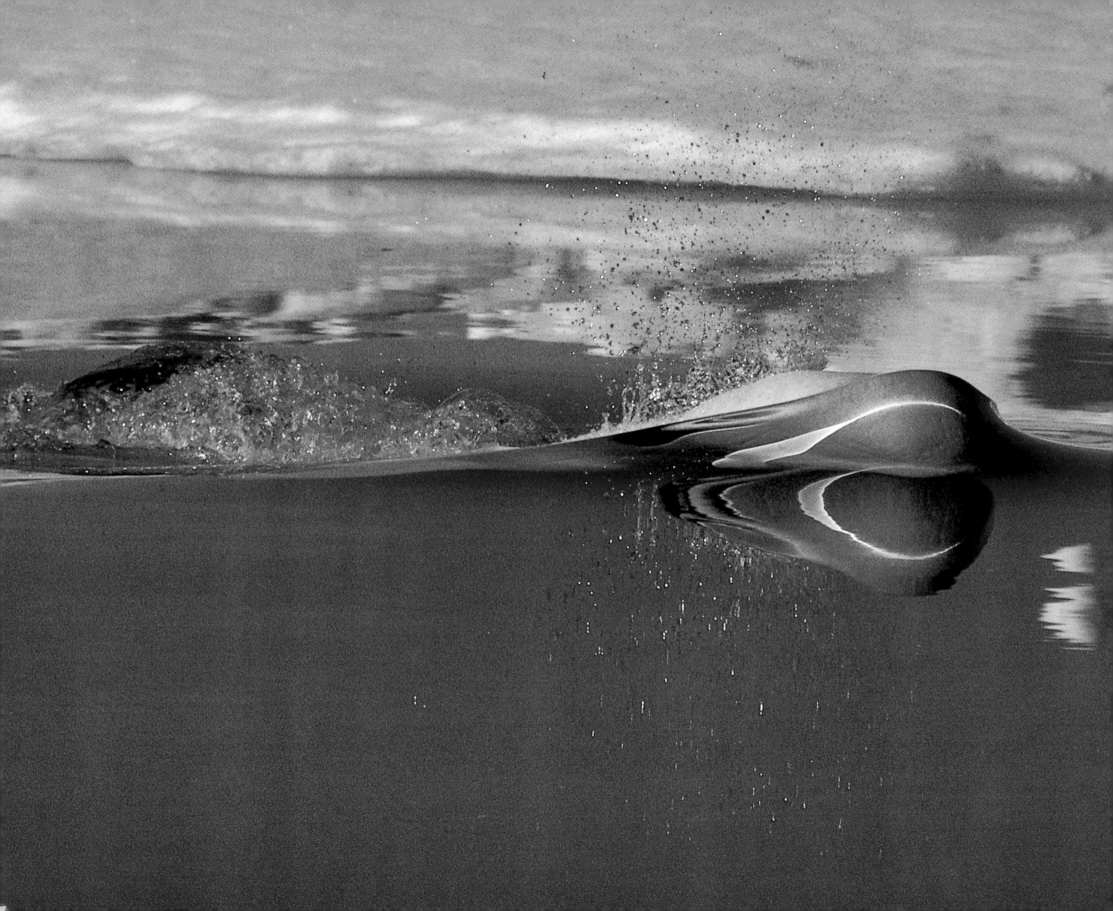

This beluga was a study in power and grace.

mammals and five hundred seabirds, including fifty-eight Dall's porpoise, three pilot whales, sixteen Pacific White sided dolphins, nine northern right whale dolphins, a harbor porpoise, a fur seal, and a Stellar's sea lion. A similar test fishery in 1986 killed forty-nine mammals, including two killer whales and five pilot whales. It is estimated that each night in the North Pacific alone 20,000 miles of drift net are set, totalling more than five million miles annually. The resulting incidental catch of marine mammals and birds is staggering. Conservative North Pacific estimates suggest more than 10,000 Dall's porpoise, 50,000 fur seals and 250,000 seabirds die annually. These are only the mortality estimates for the North Pacific. Drift nets are used all over the world.

There is also a less direct form of competition between whales and fisheries. Not as well understood, its long-term consequences are significant. The survival of many stocks of fish now depend entirely on human "management" capabilities. Thus, whales relying to any extent on commercial fish have to depend on us to survive. For example, killer whales rely on healthy salmon stocks; humpbacks eat herring or capelin; belugas move into rivers and eat salmon smolt; many whales depend on krill but a new fishery for them is developing in the Antarctic. If we overfish or otherwise destroy fish or other whale food stocks, the whales will pay the price.

If we are not competing with whales for food, we are for habitat. In an increasing number of areas, human pollution is simply over-whelming marine habitats and their residents. For example, the only non-Arctic beluga population lives in the Gulf of St. Lawrence and is being decimated by horrible diseases, including cancer. Researcher Pierre Beland tells of one beluga in which they found PCBs, myrex, benzoate pyrines, cholordine, a variety of insecticides, mercury and other heavy metals and another two-year-old animal with twice the PCB levels as adults, undoubtedly obtained through its mother's milk. The calf also had hepatitis, a blood infection, and a perforated ulcer.

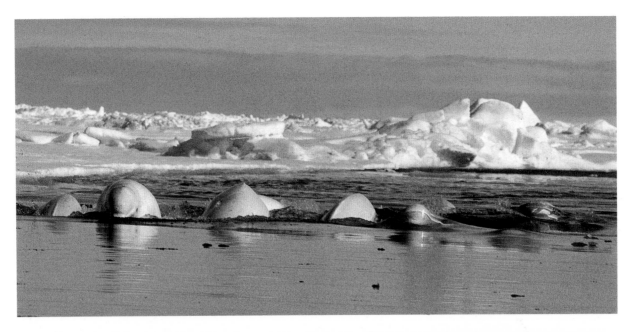

ICE PATROL

Belugas (left top) and Narwhals (left bottom) travel in large groups along the ice edge in Lancaster Sound.

CHARGE!

In the arctic spring narwhals (right) move through the cracks in the ice to the inlets of Baffin Island. Subsistence hunting by the natives is strongly self-regulated and appears to be of little threat to the narwhal. Hundreds of narwhals would pass our camp on the ice edge in a busy hour in the spring. The sounds of their blows were almost continuous.

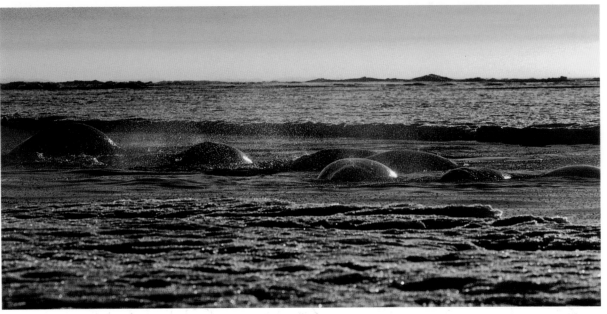

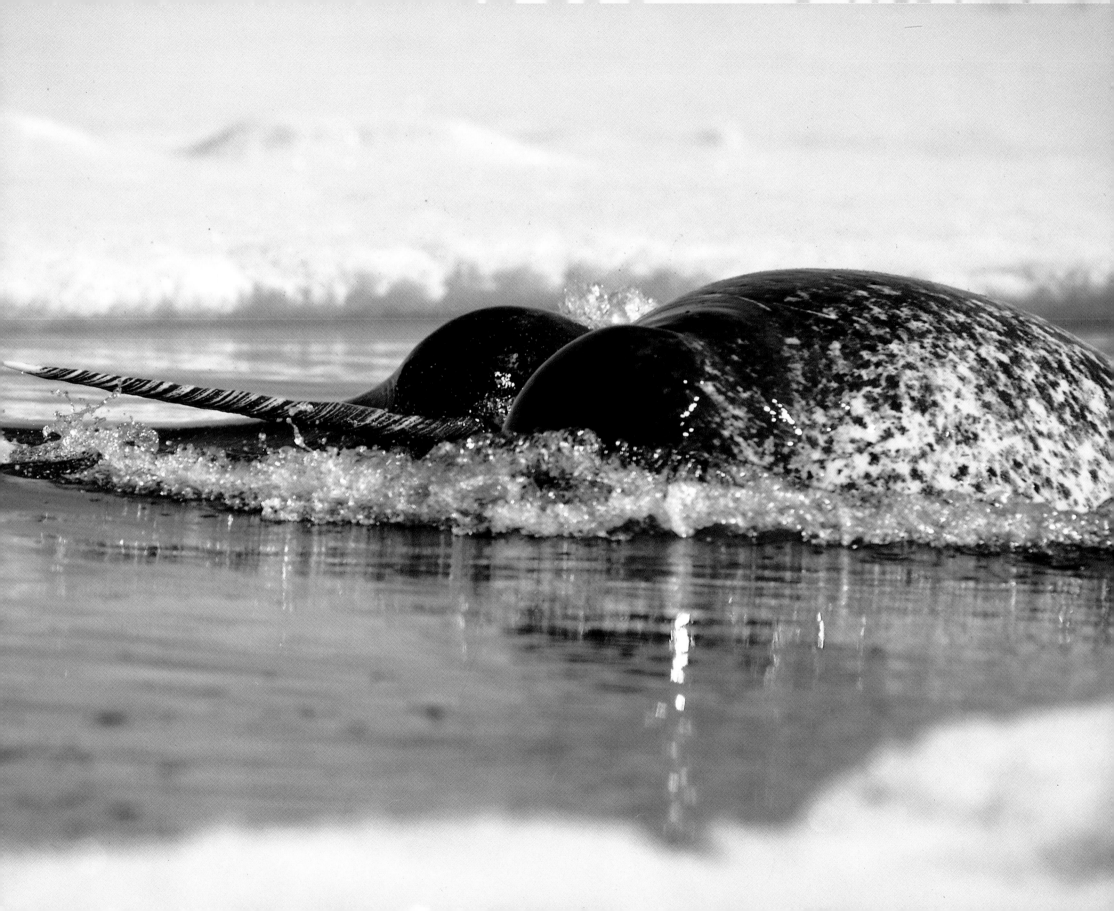

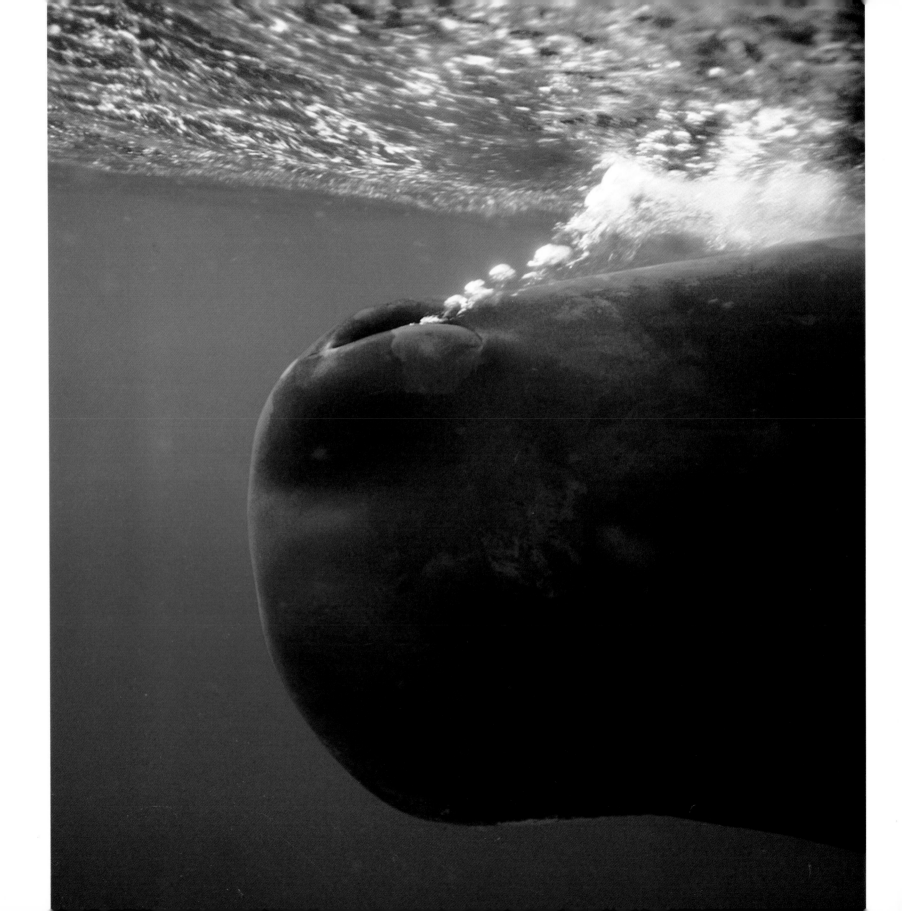

Sperm whale: up close

Whales come in all shapes and sizes. The sperm whale (left) with its blowhole at the front left of its head seems built for something other than speed.

Pilot pushing a wave

The pilot whale (right) pushes a bow wave as it swims off the Hawaiian coast.

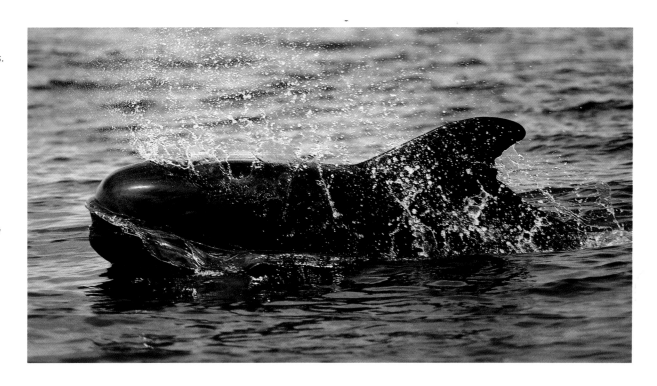

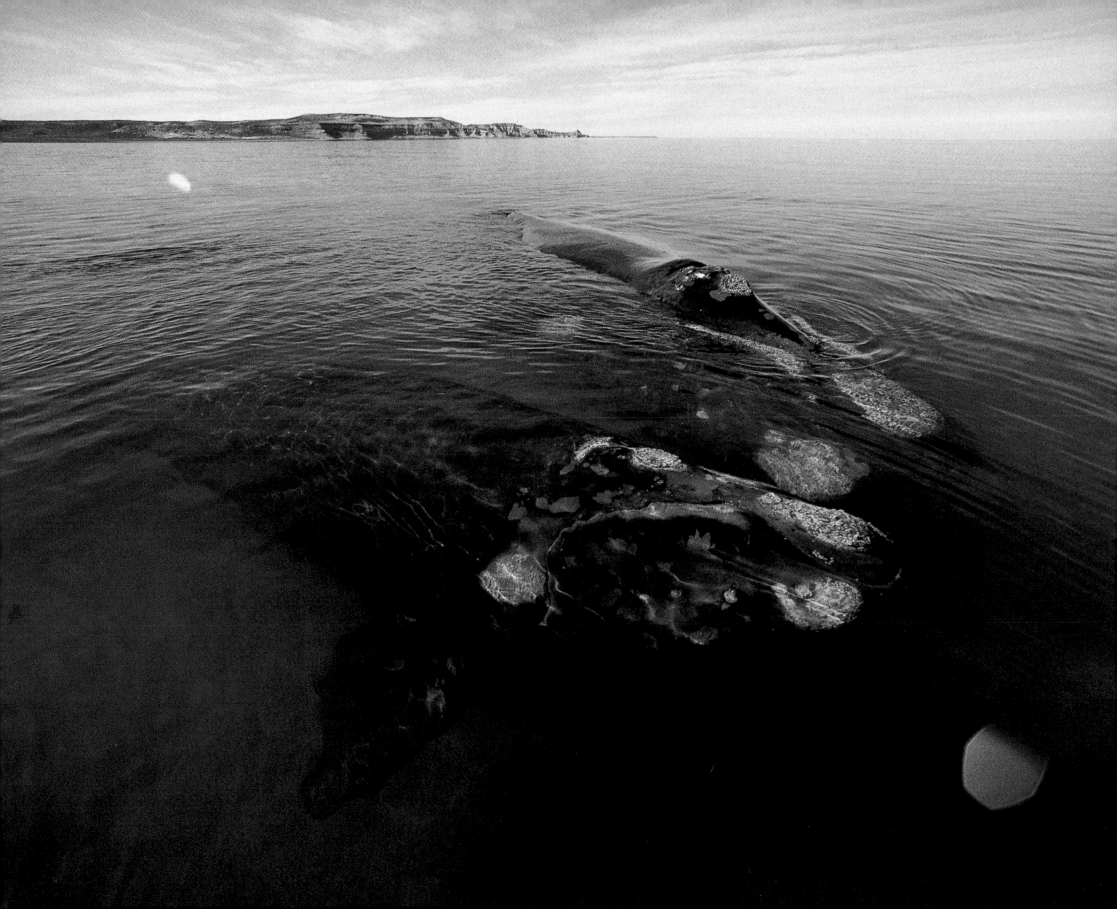

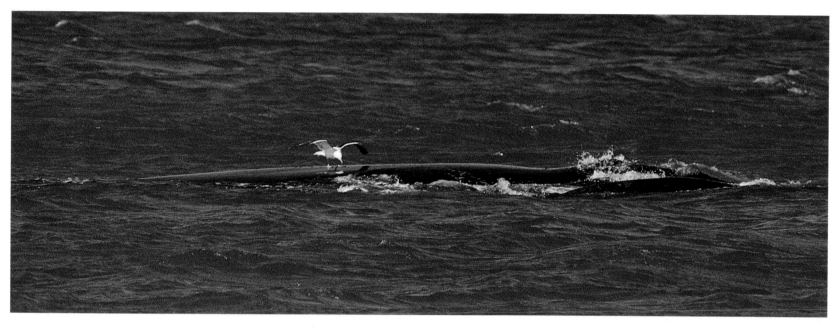

Calm days were not the norm in Gulpho Nuevo. Here two southern right whales (far left) lay quietly in about fifteen feet of water. A single gull disturbs the peace for an adult right whale (left) near shore. In one morning this same bird caused six whales to leave the area by picking at their backs.

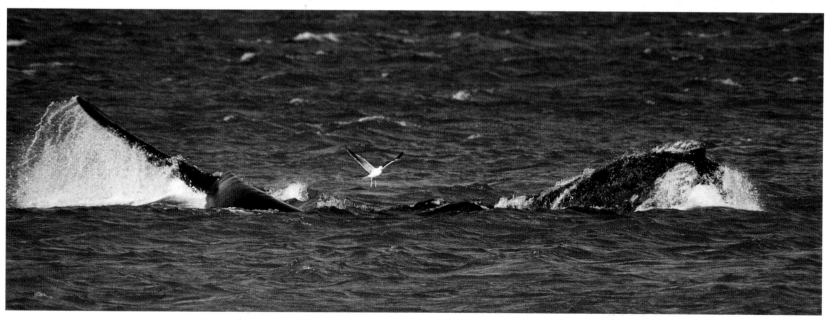

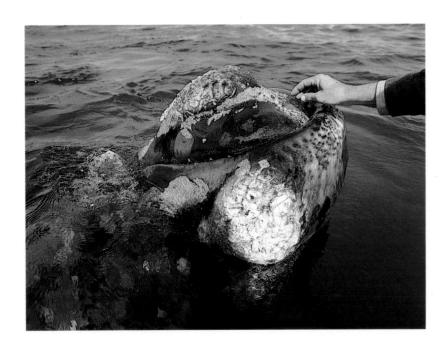

THE RIGHT TOUCH

Whales may detest the seagulls, but they seem to appreciate the occasional scratch (above) by a human hand. This particular hand belongs to Roger Payne, the individual most responsible for stimulating southern right whale research.

CHANCE ENCOUNTER

Diver Michael Bennett hangs in the water (right) as "Lasagne Tail," a curious right whale calf, comes up to take a look at him. The calf's fifty foot mother looms in the background.

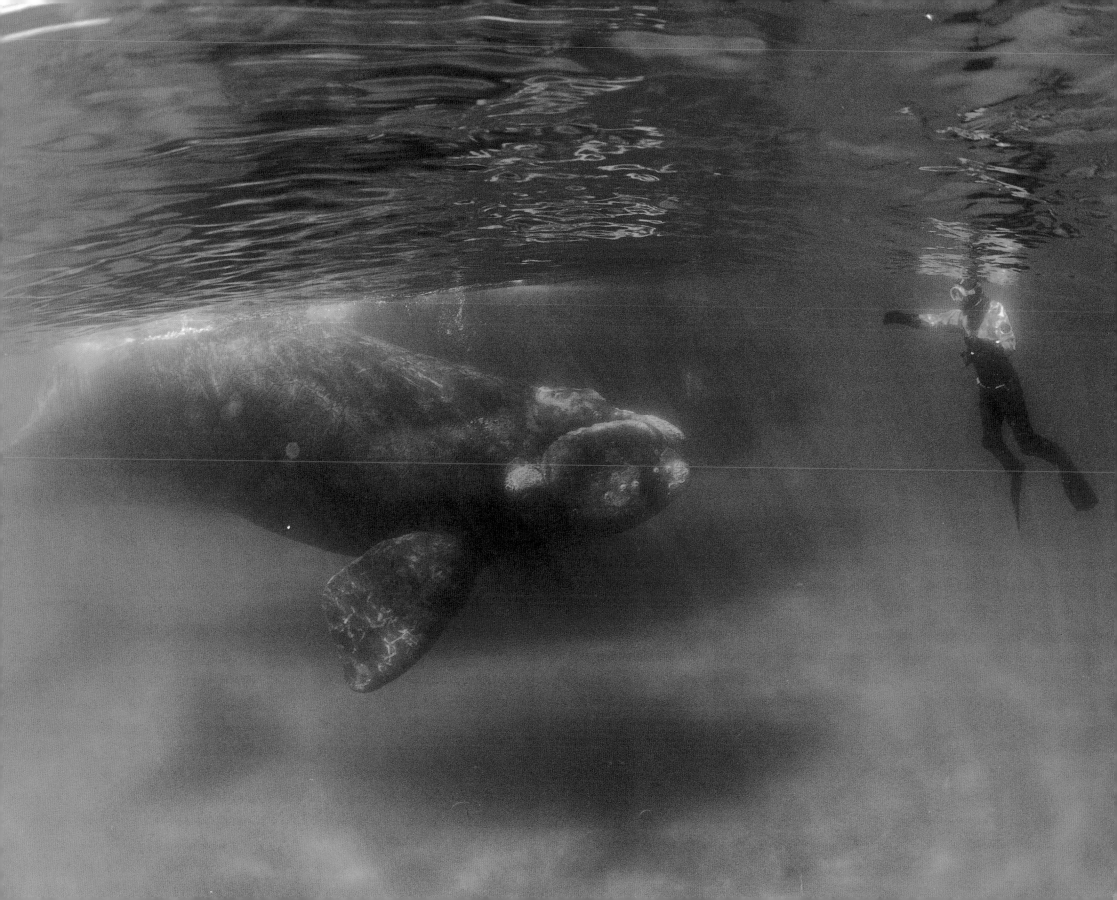

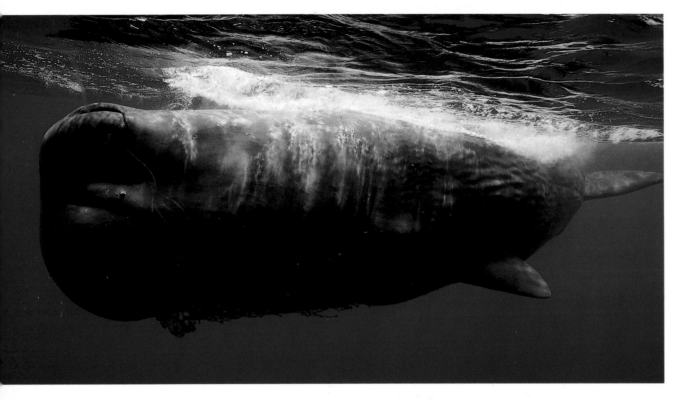

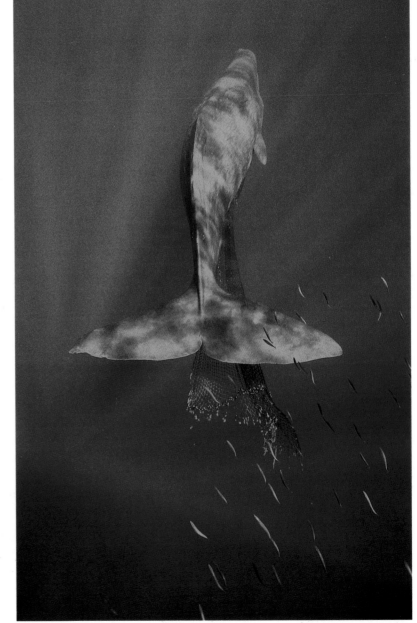

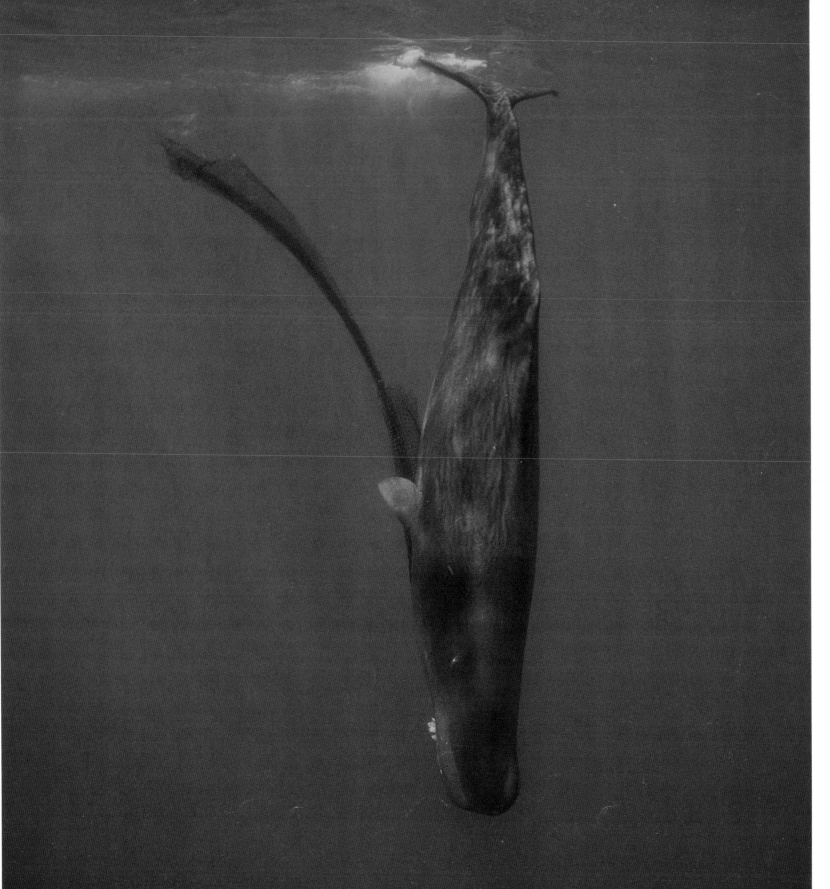

FATE UNKNOWN

We will never know what happened
to this sperm whale after this picture
was taken. The whale had become
entangled in a fishing net. It was
towing it as it swam and dove with
ease.

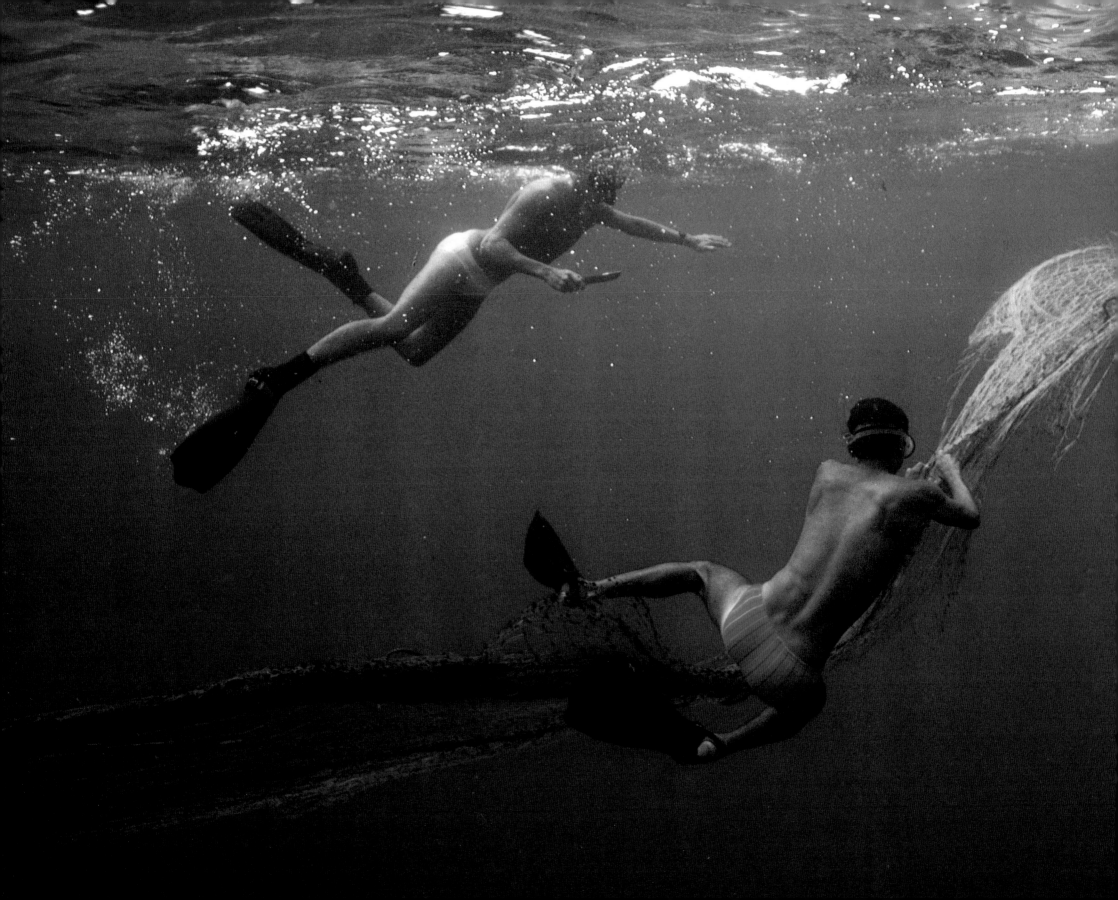

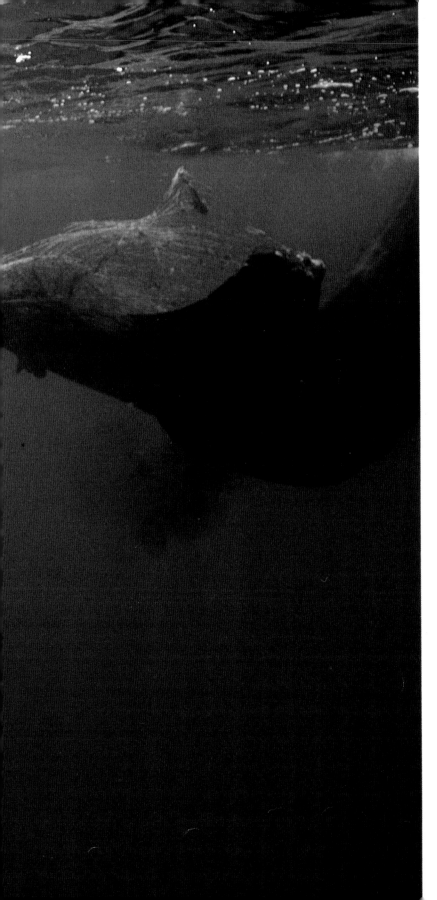

A HELPING HAND

Sometimes we can do something to help. Here Terry Nicklin and Phil Gillian were able to cut away part of an entangled net from the sperm whale.

In other stranded belugas researchers have found pathogens never before found in whales, lesions never previously seen, ruptures of pulmonary arteries, ten times the previous number of tumors, and even indications of immuno-suppression disease. That is not difficult to understand considering the pollution of their environment from nearby industry. The poisons from pollution are concentrated first in the whale's food chain, including herring, capelin, shrimp, polycheate worms, and then reconcentrated in the whales themselves.

More and more whales have died from unconfirmed causes in the past few years. During the summer and fall of 1987 and continuing into 1988, over five hundred bottlenose dolphins were recovered dead along the eastern seaboard of the United States. It appears that the animals are dying from pathogens they normally carry but can keep under control with their immune system. Something is happening to suppress the immune system and allow these pathogens to go wild. There have been sweeping epidemics in land mammal populations in the past, but no one has previously seen them occur in dolphins. These epidemics could have natural causes or could be the result of pollution. The most alarming thing is that we don't know what causes them.

"Whales are a barometer of the state of the ocean. They integrate what is going on over a long period of time and over great distances. They tell us something very important. Sometimes we have to be a little bit sensitive to see it, or somewhat clever, but the message is there. If the whales are having troubles, the ocean is having troubles, and if the ocean is having troubles, we are having troubles." This truth, stated by Steve Katona, has hit a nerve in most researchers.

We are intruding into and changing the oceanic ecosystems that support whales, and, for that matter, all life on the planet on a tremendous scale. When it comes to understanding what we are doing or the long-term consequences, we know virtually nothing.

As we move closer to the next century, we need to ask if whales are

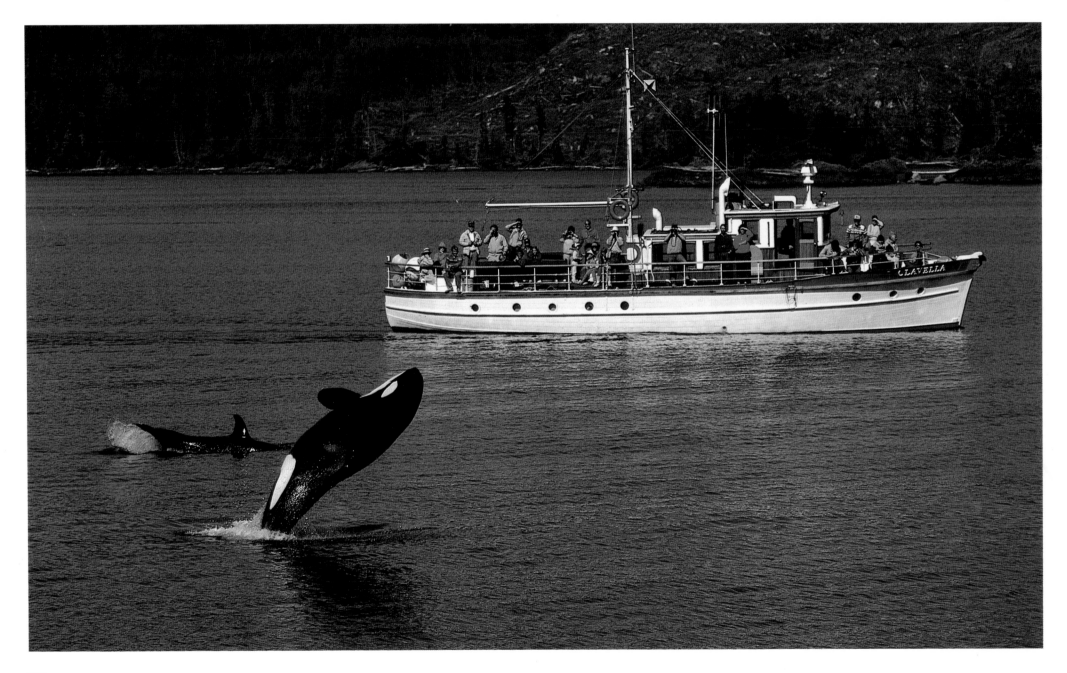

SHOW TIME

Whale watching (left), properly done, is a great way to educate people about the value and beauty of marine mammals. Stubbs Island Charters is one of the best of the whale watching groups. They give equal value to the comfort of the whales and their watchers.

CRUISE SHIP AND WHALE

Adventure cruises are part of the whale watching mix. The people who line the rails of large cruise ships will undoubtedly long recall the day they saw their first whale. While they might not recognize the fin of this transient killer whale (right) that distinguishes it from resident killer whales (left), the photographs will be cherished.

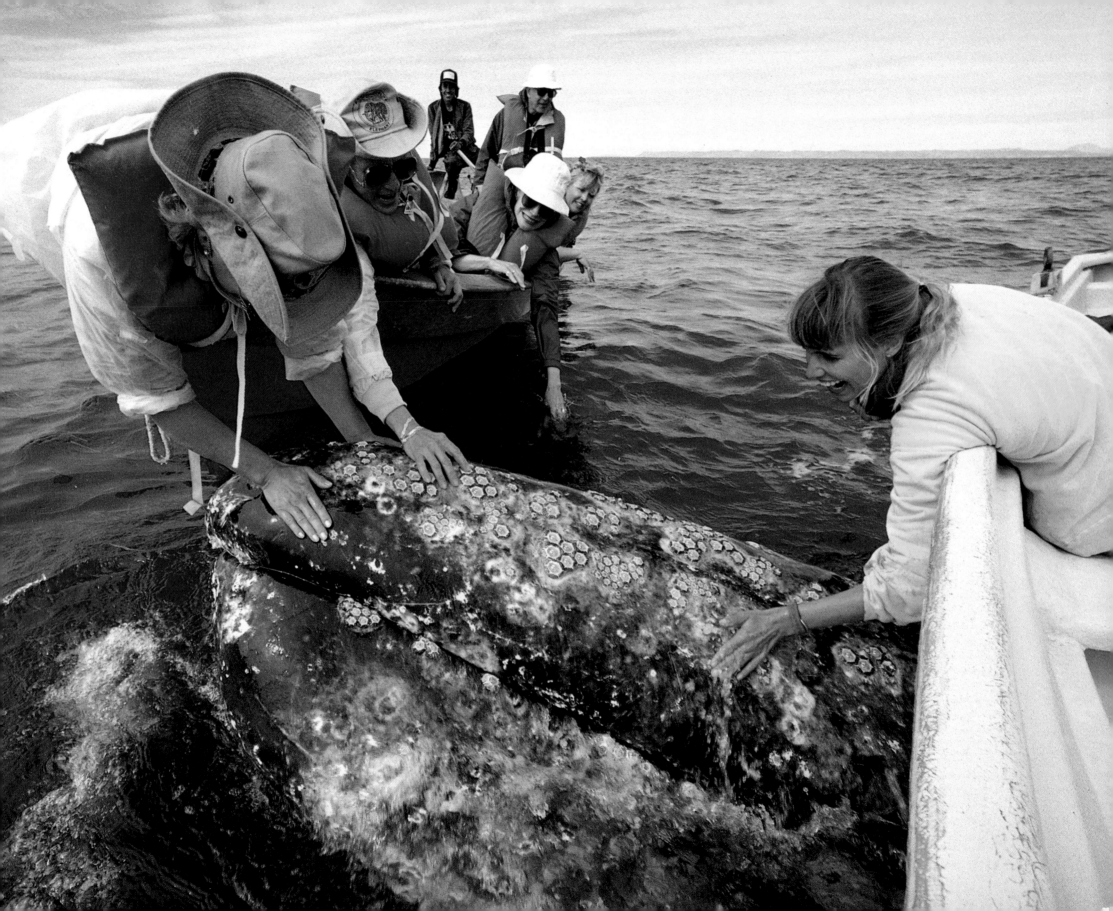

CLOSE ENCOUNTERS OF THE WHALE KIND

The whale watcher who reaches out and touches a friendly gray whale is a lifetime convert for conservation. It is increasingly apparent that some species are becoming friendlier to their human visitors. They surface, swim close to the boats and present heads to be scratched, petted or rubbed. In Baja's San Ignacio Lagoon, such experiences are becoming commonplace.

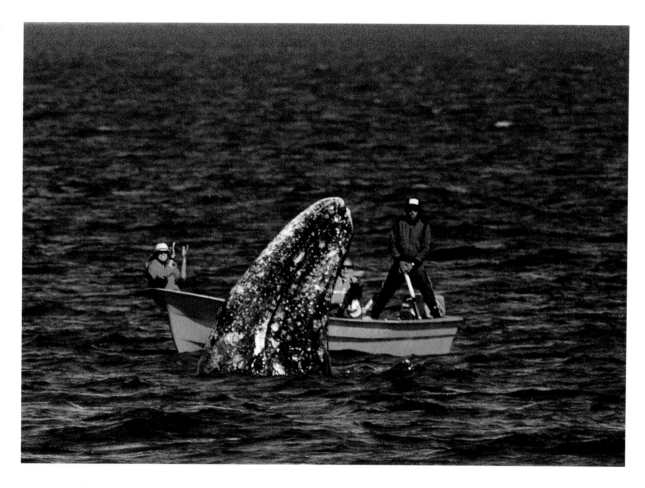

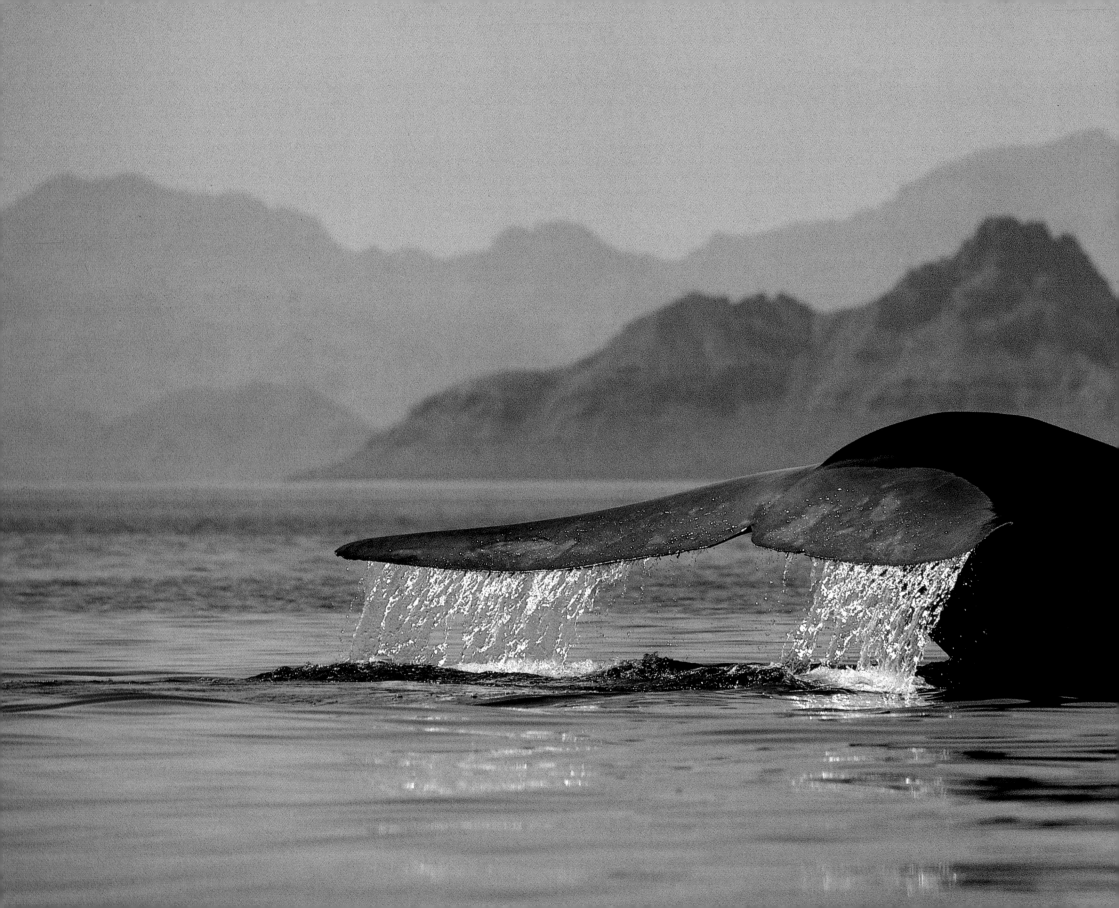

BLUE TAIL

The biggest threat to whales, as well as to us all, is the loss of habitat. If the oceans continue to be used as dumping grounds, pollution will threaten whales as much as any harpoon.

better off than they were a decade ago. The endangered species — the humpbacks, rights, bowheads, blues, finbacks — have been given some recovery time, and there is sentiment throughout much of the world that whales are worth protecting. At the same time, due to an ever expanding and industrialized world community, the future of whales does not look bright. The beluga whales of the Gulf of St. Lawrence might be the most accurate glimpse into the future.

We do not yet know enough about the animals to even properly assess the status of their populations, much less understand the consequences of human industries changing their environment. There is a great shortfall of knowledge. Even if that is countered, the future of whales, as well as all wildlife, is undeniably tied to the great social problems of the human race. Starving people in overpopulated, polluted countries do not know or care about whales. There are tremendous forces here which could easily bury our fragile ideas of research and education, making them a curiosity of the late twentieth century.

In the 1990s we are engaged in a battle with ourselves. As individuals we might care about whales; as a society we are killing them. The fate of these creatures, and quite probably that of all wildlife, depends on our will to take care of our environment.

That we are still fighting is the best sign we and the whales have.

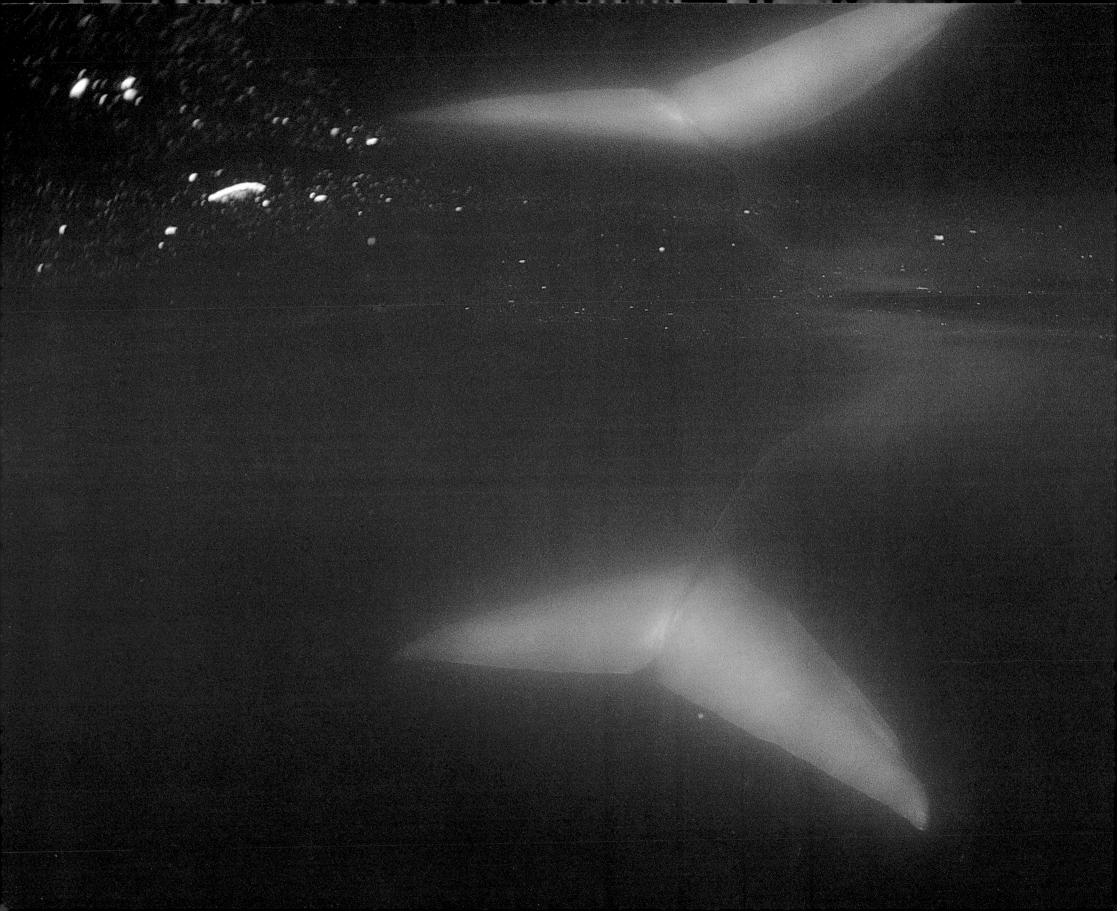

BLUE REFLECTIONS

Underwater look at a blue whale tail
reflecting on the surface of the water in
the Sea of Cortez.

"Whales in mid-ocean, suspended in the waves of the sea
great heaven of whales in the waters, old hierarchies.
And enormous mother whales lie dreaming
suckling their whale-tender young
And dreaming with strange whale eyes wide
open in the waters of the beginning and
the end."

D.H. LAWRENCE

Acknowledgements

PHOTOGRAPHER'S ACKNOWLEDGEMENTS

National Geographic Magazine and especially Bill Garrett, Bob Gilka, Tom Kennedy, Bill Graves for the time, resources and understanding to make this work possible.

Whale researchers who shared their findings and often their limited time in small boats and crowded camps. The years that these men and women have spent in the field have advanced our understanding of whales.

Jim Darling, the author, who got me started shooting whales.

The funding agencies that support whale studies in the field and in the lab.

DEDICATION

In memory of Charles Richard Nicklin Sr., who loved the wild.

EDITOR'S NOTE

Due to the technical nature of the original manuscript and to the extensive travel schedule of the author, the editors have rewritten portions of the text. The publisher is fully responsible for the accuracy and clarity of the text. The cooperation of the author during the several revisions has been appreciated.

RESEARCHERS

Gay Alling
Mike Bigg
Debbie Cavanagh
Sue Cousins
Ellie Dorsey
Larry Dueck
Graeme Ellis
John Ford
Jonathon Gordon
Jon Lien
Ian MacAskie
Beth Matthews
Dan McSweeney
Ken Norris
Roger Payne
Victoria Rowntree
Richard Sears
Greg Silber
Steve Swartz
Peter Tyack
Randy Wells
Hal Whitehead
David Wiley

NON-RESEARCHERS

Arctic Bay H.T.A.
Mike Bennet
Jim and Mary Bird
Ernesto Castro
Gustavo Alvarez Columbo
Carlos Garcia
Rick Geissler
Ted Goodspeed
Paul Gunderson (O.S. Systems)
O. Hirata
Marilyn Horn
Dr. Hiran Jayewardene
Jim Lee
Jim Lucky
TadaHiko Matsui
Dave and Irene Myers
Koji Nakamura
Eduardo Lopez Neggrete
Chuck Nicklin
Terry Nicklin
Pond Inlet H.T.A.
John Stoneman
Stubbs Island Charters
Chuck and Connie Sutherland
Juda and Andrew Tugatu
Kim Urian
Laura Urian
Peter Van Der Mark
Glen and Rebecca Williams

FUNDING AGENCIES

Clifford E. Lee Foundation
Earthwatch
East Company
Fisheries and Oceans — Canada
Japan Underwater Films
Long Term Research Institute
Maui Whale Watchers
Mingen Island Cetacen Study
National Aquatic Resources Agency — Sri Lanka
National Geographic Society
National Marine Fishery Service — United States
New York Zoological Society
Polar Shelf — Canada
Vancouver Aquarium
West Coast Whale Research Fdtn.
World Wildlife Fund

AUTHOR'S ACKNOWLEDGEMENTS

I especially thank the researchers who so readily shared their knowledge and experiences:

Pierre Beland
Mike Bigg
Jim Borrowmen
Maureen Brown
Carol Carlson
Chris Clarke
Debbie Glockner-Ferrari
John Ford
Mary Lou Jones
Steve Katona
Scott Kraus
Jerry Lowenstein
Bruce Mate
Stormy Mayo
Dan McSweeney
Ken Norris
Roger Payne
Victoria Rowntree
Vince Sarich
Richard Sears
Susan Shane
Steve Swartz
Sara Taber
Peter Thomas
Linda Weilgart
Randy Wells
Hal Whitehead
Bernd Würsig

Copyright © 1990 by Flip Nicklin

All rights reserved. No part of this
work covered by the copyrights
hereon may be reproduced or used
in any form or by any means —
graphic, electronic or mechanical,
including photocopying, recording,
taping or information retrieval
systems — without previous
permission of the publisher.

Published in 1990 by
NorthWord Press, Inc.
7520 Highway 51 South
Minocqua, WI 54548

For a free catalog describing
NorthWord's line of nature books,
tapes and gifts, call 1-800-336-5666.

ISBN: 1-55971-039-X

Printed and bound in Singapore

Photographs appearing on the dust
jacket and on pages 7, 10-11, 12-13, 18-19,
21, 22-23, 26, 32, 34, 38, 42, 46-47, 58, 67,
69, 73, 77, 81, 84, 86, 88, 91, 92, 93, 97,
100, 104, 108-109, 111, 115, 116, 126, 128,
130, 132-133, 138, 145, 147, and 148-149,
are copyright 1982, 1984, 1986 and 1988
The National Geographic Society.

599.5 N536w RBF
Nicklin, Flip
With the whales